Van Gogh to Mondrian

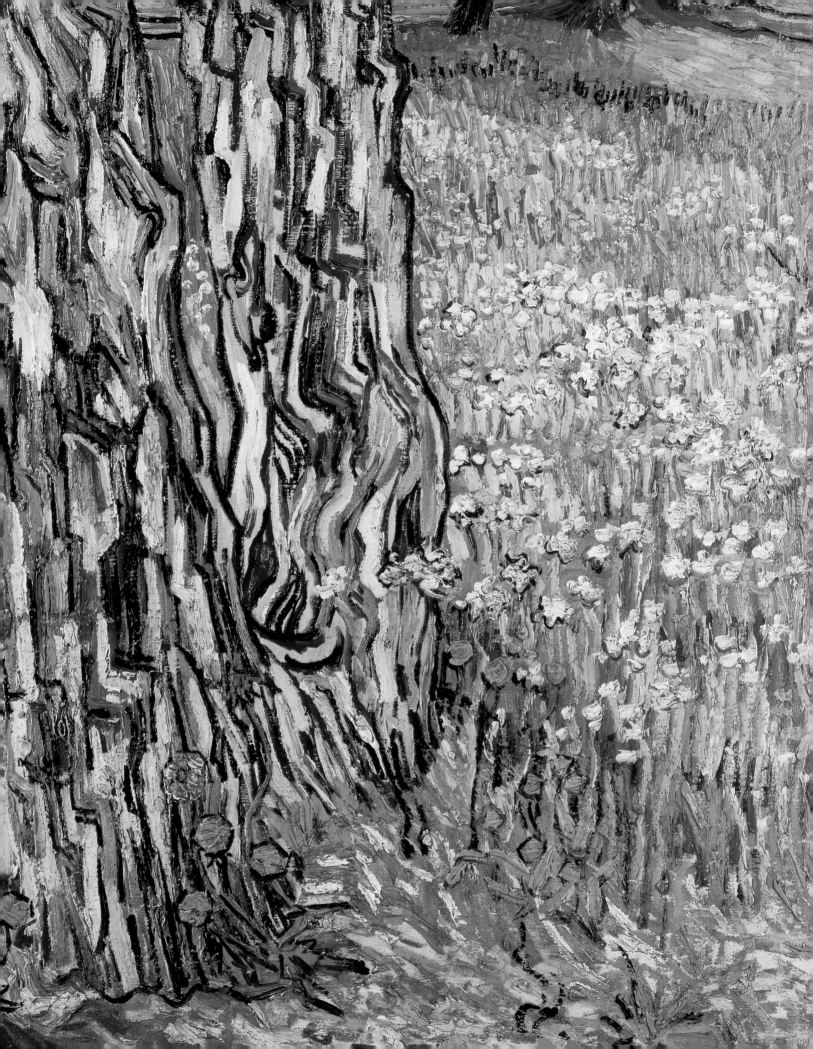

ESSAYS BY PIET DE JONGE

NANCY J. TROY

MANAGING CURATOR DAVID A. BRENNEMAN

CONTRIBUTIONS BY WIM DE WIT

STEPHEN HARRISON

JANET S. RAUSCHER

MAREK WIECZOREK

# Van Gogh to Mondrian

## MODERN ART FROM THE KRÖLLER-MÜLLER MUSEUM

HIGH MUSEUM OF ART

ATLANTA

*Van Gogh to Mondrian: Modern Art from the Kröller-Müller Museum*
is organized by the High Museum of Art, Atlanta.

In Seattle, the exhibition's presenting sponsor is Washington Mutual.

Generous support provided by Microsoft Corporation and
Seattle Mayor's Office of Arts and Cultural Affairs, with major funding
also provided by PONCHO (Patrons of Northwest Civic, Cultural, and
Charitable Organizations) and the Seattle Art Museum Supporters.
Additional support provided by Contributors to the Annual Fund.

*Van Gogh to Mondrian* was on view at the Seattle Art Museum from
May 29 to September 12, 2004, and at the High Museum of Art,
Atlanta, from October 19, 2004, to January 16, 2005.

This exhibition is supported by an indemnity from the
Federal Council on the Arts and the Humanities.

Library of Congress Cataloging-in-Publication Data
Jonge, Piet de.
  Van Gogh to Mondrian : modern art from the Kroller-Muller
Museum / essays by Piet de Jonge, Nancy J. Troy ; managing
curator David A. Brenneman ; contributions by Wim de Wit,
Stephen Harrison, Janet S. Rauscher, Marek Wieczorek.
     p. cm.
  Catalog of an exhibition held at the Seattle Art Museum
from May 29 to September 12, 2004, and at the High Museum
of Art, Atlanta, from October 19, 2004, to January 16, 2005.
  Includes bibliographical references and index.
  ISBN 1-932543-01-5 (hardcover: alk. paper)
  ISBN 1-932543-02-3 (softcover : alk. paper)
  1. Art, European—19th century—Exhibitions. 2. Art,
European—20th century—Exhibitions. 3. Art—Netherlands—
Otterlo—Exhibitions. 4. Rijksmuseum Kröller-Müller—
Exhibitions. I. Seattle Art Museum. II. High Museum of Art.
III. Title.
N6757.J65 2004
759.05'6'074758231—dc22                    2004004117

University of Washington Press
P.O. Box 50096
Seattle, WA 98145-5096
www.washington.edu/uwpress

Cover: Vincent van Gogh, *Café Terrace at Night* (detail, cat. 3)

Back cover: Piet Mondrian, *Composition No. 10* (cat. 80)

Details:

page 2: Vincent van Gogh, *Tree Trunks in the Grass* (cat. 11)

page 6: Piet Mondrian, *Composition in Color B* (cat. 82)

page 8: Vincent van Gogh, *Loom with Weaver* (cat. 1)

page 12: Maurice Denis, *April* (cat. 38)

page 34: Vincent van Gogh, *Still Life with a Plate of Onions* (cat. 9)

page 48: Vincent van Gogh, *Pine Trees at Sunset* (cat. 8)

page 74: H. P. Bremmer, *Fir Trees (Harskamp)* (cat. 32)

page 98: Bart van der Leck, *Mining Industry* (cat. 43)

page 114: H. P. Berlage, *Hall of Museum on the Franse Berg I* (cat. 56)

page 132: H. P. Berlage, *Round Table from "Art Room Suite"* (cat. 67)

page 140: Juan Gris, *Still Life with Oil Lamp* (cat. 72)

page 154: Piet Mondrian, *Composition in Line and Color* (cat. 79)

Washington Mutual is pleased to sponsor the Seattle Art Museum's presentation of the exhibition *Van Gogh to Mondrian: Modern Art from the Kröller-Müller Museum*. This is a treasured collection and it is our great pleasure to welcome you to this splendid event.

Whether supporting affordable and safe housing initiatives, investing in programs to support our schools, or sponsoring events that provide access to the arts, Washington Mutual is committed to making our communities better places to live and work.

Each year we donate millions of dollars through cash contributions and matching gift programs, and we encourage our employees to volunteer and to give back to their communities. By partnering with organizations like the Seattle Art Museum, we ensure that the arts remain a vigorous part of our community's well-being.

On behalf of all of us at Washington Mutual, we hope you enjoy *Van Gogh to Mondrian*.

Brad Davis, *Executive Vice President, Marketing*
Washington Mutual

# Sponsor's Statement

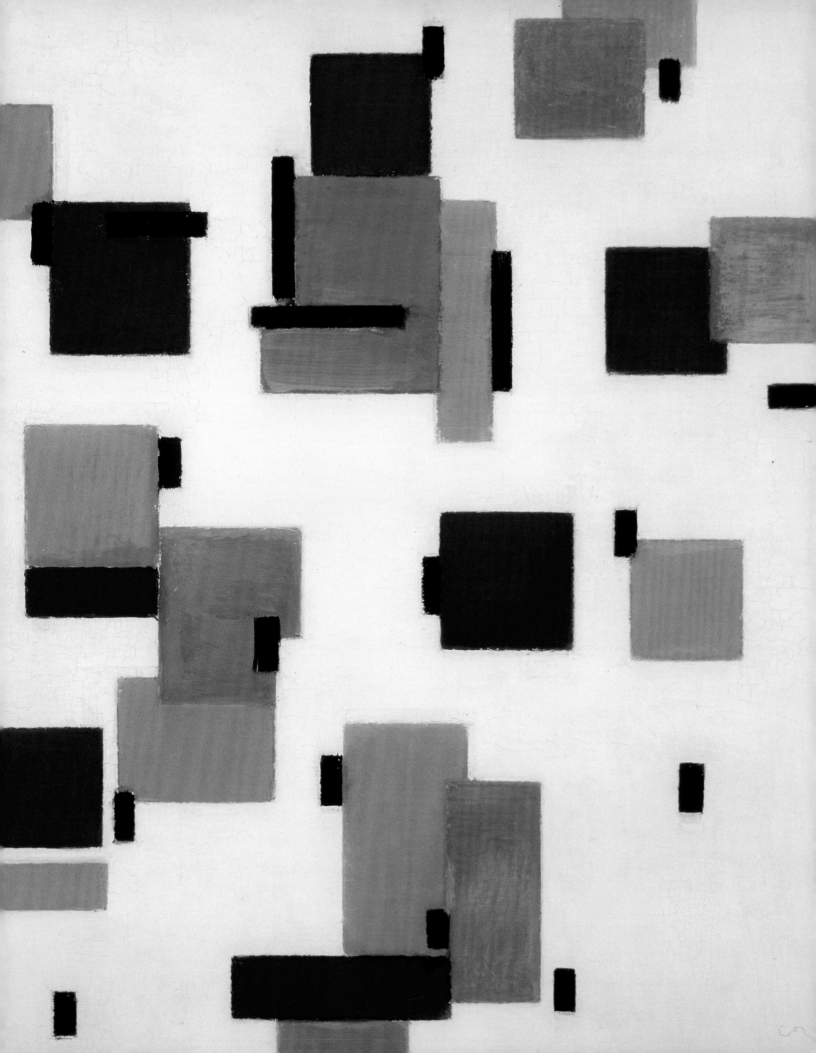

# Contents

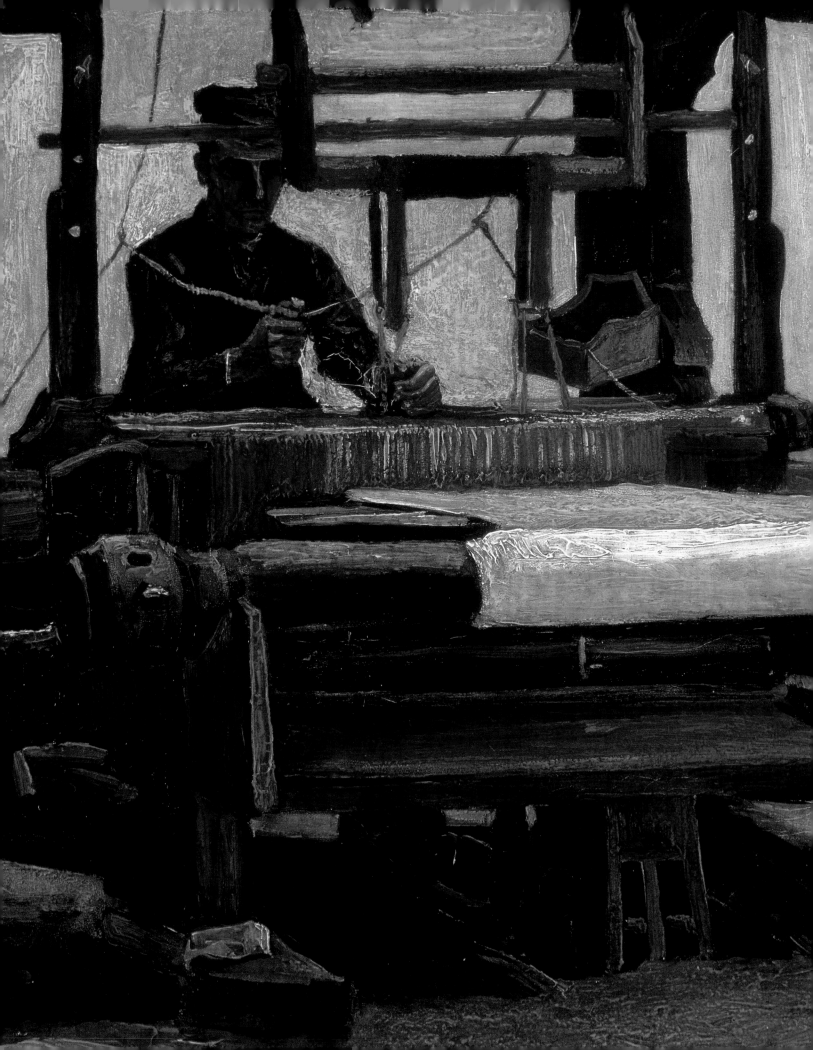

ALMOST ONE HUNDRED YEARS AGO, Helene Kröller-Müller began to assemble what would become one of the world's foremost collections of early modern art. Like some of her avant-garde contemporaries at the beginning of the twentieth century, Helene Kröller-Müller believed that art is an expression of spiritual forces. Her first passion was for the work of Vincent van Gogh, and she eventually acquired almost 300 works by the artist, making her collection today second only to that of the Van Gogh Museum in Amsterdam. She also voraciously collected the works of the French Neo-Impressionists, whose influence had quickly spread to Holland in the 1890s. Her adventurous taste and expansive philosophy of art later fostered her appreciation of the work of such early-twentieth-century artists and architects as Henry van de Velde, Bart van der Leck, and Piet Mondrian. Just before her death in 1939, she opened the museum that would bear her name so that she could share the art she loved so much with the public.

This exhibition and the accompanying catalogue have a dual purpose. The first is to expose American audiences to the treasures of this great European collection. Although the Kröller-Müller Museum is well known to connoisseurs of modern art, it is not heavily visited by American tourists to the Netherlands because it lies off the beaten path in the rural southeastern part of the country. The last time that a significant grouping of Mrs. Kröller-Müller's paintings traveled to the United States was in 1935 for the first major American retrospective of Van Gogh's paintings at the newly opened Museum of Modern Art in New York. That museum was also the host of an exhibition of drawings from the Kröller-Müller Museum in the early 1970s. The second purpose of this project is to explain how and why this remarkable collection came into being. As the twentieth century progressed and the history of modern art was codified, certain aspects of the early formation of the collection were obscured because they did not fit within the rigid narrative of modern art. This catalogue seeks to recover the unique character and circumstances of Mrs. Kröller-Müller's collecting and to tell her own intriguing story.

The High Museum of Art and its partner, the Seattle Art Museum, are pleased to be able to present Helene Kröller-Müller's story. The exhibition was the result of a close collaboration with the staff of the Kröller-Müller Museum. We would like to thank Dr. Evert J. van Straaten, Director of the Kröller-Müller Museum, for his strong support of this project. The exhibition was the brainchild of Piet de Jonge, Head of Collections

# Directors' Preface
# and Acknowledgments

and Presentation of the Kröller-Müller Museum. He worked closely with Nancy J. Troy, Professor of Art History at the University of Southern California and guest curator for this project, and David A. Brenneman, the High's Chief Curator and Frances B. Bunzl Family Curator of European Art. Other key staff at the Kröller-Müller Museum include Rinus Vonhof, Deputy Director; Esther van Maanen, Project Coordinator; Andre Straatman, Registrar; Margaret Nab, Photography Department; Maureen Ruchtie, Assistant to Piet de Jonge; and Wanda Vermeulen, Public Relations Department.

At the Seattle Art Museum, we would like to acknowledge the efforts of Maryann Jordan, Senior Deputy Director; Robert S. Cundall, Chief Financial Officer; Lisa Corrin, Deputy Director of Art and Jon & Mary Shirley Curator of Modern & Contemporary Art; Erik Pihl, Director of Development; Zora Foy, Manager of Exhibitions & Curatorial Publications; Susan Rosenberg, Associate Curator of Modern & Contemporary Art; Jill Rullkoetter, Kayla Skinner Director of Education & Public Programs; Michael McCafferty, Director of Exhibition Design & Museum Services; Sue Bartlett, Director of Marketing; Dianne Simmonds, Senior Assistant Registrar; Sheryl Ball, Curatorial Editor; Liz Andres, Exhibitions & Collections Coordinator; Victoria Moreland, Director of Community Affairs; Jill Robinson, Corporate Relations Officer; and Laura Hopkins, Foundation Relations Officer.

At the High, we would like to thank the following individuals for their support: Philip Verre, Deputy Director; Rhonda Matheison, Director of Finance and Operations; Sandra Kidd, Director of Museum Advancement; Al Holland, Chief of Security; Kevin Streiter, Manager of Facilities and Logistics; Jody Cohen, Manager of Exhibitions; Frances Francis, Registrar; Maureen Morrisette, Associate Registrar; Amy Simon, Assistant Registrar; Melody Hanlon, Assistant to the Registrar; Saskia Benjamin, Exhibition Coordinator; Jim Waters, Exhibitions Designer; Caroline English, Gene Clifton, Larry Miller, and Ed Hill, Preparators; Angela Jaeger, Head of Graphics; Kelly Morris, Manager of Publications; Lori Cavagnaro, Assistant Editor; Christin Gray, Publications Coordinator; Patricia Rodewald, Eleanor McDonald Storza Chair of Education; Fontaine Huey, Senior Development Manager; Rebecca Guberman, Manager of Individual Support; Tom Rowland, Manager of Marketing and Communications; Lauren Shankman, Public Relations Coordinator; Stephen Harrison, Curator of Decorative Arts; Amie Servino, Curatorial Assistant in European Art; and Jennifer Baughman, Curatorial Assistant in African Art and Decorative Arts.

We would like to acknowledge Nancy Troy, Piet de Jonge, David Brenneman, Janet Rauscher, Stephen Harrison, Wim de Wit, and Marek Wieczorek for their excellent contributions to the catalogue. For their help on various aspects of the project, we would also

like to thank Armin Kunz, Director, Artemis Fine Arts, Inc.; Frans Leidelmeijer, Kunsthandel Frans Leidelmeijer; Dorothy Kosinski, Senior Curator of Painting and Sculpture and The Barbara Thomas Lemmon Curator of European Art, Dallas Museum of Art; and Marjorie B. Cohn, Carl A. Weyerhaeuser Curator of Prints, Fogg Art Museum.

Finally, we acknowledge the significant financial support of our corporate sponsors. We are deeply grateful to UBS for its leadership role as the Atlanta Exhibition Sponsor of *Van Gogh to Mondrian.* We also wish to acknowledge John van Vlissingen and BCD Holdings for their generous support of the exhibition. In Seattle, we are most grateful to the presenting sponsor, Washington Mutual.

The exhibition is supported by an indemnity from the Federal Council on the Arts and the Humanities. We applaud this important government program that provides such vital support for international exhibitions in the United States.

Mimi Gardner Gates
*The Illsley Ball Nordstrom Director, Seattle Art Museum*

Michael E. Shapiro
*Nancy and Holcombe T. Green, Jr. Director, High Museum of Art*

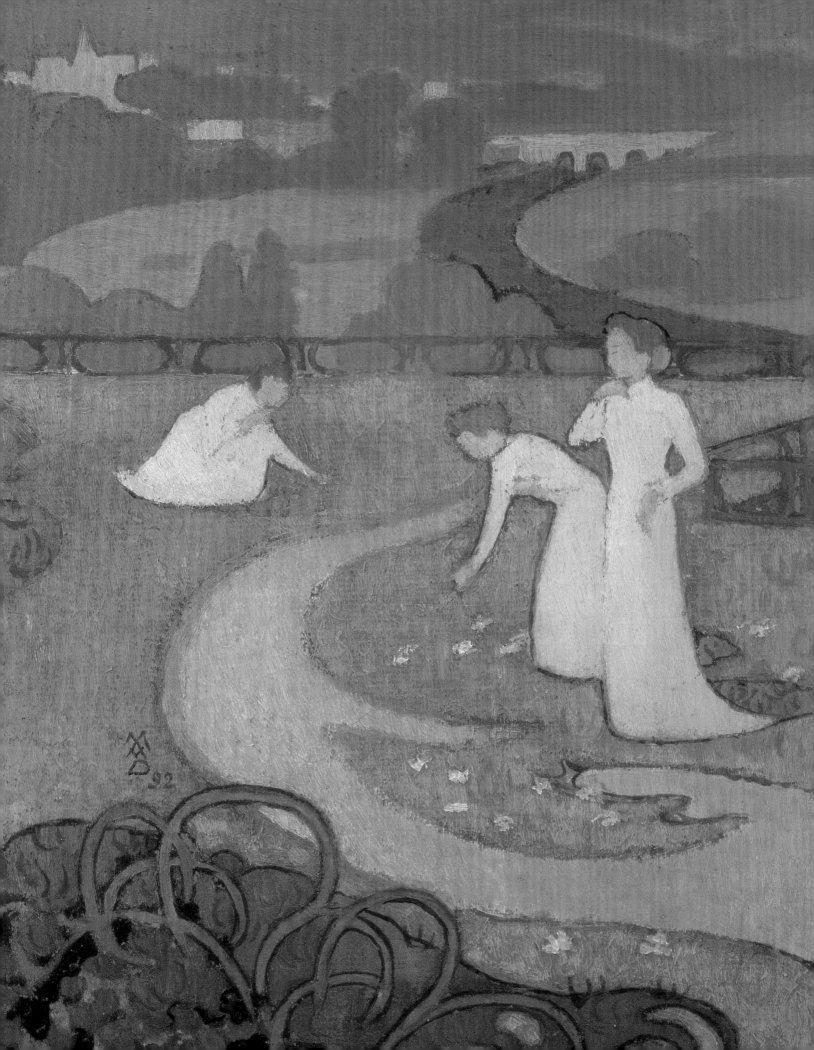

Fig. 1 Helene Kröller-Müller,
ca. 1910.

PIET DE JONGE

Although Helene Kröller-Müller's Dutch must have been faultless and spoken with no hint of a German accent, and she had exchanged her Gothic script for a Dutch hand, she always prided herself on her German heritage.[1] The question remains to what extent she felt at home in her adopted country. When, in 1922, the Dutch state received the credit for commissioning Henry van de Velde to build a museum in the Netherlands, Helene (fig. 1) set the record straight with characteristic patriotism: "It was a woman born and raised in Germany, with a German heart, even if the law bestowed Dutch nationality upon her when she married."[2] Indeed, twelve years earlier, when anti-German sentiments in the Netherlands became overpowering during the First World War, Helene returned to Germany. Like many other German women, she worked in a hospital in Liège during the Great War.

Helene Kröller-Müller must have been quite a phenomenon, a formidable woman with extremely varied enthusiasms, including riding horses, organizing children's camps, establishing a model farm, and building houses. She undertook every activity with an unquestioning devotion, but it was not until her fortieth year that she discovered her life's destiny: the accumulation of an art collection and the founding of a museum (fig. 2) in the Hoge Veluwe to house it.

### Helene Müller

Helene Emma Laura Juliane Müller was born on 11 February 1869 in Horst near Essen, the third child of Wilhelm Heinrich Müller and Emilie Neese. She was the sister of Gustav (1865), Martha (1866), and Emmy (1872). The Müllers belonged to the upper middle class and were members of the Evangelical Church. In 1876 the family (fig. 3) settled in Düsseldorf, in a large house at Tonhallestrasse 15, which Helene's father called "ein kleines Palais."[3] Müller traveled widely and corresponded extensively with his wife and father. In 1924 his sister Anna chronicled his story and that of his family and business in an unpublished four-volume manuscript. "Wm. H. Müller: From Letters and Personal Recollections of His Sister Anna" also contains observations about the young Helene (fig. 4). When she was eight, her father wrote of her: "Leneken [is] a wagtail and a floater à la Gustav."[4] At eighteen years of age, Wilhelm Müller followed his father to America. Father and son made their fortunes and around 1864, after an eight-year

# Helene Kröller-Müller

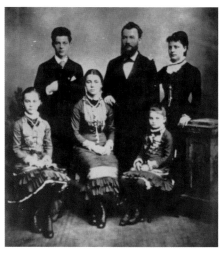

absence, Wilhelm Müller returned home: "From the setbacks in America I learned the necessary lessons to eventually succeed."[5] Upon his return, he worked for twelve years for Union, a small blast furnace in the Ruhr district, initially as office manager and later as director.

At the end of the nineteenth century, industry in the Ruhr district developed at high speed. The exploitation of the region's coal deposits produced great possibilities for the steel industry, and the demand for iron ore grew rapidly. In early 1876 Wilhelm Müller left Union to begin his own company, Wm. H. Müller & Co. Agents, Wholesalers and Dealers in Mining and Blast-furnace Products.[6] "Our activities will focus on the trade in German and English products within the domestic market ... and the export of German mining and metallurgical products and the representation of the interests of German manufacturers abroad."[7] The trade in blast-furnace components grew so swiftly that within two years Müller opened a branch on the Willemsplein in Rotterdam. There he was able not only to manage his own shipments through Rotterdam but also to operate as an intermediary for other shippers. His agent in the Netherlands was Willem Kröller.[8]

## Helene's Youth

When Helene was nine years old, her father wrote: "Helene is a model child: stormy, wild and volatile, but in essence very pleasant, for the rest, just like Gustav, a very poor student." Of their family life, he reported that it was "very quiet and entirely restricted to the home. Only occasionally do we make excursions with the children to Grafenberg, the zoo etc. Exceptions to the rule."[9] Helene Müller went to a private school led by the idealistic Frau Schuback, whose motto was "Nobility, Beauty, Truth." In the diary that she kept from her thirteenth year (April 1882 to July 1885), one can read how sensitive and insecure the young Helene must have been. She felt misunderstood and alone. Henrika Rogge, "an extremely independent young teacher," played an important role in Helene's development and remained her confidante.[10] Their bond was extremely strong and Helene corresponded with her until Rogge's death in 1937.

Although Helene's father had remarked that she was a poor student, with guidance Helene's perfectionism came to the surface. When she was fourteen, the extent to which Helene engrossed herself in her lessons caused her father some alarm: "Helene is an extremely diligent student, so much so that we have to restrain her studiousness. Helene has such an outspoken scholarly ambition that she has entirely pushed aside her interest in the theatre and all other diversions. She studies from five in the morning until ten or eleven at night and, because her health is visibly suffering, I have now expressed my veto. With

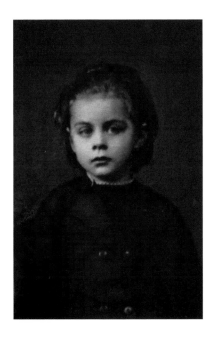
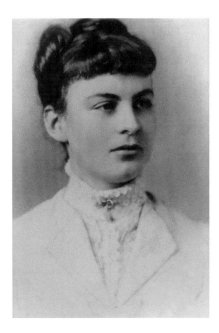

Fig. 4  Helene Müller at age 5.
Fig. 5  Helene Müller, ca. 1887.

Miss Schuback's consent we have dropped a whole range of subjects."[11] However, her ambition did not dwindle, as her father wrote a year later: "Helene is cramming again for math."[12] Within a few years the poor student had become an extremely eager one.

This pattern would repeat itself in her later life. Inspired by an animated mentor, Helene would spare no energy to match her teachers and then to outstrip them. She consistently sought out sources of inspiration—for example, in literature, for which she developed a great interest at school: "To read the writings of great men, to absorb their lives and characters, remains for me the highest achievement."[13] The German classics—Goethe, Lessing, and Schiller—were her favorites. Her library contains every important work by these authors, together with those of Rilke.

Anna Müller describes in her chronicle how family life focussed on finding suitable partners for the children. In 1885 Wilhelm was a beloved *"maître de plaisir,"* who encouraged his children to go out. Their son Gustav wrote: "Since I received a top hat and tails for Christmas, I can respectably accompany Martha when she goes courting. We both hope to find, as soon as possible, a wife and a husband who can support us."[14] Helene did not care much for nightlife; she was much more interested in the serious business of life. A characteristic example is her view on the infallibility of the Bible. Helene's interpretation of the Holy Trinity did not agree with the accepted viewpoint but she nonetheless eventually confirmed her faith. The conflict has an important place in her diary. Although the Kröller-Müllers would later list themselves as "without belief" in the register of births, deaths, and marriages, for Helene religion, and spirituality in general, would remain a lifelong motivation.

Although Helene was a good student and would have preferred nothing more than to continue her studies, her mother had other plans. Helene was to find a suitable husband and become a devoted mother.[15] In order to groom her for this future, her Aunt Anna took Helene to Mademoiselle Schollmeyer's finishing school in Brussels (fig. 5). In her letters home Helene gave a thorough account of her stay there.[16] Within a brief period she learned to speak fluent French.

In May of the following year Helene returned to Düsseldorf and took charge of the housekeeping because her mother was staying in Magdeburg. Her father wrote to his wife:

I can assure you that the household is in excellent hands. Helene goes about the task with the certainty of one who has done it for a year and a day. She presides over the coffee table, convinces herself that the dinner menu she has assembled meets my approval, interrogates the cook about the accounts, gives the latter her instructions, and indeed today, because it is washday, took charge of the cooking herself. For the rest, she is not idle for a moment—embroidering during breakfast, darning stockings after lunch and mending the washing in the evenings. I think that she gets it from her mother.[17]

Helene was then eighteen years old. In her father's office she recognized an old acquaintance: the Rotterdammer Anton Kröller.

## Anton Kröller

Anthony George Kröller's ancestors were farmers and artisans from Auel, a village in Nassau-Dillenburg in Germany. At the beginning of the nineteenth century, his grandfather settled in Rotterdam. Anton's father was born there, where he ran a construction and carpentry business. He married Maria Helena Kemp, with whom he had four children. In 1862, shortly after the birth of her youngest son, Anton, Maria died. Because the elder Kröller was already advanced in years, he entrusted his children's upbringing to his sister Marie. Anton graduated from high school with ease in 1879 and immediately entered the service of the Müller firm, the company for which his eldest brother Willem worked. Willem had served his apprenticeship with the shipping firm Ruys & Co. and was certainly aware of the opportunities that Wm. H. Müller & Co. could offer. Not only did he advise his brother to join him, but in 1881 he also invested his entire winnings from a lottery in Antwerp in the business. The enormous sum of 100,000 guilders secured him co-directorship of the firm, and the capital was immediately invested in new ships.[18]

Willem sent his youngest brother to the Düsseldorf office to train him in business. Upon his return in 1883 Anton was promoted to deputy manager. The Rotterdam office did a thriving business. By contrast, the Düsseldorf branch suffered from the economic crisis that gripped Germany in 1885. However, the Rotterdam office was not without its problems. Willem Kröller had a nervous breakdown during this period (from which he never fully recovered) and Anton, just twenty-three, had to take over the company's most important negotiations. The admirable performance of this young employee was not lost on Wilhelm Müller.[19]

## Anton and Helene

When Wilhelm Müller heard that Anton had his eye on Helene, he told her: "Helene, if you can do it, in one way or another, then do it, because I cannot do without him."[20] A "no" from Helene could have been a deciding factor in the company's survival. She said "yes." Wilhelm stipulated that Willem Kröller give his brother a quarter of his shares in the company, just as Wilhelm would later do for his son Gustav. Thus, with his marriage to Helene, Anton Kröller received an important stake in the firm of Wm. H. Müller & Co.

On 15 May 1888 the twenty-six-year-old Anton married Helene in the Johanniskirche in Düsseldorf (fig. 6). They procured an upstairs apartment on the Kortenaerstraat in Rotterdam, which the bride's mother decorated during their honeymoon in Italy.[21] At the end of the year Anton developed a lung infection, which caused great concern. Wilhelm Müller traveled to Rotterdam and reported extensively on the patient's condition to his wife, who remained at home, adding that Helene was "an extremely attentive nurse."[22] Anton's recovery was slow and a few months later he also developed a painful infection of the eye, a complaint from which he had suffered a few years earlier. Because Willem Kröller did not want to appoint an acting deputy, Wilhelm Müller decided that he and his wife should move to Rotterdam for a while. He had in mind a period of two years. They moved in with Anton and Helene at the beginning of 1889.[23]

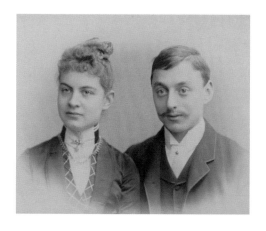

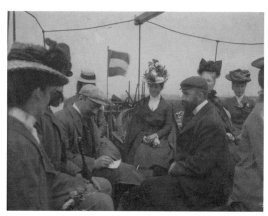

Fig. 6  Helene Müller and Anton Kröller, ca. 1888.

Fig. 7  Helene and Anton boating, ca. 1898.

BELOW

Fig. 8  Helene Kröller-Müller the equestrian, ca. 1898.

## Rotterdam

The Kröller-Müllers had four children: Helene in 1889, Toon in 1890, Wim in the following year, and in 1897 their last child, Bob, was born. The apartment soon became too cramped and Anton wanted something more representative of their social standing, so the family moved to a large house on the Haringvliet.[24] The couple regularly played host to Helene's family and their many friends, mostly shipping magnates who had made their fortunes in Rotterdam's harbors. The house overlooked the River Maas, on which the family and friends rowed and sailed during the summer (fig. 7). Helene shared Anton's love of horses and they often rode with friends at Rotterdam's riding academy. Helene threw herself into this new pastime and quickly proved to be a skillful equestrian (fig. 8).

Shortly after moving in with his daughter and son-in-law, Wilhelm Müller was diagnosed with hardening of the arteries. Gustav wrote to his aunt: "Papa's condition is comparable with the symptoms of heart failure."[25] During his recuperation Wilhelm dictated a letter to his agent in Bilbao: "Luckily I can count on my son-in-law Kröller's return at the end of the week. The cure in Wiesbaden has done him a world of good. He will have to take sole responsibility for the business, at least for a while."[26] On 30 May 1889 Helene's father had a heart attack during break-fast and died at age fifty-one. In the same year, Willem Kröller definitively relinquished his directorship of the Rotterdam branch because of ill health. Thus, at the age of twenty-seven Anton Kröller unexpectedly became the sole director of Wm. H. Müller & Co. in Rotterdam. At his request the twenty-five-year-old Gustav Müller became the managing partner of the German branch a year later, on 1 June 1890.[27]

Due to the increasing importance of the firm's shipping activities and international business relations, the Dutch branch became dominant. The firm's development kept pace with the

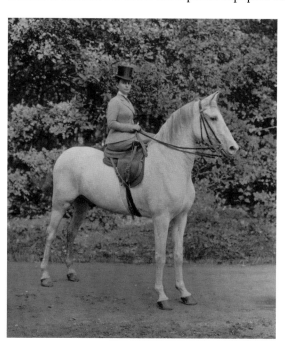

17

enormous growth of Rotterdam's harbor at the turn of the century. In order to situate himself directly between the recently opened office in Amsterdam and the old office in Rotterdam, and to foster a closer bond with the government, Anton Kröller decided to move the company's headquarters to The Hague. He remained close to the government, and above all to the Ministry of Foreign Affairs, until his death.[28]

## Life in the Capital

The Kröller-Müllers also moved to The Hague in 1900. They initially lived in the Villa Rembrandt on the Cremerweg in the Van Stolkpark. These accommodations were temporary because Anton Kröller had bought two villas on the large lake with land totaling two and a quarter acres. One of these, Ma Retraite, was reduced to its foundations and the fashionable architect L. J. Falkenburg was commissioned to rebuild the villa.[29] A year and a half later the Kröller-Müllers took possession of their new house (fig. 9) and named it the "Huize ten Vijver" (Lake House). The interior's fashionable mix of historical styles highlighted the family's newly attained status. The man of the house had an Empire room, and the green salon and blue dining room were in the style of Louis XVI (fig. 10). Helene placed the white Delftware that she had already

begun to collect in Rotterdam in the marble hallway on gilded neo-Baroque consoles.[30] Their move altered the Kröller-Müllers' social life and their contact with friends and acquaintances in Rotterdam dwindled.[31] They now socialized with politically important figures essential to Anton Kröller's business. The many photographs of South African dignitaries in Helene's collection bear witness to this fact (fig. 11).[32]

Between 1906 and 1916 Anton Kröller acquired nearly 15,000 acres in the Hoge Veluwe in the center of the Netherlands, where the family spent part of their free time. The stables in The Hague were converted into garages around 1913 and the horses were restabled in the Hoge Veluwe, where Helene resumed regular riding.[33] However, a few years earlier she had discovered a new enthusiasm.

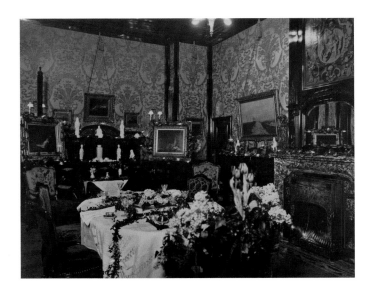

Fig. 10 Dining room in the Lake House, ca. 1907.

## Hendricus Petrus Bremmer

In the fall of 1905 Helene began to receive lessons from the
Hague-based art historian H. P. Bremmer.[34] Bremmer (fig. 12)
had begun his art appreciation courses for the well-heeled
almost ten years earlier and had transformed himself from a
relatively unsuccessful artist into an "art apostle," as his wife
called him in her unpublished biography. In various places in
the Netherlands he established clubs, through which, with the
aid of lantern-slide shows, reproductions, and original works,
he infected his enthusiastic acolytes with his love of classical
and, above all, contemporary art.

Bremmer's classes met the middle-class need for cultural
refinement. Bremmer held the meetings in students' homes,
allowing for a discreet membership ballot. The "Bremmerclub"
in Rotterdam was dominated by ladies from rich mercantile
families.[35] The Kröller-Müllers had many friends in this circle,
but Helene was not invited to join the Rotterdam club. It also
took some time for her to be admitted to Bremmer's course in
The Hague. The members of the extremely closed and status-
conscious social circle in The Hague would never have asked
this new resident of the capital city to join their Bremmerclub:
a German woman with an arriviste husband!

In 1902 Bremmer also began to give lessons in his own
home in The Hague. In the spring of 1905 the Kröller-Müllers'
seventeen-year-old daughter Helene enrolled for private lessons
in Italian art, in preparation for a trip to Italy, where she would
join her mother. Italy had remained a favorite destination for
the mother since her honeymoon. Bremmer's classes made quite
an impression and in the fall both mother and daughter enrolled
for the following spring's course. At thirty-eight years of age,
Helene Kröller-Müller discovered her life's fulfillment.

Bremmer broke from the then-current art historical approach
based upon knowledge of facts, styles, and historical context. His
"practical aesthetic" focussed on the work of art itself. He empha-
sized the artist's technique, the relationship between form and
color, and the artist's starting point in relation to his or her envi-
ronment. He also stressed the artist's emotional motivations. For
him the work of art was not an imitation of nature but rather,
"a consciously subjective aesthetic emotion."[36] Bremmer's classes
were characterized by the highly emotional manner in which he
discussed works of art, which were often sold at the end of the
lesson. During his classes Bremmer often recited poetry or prose
to intensify his students' responses to the work. By presenting
the work of art as an expression of the artist's psyche and placing

it within an aesthetic context, he emphasized the individual creative process and the personal expression of the artist.

Bremmer was no longer an artist but an interpreter of other people's art. His fascination with Van Gogh's work was especially strong and had a considerable influence on his method. Indeed Bremmer identified personally with the artist. He viewed Van Gogh's work as "objectified emotion." For both men art was a new form of religion. Helene, her husband, and her daughter attended his lessons, which were held on Sundays. She considered these lessons insufficient and in 1908 decided to organize a club on Fridays in her own home.[37] She invited her brother and his wife; her bachelor brother-in-law, Nico Kröller; her husband's secretary, Sam van Deventer; and probably other employees.[38] On 1 September 1913 she suggested to Bremmer that he dedicate his Mondays to advising her on her collection.

## The Collection

Bremmer's lessons made a deep impression on Helene. She had her shorthand annotations typed, which, augmented with illustrations, she distributed to her family and the staff of the Müller company. Thirty-six of these books have survived.[39] Bremmer's use of illustrations inspired her to build up her own archive of images. This nearly inexhaustible stock of illustrations has been kept: the folders, classified by country, artist, and subject, reveal the art that interested Helene. They also show the systematic manner in which she researched acquisitions for her collection.

Before enlisting Bremmer as her adviser, Helene had bought Persian rugs, antique furniture, and ceramics, but under his direction she quickly began to form a serious art collection and one that clearly reflected Bremmer's own preferences. In 1908 she acquired an important work by Van Gogh, *Four Sunflowers Gone to Seed* (page 50, fig. 2). In the following year she bought *The Sower (after Millet)* and *Basket of Lemons and Bottle*. The highly colorful paintings were hung in the green Louis XVI salon. Van Deventer called it "a singular combination."[40] Van Gogh's work would form the core of Helene's collection. She bought 97 paintings and 185

drawings by him.[41] She described Van Gogh as "so Ur-Dutch." He was decidedly not French and certainly no Impressionist: "That during his stay in France he painted with stipples or pointilliste strokes, that he employed contours and filled large areas with mixed or unmixed colors, is beside the point. His value lies not in his means of expression, his technique, but rather in his great and novel humanity.... He invented modern Expressionism."[42] Her collection became the world's largest private collection of Van Goghs.[43] Around these works she created a survey of the art of her time, emphasizing French and Dutch art. She avoided German painting, which she found "insufficiently authoritative."[44]

Helene's collection had a very broad range. She purchased works by Old Masters such as Lucas Cranach the Elder (fig. 13), Hans Baldung Grien, Tintoretto, El Greco, and Jan Steen. To these she added Egyptian, Chinese, and Japanese objects; sculptures by Joseph Csaky, Wilhelm Lehmbruck, Aristide Maillol, and George Minne; Old Master and contemporary prints; and rare books. Because she lived in a number of different houses, each of them built or rebuilt and furnished by prominent architects, she acquired a considerable collection of furniture, above all by H. P. Berlage and Henry van de Velde. The seemingly inexhaustible funds at her disposal enabled her to collect on a scale far beyond that of other "Bremmerians."

Despite her varied collecting interests, her heart belonged to her modern paintings. For Helene,

Fig. 13 Lucas Cranach the Elder, *Venus and Cupid Stealing Honey*, ca. 1537, oil on panel, Kröller-Müller Museum.

modern painting began with the "Positive Realism" of circa 1860 (Camille Corot, Henri Fantin-Latour, and Johan Jongkind), followed by Symbolism, Impressionism, Post-Impressionism, and Cubism. She had a special appreciation for artists who did not conform to the Zeitgeist, whose "souls were too strong," such as Odilon Redon, James Ensor, and Van Gogh.[45]

The manner in which she presented the collection in her museum in 1938 reflected this view of history. Visitors entered a space with non-Western art in order to raise their awareness of cultures beyond Europe. They then came to a gallery with Old Master paintings, which established the historical roots of what was to follow. On each side of the corridor that traversed the museum Helene hung works of "realism" and "idealism." Between these two poles "the line shifts back and forth among the main movements and the individuals."[46] At the Museum's heart was the heart of the collection: Van Gogh (fig. 14). Then the corridor again, with galleries for the Cubist works of Pablo Picasso, Georges Braque, Juan Gris, and Gino Severini and the abstraction of Piet Mondrian and Bart van der Leck.

## History of the Collection

The history of Helene's acquisitions is worthy of a separate study and publication.[47] Helene and Anton made regular art-buying trips to Paris and Berlin together with their adviser Bremmer. They often purchased from dealers but also at auctions, where they usually allowed Bremmer to do the bidding. Bremmer often went alone, always with precise commissions for purchases. Helene also frequently bought works in Amsterdam, Haarlem, The Hague, Rotterdam, and Utrecht, where there were internationally respected art dealers and auction houses. The Kröller-Müllers patronized the Frederik Muller auction house, where they bought not only Van Goghs but also works by Corot, Honoré Daumier, Eugène Delacroix, Fantin-Latour, and Jean-François Millet (all in 1912). A few extraordinary forays will serve to illustrate the militancy with which she built her collection.

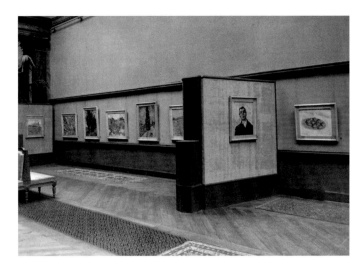

Fig. 14  Helene Kröller-Müller's Van Gogh collection, installed at the Royal Museum of Fine Arts, Brussels, 1927.

## 1912

The year 1912 was spectacular. Van Deventer reported on Helene's April 1912 Parisian visit with her husband and adviser: "Yesterday evening we all went in search … of our singular goal: the paintings of Van Gogh."[48] Helene describes how she found *La Berceuse* (cat. 5) at Galerie Bernheim-Jeune. On the same day she bought six other paintings: *Landscape with Wheat Sheaves and Rising Moon, Basket of Apples, Olive Grove* (cat. 4), *Portrait of Joseph-Michel Ginoux, The Ravine (Les Peiroulets)*, and an early work, *Loom with Weaver* (cat. 1). "We saw more, but Bremmer considered only these paintings as good as or better than ours, and made an offer for them—a third of the asking price."[49] She reported again the following day: They visited Paul Signac, one of the few times she visited an artist at home, because Bremmer knew that Signac had a work by his late friend Georges Seurat. Following this visit they immediately bought an early work by each of these artists, again at Bernheim-Jeune.[50] Unfortunately, there is no account of the visit, earlier in the month, to the art dealer Amédée Schuffenecker in Meudon, where they purchased a mere eight Van Goghs.[51] In April 1912 alone, Helene added fifteen Van Goghs to the collection.

By May the market was acutely aware of the scale of the Kröller-Müllers' purchases and the sums they were able to pay. Dealers such as Vollard and Bernheim-Jeune from Paris and Cassirer and Perls from Berlin were in attendance on 21 and 22 May, when a substantial part of the extraordinary collection of Cornelis Hoogendijk, including twelve Van Goghs, was auctioned by Frederik Muller in Amsterdam. The prices the Van Goghs reached were undoubtedly a reaction to the Kröller-Müllers' grandiose purchases a month earlier. The dealers in the room bid fiercely against one another, and Bremmer was able to secure only three paintings and one drawing, including *Bridge at Arles,* which was estimated at 3,000 guilders but went for 16,000. At the same sale Bremmer also bought works by Jules Breton, Corot, Gustave Courbet, Charles-François Daubigny, Daumier, Armand Guillaumin, Adolphe Monticelli, Jan Toorop, and Redon, amassing in a single day an important part of Helene Kröller-Müller's desired historical overview.[52]

During the remaining months of 1912, Helene acquired nine additional Van Goghs. One of these she received from her husband, with the *Portrait of Mlle Eva Callimaki Cartagi* by Fantin-Latour (cat. 33). This portrait of a Romanian beauty, who bore a remarkable resemblance to Helene before her marriage (fig. 15), was a gift for their twenty-fifth wedding anniversary, together

with *Sorrowing Old Man ("At Eternity's Gate")* (cat. 10). This marvelous gift shows not only Anton Kröller's generosity but also his sense of humor. The pair of paintings forms a portrait of a marriage. In total the Kröller-Müllers purchased twenty-seven Van Goghs in 1912, almost all of them masterpieces, and acquired large numbers of works by other major artists. Helene had laid the foundation of her collection within only five years.

## The Period Thereafter

In June of the following year, Bremmer traveled to Paris to secure for Helene a number of important Old Master paintings at the sale of the Nêmes collection. He came away with Hans Baldung Grien's *Venus and Cupid* from 1524, a panel by Lucas Cranach the Elder, and a canvas by Van Gogh, *Still Life with a Plate of Onions* (cat. 9). Helene also bought works by her contemporaries, again guided by Bremmer. The obsessive nature of her collecting is most apparent in her acquisition of more than 400 works by Van der Leck, including paintings, gouaches, drawings, tiles, and designs.

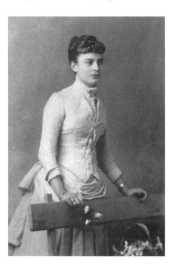

Fig. 15  Helene Kröller-Müller, ca. 1887.

Fig. 16  Bart van der Leck, *Mining Industry,* 1916, leaded glass, Kröller-Müller Museum.

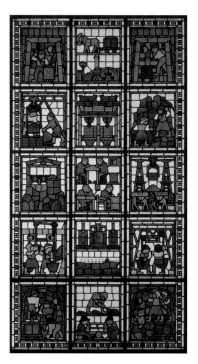

In January 1914 the Müller firm commissioned the artist to produce designs for the Batavier Line (cat. 44) and a stained-glass window (cat. 43, fig. 16) for the headquarters in The Hague.[53] Piet Mondrian also signed a contract, which supported him during the First World War. Between 1913 and 1920, Helene acquired nine of Mondrian's works, the most important of which was *Composition in Black and White* (cat. 81). In 1913 she bought her first Cubist work, *Still Life with Oil Lamp* by Juan Gris (cat. 72). She quickly acquired more works from this new movement. From the dealer Léonce Rosenberg in Paris she bought works by Picasso, Braque, Gris, and Fernand Léger. But she remained loyal to her greatest love: in June 1914 she bought eight more Van Goghs, including *Café Terrace at Night (Place du Forum)* (cat. 3) and *L'Arlésienne, Portrait of Madame Ginoux* (fig. 17).

The major acquisitions came in the 1920s when Helene acquired two older collections of Van Gogh works. In 1920 Bremmer bought twenty-six paintings, including works by Paul Gauguin, Signac, and six by Van Gogh from the collection of Lodewijk Cornelis Enthoven, once again at the Frederik Muller auction house in Amsterdam.[54] But by far the most extravagant purchase came when Helene and Bremmer already considered the collection complete. Helene and Van Deventer were staying in a sanatorium in 1928, when Bremmer wrote that he was able to buy 110 early Van Gogh drawings from the collection of Hidde Nijland for 100,000 guilders in advance of their sale at Kleikamp in The Hague. Helene balked at the high price and sought the advice of an American acquaintance who, by coincidence, was also staying at the sanatorium. He sat on the board of directors of an American museum and knew Helene's collection well. They proposed to split the purchase of the drawings. However, the American wished to consult with his director. When Anton Kröller joined them on the weekend and heard of the plan, he telegraphed Bremmer with the instruction to buy all the drawings. He was thus too fast for the American, who in the meantime had also been instructed by his director to buy the whole lot.[55]

Fig. 17  Vincent van Gogh, *L'Arlésienne, Portrait of Madame Ginoux*, 1890, oil on canvas, Kröller-Müller Museum.

## The Presentation of the Collection

Helene Kröller-Müller saw herself as a special collector. In a letter to Van Deventer, she referred to an article about collectors in *Kunst und Künstler* and remarked that she had not been included.[56] Her ambition was to collect works that would "stand the test of time ... because I collect to give to future generations that which I consider the best in life."[57] Beginning 1 September 1913, in the building adjacent to Wm. H. Müller & Co., the collection could be viewed upon written application. Until 2 November 1933 Helene organized exhibitions of the collection there.[58] Museums in Amsterdam, Rotterdam, The Hague, and Arnheim also regularly exhibited selections from the collection. In 1927 the entire Van Gogh collection traveled to Basel and Bern, four cities in Germany, and the Musée d'Art Moderne in Brussels.

Sixty of Helene's Van Goghs formed an important part of the Van Gogh exhibition held in the United States in 1935–1936.

The organizer, Alfred Barr, Director of the Museum of Modern Art in New York, had already visited Helene in The Hague in 1927. The exhibition began in New York and was so successful that, following a tour of nine other cities, it returned to New York for a repeat showing. More than a half million Americans saw the exhibition. In an enthusiastic letter to Dr. Christian Bruhn, Helene reported that "It is such a great sensation that throughout America the influence of the so-called 'Van Gogh colors' is noticeable even in the shop windows."[59]

## "I Am a Builder"

At the beginning of 1909, the Kröller-Müllers bought a farm with approximately 1,100 acres of land at Harskamp in the Hoge Veluwe. They used one of the houses on the estate as their country home (fig. 18), which they called "Het Klaverblad." It was most probably rebuilt by L. J. Falkenburg, the architect who had built their house in The Hague. In the same year they bought another 3,000 acres of land at public auction directly adjacent to their farmland. Here Helene rode her horses undisturbed and Anton hunted with friends and business relations. Through additional purchases over the following seven years, Anton enlarged the estate to more than 15,000 acres, an unprecedented amount of land in private hands in the Netherlands (fig. 19). The purchase of the farm and its surrounding land inspired Anton and Helene to acquire a new estate in The Hague where they could build a new house.

In June 1910 Helene traveled with her daughter to Florence. Her fascination with the Medici family's cultural self-promotion is evident from her correspondence, and she began to dream of building her own museum-house: "Then, in a hundred years time, it will be an interesting cultural monument, proof of the extent to which a merchant family at the turn of the century could achieve intrinsic refinement."[60] On the day she returned from Italy, she wrote to Bremmer: "My house will be no ordinary house, not something that one builds simply for practical considerations."[61] She wanted a house that exuded a "serene silence" through its proportions and lack of decoration. She considered a single story sufficient. She had a clear picture of the house in its entirety and sighed: "But where can I find someone who can build such a house for me?"[62] A few days later the Kröller-Müllers decided to purchase the Ellenwoude Estate in Wassenaar near The Hague and again commissioned Falkenburg to build a house for them.

Since the beginning of the century Helene had been a devoted reader of *Kunst und Künstler*, published by the Berlin-based art dealer Paul Cassirer. This magazine promoted the newest style in architecture and design, the Jugendstil. She would have recognized this modern visual language in two houses that stood near her own: Villa Leuring, designed by Henry van de Velde, and Villa Henny by Hendrik Petrus Berlage. By comparison, Huize ten Vijver was a dark and old-fashioned eclectic mix of styles.[63]

Fig. 18 "Het Klaverblad," ca. 1920.

Fig. 19 Kröller-Müller estate in the Hoge Veluwe.

This led Helene to reconsider her choice of Falkenburg and she wrote to Bremmer: "Might you have the opportunity to prompt him a little in the right direction? You are probably better disposed to explain my wishes than am I."[64] In any case, she decided on the gallery for her embryonic art exhibition: "By which I mean a pleasant, top-lit room closed off from the outside world, with a few tables and chairs, where one can happily sit and read and where, if one looks up, one's eye will fall upon something beautiful."[65]

## Peter Behrens

Helene Kröller-Müller made a thorough study of modern architecture. Her library contains a great many books on this subject, including the pioneering three-volume standard work *Das Englische Haus* by Hermann Muthesius, which introduced the work of William Morris and Charles Rennie Mackintosh to continental Europe.[66] She would have read the articles about the architect Peter Behrens by Karl Ernst Osthaus and K. Scheffler in *Kunst und Künstler*. Behrens so inspired her that, in February 1911, she traveled with her husband to Berlin to see several of his houses. They made an appointment with him and invited him to visit The Hague. He advised them to travel to Hagen to see two of his completed villas and a third then under construction. Together with Van de Velde he had designed the Folkwang Museum in Hagen for the collector Karl Ernst Osthaus, with whom Helene and Anton would conduct a correspondence in the coming years. The following month Behrens visited The Hague and, with Helene and Anton, viewed the recently acquired Ellenwoude Estate. He received the commission to design a house for the couple with reception rooms for guests and a private wing, but also spaces for various parts of the collection and a conservatory. The plans proceeded with some difficulty, partly because the couple had conflicting wishes—Anton wanted a grand and monumental building, whereas Helene sought greater privacy. Furthermore, Behrens must have felt his possibilities restricted by the requirement to use Falkenburg's ground plan as his starting point.

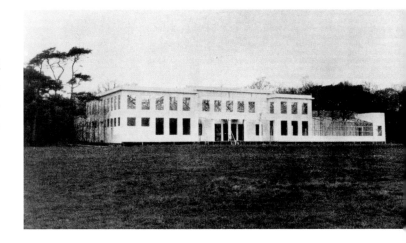

Fig. 20  Full-scale wood and canvas model for Ellenwoude House by Peter Behrens, on site in Wassenaar, ca. 1912.  The structure was not built.

Another complicating factor was Helene's health. On 23 August 1911 she was diagnosed with cancer. The surgery, which was kept secret from her children (who ranged from 14 to 22), was successful. During her recovery she continued an extensive correspondence with Sam van Deventer, in which she formulated her plans with increasing clarity. Although her collection was not especially large at that time (in comparison with that of her exemplar Osthaus), Helene was convinced of her vision: "And now the great wonder must be expressed. My new house will be a museum and will later belong to the public." In her mind the house "that we shall raise as a monument" had grown into a real museum.[67]

As her own ideas matured, Helene became increasingly dissatisfied with Behrens's plans. In January 1912 Anton Kröller took decisive action. He had the building mocked up at full scale in wood and canvas and placed on rails so that they could view it at various points in the landscape (fig. 20). Helene eventually rejected the design because it did not sufficiently represent her wishes.

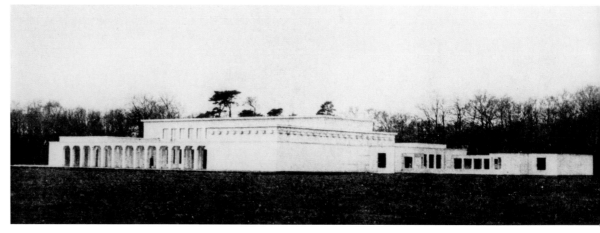

Fig. 21  Ludwig Mies van der Rohe, ca. 1912.

Fig. 22  Full-scale mock-up for Ellenwoude by Ludwig Mies van der Rohe, on site in Wassenaar, 1913.

## Ludwig Mies van der Rohe

Behrens's assistant, Ludwig Mies van der Rohe, had a more receptive ear for her ideas. It is not clear whether this led directly to the break between Behrens and Mies, but the younger architect (fig. 21) continued independently with the commission. He, in turn, had to base his design upon the floor plan that Behrens had developed. From late May until September 1912, Mies worked on his design in the offices of Wm. H. Müller & Co. on the Lange Voorhout.[68] The twenty-six-year-old architect maintained intense, almost daily contact with Helene and worked hard to find suitable architectonic solutions for her complicated brief. The house should consist of several large boxlike volumes united by a pergola. The complex contained various inner courtyards and water gardens. The photograph of the model illustrates clearly how Mies situated the house within the landscape. One drawing of the design has survived, as well as some photographs of drawings, the maquette, and the full-size model (fig. 22).

Upon Bremmer's recommendation, H. P. Berlage was also commissioned to produce a design for the house, again based on Behrens's plan (page 115, fig. 2). He worked on the design in his office in Amsterdam without Helene's interference. When, after three months, both architects presented their designs, Bremmer made his pronouncement: Berlage's design was "art," Mies's was not. Because Helene was deeply disappointed and had difficulty accepting the veto of her aesthetic adviser, Anton repeated the previous year's trick. In January 1913 he had Mies's design mocked up at full scale and placed on rails on the site. This resulted in Helene's following Bremmer's choice of the cloister-like design of Berlage rather than Mies's elegant, classical design. Shortly thereafter Helene heard that a tramline was to be laid on the land, spoiling the view. She decided to abandon the entire Ellenwoude project.[69]

## Hendrik Petrus Berlage

Nonetheless, H. P. Berlage would come to play an important role in the Kröller-Müllers' story. When, in 1912, the architect was unsuccessful in the competition to design Rotterdam's City Hall, Helene was so outraged that she wrote to her husband, who was traveling abroad. Shortly after his return, Anton Kröller offered Berlage a ten-year contract upon the condition that he move to The Hague and design exclusively for the Müller firm and the Kröller-Müllers. "Now we shall finally restore him to his rightful honor," she wrote to Van Deventer.[70] On 1 September, after some hesitation about the exclusive contract, Berlage and two assis-

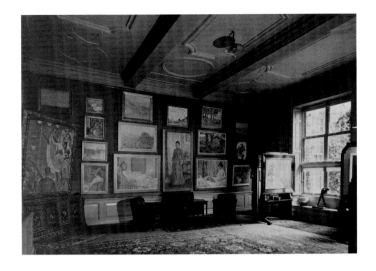

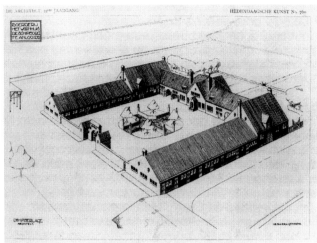

tants, Rozenburg and Saayer, began work in the headquarters of Wm. H. Müller & Co. on the Lange Voorhout, where Helene also had her office.[71] As Director of the Estates Department, she managed the firm's land and buildings and her art collection (fig. 23).[72]

Berlage's first two projects were a farm for the Kröller-Müllers' eldest son, Toon Kröller, called De Schipborg (fig. 24) and a large office building for the firm in London, to be called Holland House (fig. 25). With the outbreak of the First World War in August 1914, the Müller company was beset with financial difficulties and the realization of Berlage's projects became uncertain. Despite the stagnant market Anton Kröller decided to go ahead with construction. The neutrality of the Netherlands enabled Anton to carry out some dexterous maneuvers, and within six months the company, which had interests in ore, grain, and shipping throughout the world, reaped extremely high profits. The costly building project in London could now be completed without problems and an even more ambitious plan was developed: a hunting lodge in the Hoge Veluwe where Anton could receive his friends in style. Berlage received the commission to design a house that illustrated the hunting legend of Saint Hubert of Liège. The sequence of rooms, the decorative elements, and the particular use of colors and materials are all imbued with heavy symbolism (see cats. 60–63). Even the building's plan is in the form of antlers, and the

Fig. 23  Main room of Helene Kröller-Müller's private museum on the ground floor of Wm. H. Müller & Co., Lange Voorhout.

Fig. 24  Design for De Schipborg by H. P. Berlage, ca. 1912.

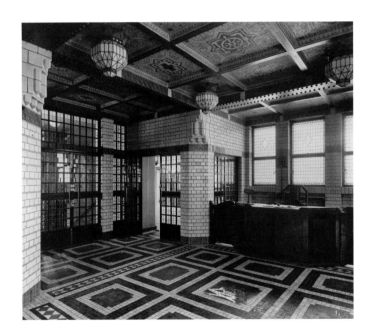

Fig. 25  Holland House, designed by H. P. Berlage, 1914–1918.

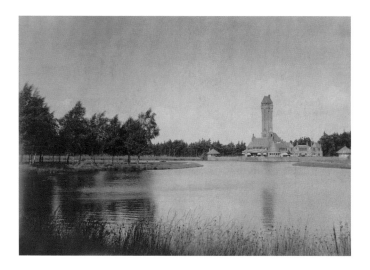

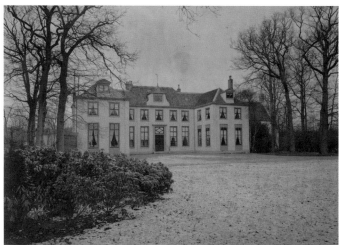

Fig. 26   St. Hubertus Hunting Lodge in Hoge Veluwe, designed by
H. P. Berlage, 1914–1920.

forecourt's paving echoes the burning cross witnessed by
Saint Hubert—features apparent only from the building's
highest point, the tower room (fig. 26).[73]

The house was fitted with the most advanced technical
features of the day: centrally regulated clocks in each room, a
central vacuum cleaning system, the first passenger elevator
in a private house in the Netherlands, and an *en suite* bath-
room in each of the twenty bedrooms. All the furnishings
and fixtures were designed by Berlage. The construction took
six years (1914–1920) and cost many millions of guilders.[74]
During this project, in 1916, Anton and Helene sold the Huize
ten Vijver and bought the Groot Haesebroek Estate. With its
200-acre park and dunes, it was, despite neglect, one of the
most beautiful properties in Wassenaar. In addition to the
main house, Huize Groot Haesebroek (fig. 27), there were also
two villas on the land: Wildrust, which became Van Deventer's
new house (fig. 28) and Duinhoeve, which was used as a guest
house and was the location of children's camps organized by
Helene (fig. 29). Although no designs survive, it is likely that
Berlage rebuilt the large house and replaced the roof with thatch

Fig. 27   Huize Groot Haesebroek, ca. 1916.

Fig. 28   Wildrust villa on Groot Haesebroek estate, ca. 1916.

(fig. 30), a reference to the English country houses in Muthesius's
great work.[75]

While the building of Holland House, De Schipborg, and the
St. Hubertus Hunting Lodge was still underway, Helene developed
other plans. "The museum house will be situated in Hoenderloo,"
she wrote to Van Deventer. The new house in Wassenaar could in
no way satisfy Helene's concept of a "museum house."[76] With the

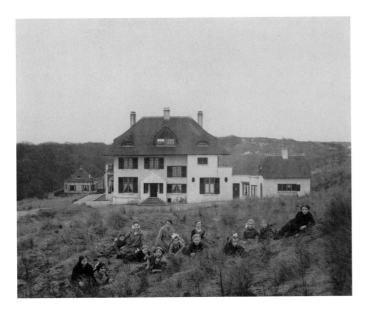

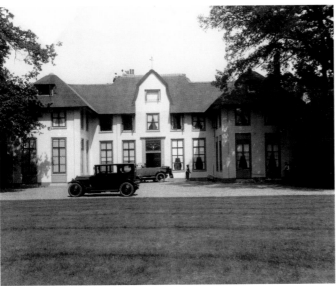

Fig. 29 Children's camp at Duinhoeve, guest house on Groot Haesebroek estate, ca. 1916.

Fig. 30 The old Groot Haesebroek with a new roof, ca. 1916.

extremely high profits the company made during the Great War, the collection continued to grow: the only solution was the building of a large museum. Its location would be the French Hill on the Hoge Veluwe Estate. Here she could construct a large building against a painterly background with a vast and uninterrupted view. Berlage designed a complex of unparalleled grandeur and luxury, where the Kröller-Müllers could live with their collection (see page 115, fig. 3, and cat. 56). Despite the great possibilities the Kröller-Müllers offered him, Berlage must have had his doubts. In the summer of 1919 he reneged on his exclusive contract with the Kröller-Müllers, presumably because he was offered the commission to build a new museum in The Hague, the realization of which struck him as more likely.

## Henry van de Velde

Following Berlage's departure, Helene wasted little time in finding a replacement. She asked her adviser Bremmer to gather information about the recent work of Henry van de Velde. She was familiar with the Belgian architect's work from the Villa Leuring near her house in Scheveningen and the buildings she had seen seven years earlier while visiting the collector Osthaus in Hagen. After an initial introduction, Helene and Van de Velde quickly reached an agreement: "I am in agreement with Professor Van de Velde. In the coming two years he will build, or rather design, a house and a museum for us, thereafter we will be free of each other."[77] An additional project was soon added to his workload—a new house on the Groot Haesebroek Estate in Wassenaar. Anton Kröller was the driving force behind this project.[78] Van de Velde took the project so seriously that he first had a wooden house built on the land in order to develop his plans on-site. The Huize Groot Haesebroek was completed within a few years but in a more modest form than initially envisioned (figs. 31, 32). The demolition of the old house and the construction of the new one in 1932 are extensively documented. Nonetheless, the working relationship lasted six rather than two years as Van de Velde was also commissioned to complete Berlage's work. Thus, Van de Velde

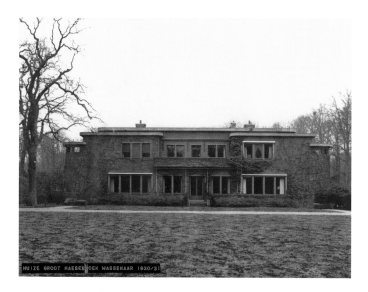

Figs. 31, 32  The new Groot Haesebroek, Wassenaar, designed by
Henry van de Velde, 1930–1932.

designed some elements of Holland House and the St. Hubertus
Hunting Lodge.[79] In addition, he also built a house called De
Witte Raaf (The White Raven), various wooden houses for the
Kröller-Müllers' staff, and a farm and house called De Harskamp
for Anton and Helene's eldest son on the Hoge Veluwe estate. For
the Müller firm he designed the interior of one of the ships of the
Batavier Line (fig. 33).

In 1920 Helene threw herself, with characteristic energy, into
her ultimate project, the large museum at the foot of the French
Hill. Together with Van de Velde, she worked on the plans. The
central section would house her collection of Van Gogh paintings.
Through their positioning and the art works that would hang
within them, all the surrounding galleries would lead to the ulti-
mate experience: the work of Van Gogh. In the following year, the
excavations and the concrete construction for the entrance and
the terraces began: "Oh, the museum will be beautiful. You will
be amazed when you see the plans, they far exceed my expecta-
tions and, I believe, anything of the kind that has been built or
designed until now." Helene's enthusiasm overshadowed her
sense of reality: "I read it [the building costs] and quickly closed
the pages."[80] In the years immediately following the First World
War, the Müller firm's profits fell sharply and eventually the com-
pany took a loss. The world economic crisis had a serious effect
on the Kröller-Müllers and their art collection. Construction of
the museum halted and Helene informed Bremmer on 17 August
1922 that no further art acquisitions would be possible.

## Contacts with the State

In May 1924 Helene was diagnosed with neuroses. The company's
financial difficulties threatened to endanger her life's work. For
peace of mind, she paid regular visits to Dr. Dengler's sanatorium
in Baden-Baden,[81] and in the following years she spent several
months in a sanatorium in the Black Forest.[82] In her letters to
Van Deventer, she wrote unremittingly about the museum, insist-
ing that the drawings must be finished in anticipation of better
times ahead. In 1926 Van de Velde departed, the firm's Estates

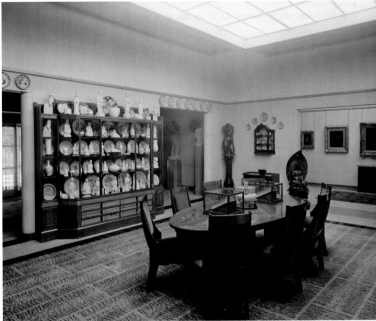

Fig. 33   Interior designed by Henry van de Velde, Batavier Line.

Fig. 34   Gallery in Kröller-Müller Museum, installed by Helene Kröller-Müller, ca. 1938.

Department was liquidated, and the designs for the museum (the smallest details of which had been completed) were stored away in the company's vault. In 1927 the firm paid off a large bank loan through the sale of its shares in iron mines in North Africa and so regained some freedom to trade. Anton Kröller focussed on safeguarding his estates and his wife's art collection. On 14 March 1928 he established the Kröller-Müller Foundation, which took official ownership of the collection the following day. The transfer of the land and construction of the museum would come later. It was not until 1935 that a definitive decision was made, when the Dutch state purchased the land and agreed to construct the museum on the understanding that the collection would be bequeathed to the nation. The 1930s were even less profitable for the State than for Wm. H. Müller & Co., and the former was unable to honor its promise to build the large museum. Together with H. P. Marchant, then Minister for Education, Arts, and Sciences, Anton Kröller came to a mutually satisfactory solution: Van de Velde was commissioned to design a smaller, temporary building. In marked contrast to all the Kröller-Müllers' other building projects, the temporary museum was built with great speed. The building opened a mere fourteen months after the groundbreaking in 1937. Helene was appointed director of the Museum and took charge of installing the collection (fig. 34). She died a year later. Sixty-five years later, the building remains the home of the Kröller-Müller collection.[83]

*Translated from the Dutch by Gerard Forde, London.*

In writing this essay I have relied upon the indispensable assistance of an outstanding team that has been busy for some time with the cataloguing of Helene Kröller-Müller's archive: Bas Mühren, Karin Coopmann, and Karin van Lieverloo. Marjon Gemmeke, who is currently digitizing Helene's collection of photographs, has supplied much of the photographic material. I am especially indebted to Hildelies Balk, who is writing her doctoral thesis on H. P. Bremmer. I am grateful to my colleagues Toos van Kooten and Wanda Vermeulen for their critical advice.

## Notes

1. Remembrances of Noor van Andel and Helene Kröller-Müller's granddaughters. However, her book is full of German expressions.

2. Letter from Helene Kröller-Müller to E. van de Velde, 20 December 1922, Kröller-Müller Museum Archive.

3. Anna Müller, "Wm. H. Müller: Nach Briefen und nach eigenen Erinnerungen von seiner Schwester Anna," Hannover, 1924, vol. 4, p. 8. Unpublished manuscript in Kröller-Müller Museum Archive. Like her father, Helene conducted an extensive correspondence, through which it is possible to form an excellent picture of the many contacts she maintained and the activities she undertook. Her archive in the Kröller-Müller Museum contains approximately 1,200 letters.

4. 21 May 1877, Müller, "Wm. H. Müller," vol. 3, p. 16.

5. Ibid., vol. 1.

6. Ibid., vol. 3, p. 8.

7. Ibid.

8. 1 July 1878, ibid., vol. 3, p. 25. "The aim of which is, on the one hand, to independently freight our own merchandise, and on the other, to act in the same capacity for third parties." See also Sam van Deventer, Kröller-Müller: De geschiedenis van een cultureel levenswerk (Arnheim: J. S. R. van Deventer, 1956), p. 62.

9. 16 May 1878, Müller, "Wm. H. Müller," vol. 3, p. 26.

10. Ibid., p. 58.

11. Ibid., p. 92.

12. 3 October 1884, ibid., p. 56.

13. Van Deventer, Kröller-Müller, p. 9.

14. Müller, "Wm. H. Müller," vol. 3, p. 56.

15. Van Deventer, Kröller-Müller, p. 14.

16. Müller, "Wm. H. Müller," vol. 4, p. 64.

17. Ibid., p. 84.

18. Ibid., vol. 3, pp. 45, 70. The ships built for the transportation of Spanish iron ore to the Netherlands were Senior, Hollandia, Hispania, Rhenania, and Iberia.

19. Ibid., vol. 4, p. 88.

20. Ibid., p. 90. Speech by Helene Kröller-Müller for Anton's twenty-fifth anniversary as director of the firm.

21. Ibid., p. 99.

22. Ibid., p. 105.

23. Ibid., pp. 108–109.

24. Van Deventer, Kröller-Müller, pp. 20–21.

25. Müller, "Wm. H. Müller," vol. 4, p. 110.

26. Ibid., p. 111.

27. Ibid., postscript.

28. Van Deventer, Kröller-Müller, p. 25.

29. Anneke Landheer-Roelants, Romantisch buiten wonen in de stad: 125 jaar van Stolkpark (Utrecht: Uitgevery-Matrijs, 1999), p. 197. During this period Falkenburg also rebuilt the Müller company's headquarters. A few years later he would also build the large Villa Sandhage for Gustav Müller.

30. Several items of furniture are still in the collection of the Kröller-Müller Museum, including the couch and secretary from Helene Kröller-Müller's boudoir, which Van Deventer mentions in his description. Van Deventer, Kröller-Müller, pp. 26–27.

31. Ibid., p. 27.

32. The South African General de Wet was given a warm reception by the Kröller-Müllers. A number of prominent Dutch figures lent their support to the Boers, who were of Dutch descent, in their struggle with the English. Helene's admiration for their cause even extended to erecting monuments on the grounds of the Hoge Veluwe: Monument to De Wet by Joseph Mendes da Costa (1915, executed 1921–1922) and Steynbank by Henry van de Velde (1923–1924). Her correspondence from this period is convincing evidence of her political commitment.

33. Van Deventer, Kröller-Müller, p. 29.

34. A. Bremmer-Beekhuis, "Dienaar der kunst," 1937–1941 (with supplements until 1943), unpublished manuscript in the H. P. Bremmer Archive, Gemeentearchief, The Hague. Bremmer's widow gives 1905 as the first year that Helene and her daughter followed Bremmer's course. According to her, it was the daughter who made the first contact with him. Although, in his 1956 or 1957 book Dr. H. P. Bremmer: Kunstberater des Ehepaares Kröller-Müller (Eschwege: Poeschel & Schulz-Schomburgk, ca. 1957), Van Deventer tells us that Helene enrolled with Bremmer in 1906–1907, there is no reason to doubt the earlier date given by Bremmer-Beekhuis in 1937. Van Deventer's text from 1957 is colored by the information supplied by Helene Kröller-Müller. She also denied her daughter's precedence in other matters, and Van Deventer happily repeats this misinformation.

35. With thanks to Hildelies Balk for this reference.

36. H. P. Bremmer, Een inleiding tot het zien van beeldende kunst (Amsterdam: W. Versluys, 1906), p. 58. See also, Elly Stegeman, "Bremmer, Van Gogh en de praktische esthetica," Jong Holland 2 (1993), pp. 37–48.

37. Van Deventer, Kröller-Müller, p. 55.

38. 13 April 1912, letter from Helene Kröller-Müller to Van Deventer, ibid., p. 55.

39. A set of these books, from Sam van Deventer's collection, is in the Centraal Museum, Utrecht. See Hildelies Balk, "De freule, de professor, de koopman en zijn vrouw, het publiek van H. P. Bremmer," Jong Holland 2 (1993), p. 23, note 9. The other copies are in the Kröller-Müller Museum Archive.

40. Van Deventer, Kröller-Müller, p. 34.

41. Six of these works are no longer attributed to Van Gogh.

42. December 1934, Helene Kröller-Müller to P. Visser, Kröller-Müller Museum Archive.

43. The Kröller-Müller Museum now has eighty-six Van Gogh paintings acquired by Helene Kröller-Müller. Of the ninety-seven original paintings, she gave five to family and friends.

44. Helene Kröller-Müller, *Beschouwingen over problemen in de ontwikkeling der moderne schilderkunst* (Hoenderlo: 1925).

45. Ibid., p. 247.

46. Ibid.

47. Concerning the acquisition of works by Van Gogh, see Jos ten Berge et al., *The Paintings of Vincent van Gogh in the Collection of the Kröller-Müller Museum,* ed. Toos van Kooten and Mieke Rijnders (Otterlo: Kröller-Müller Museum, 2003).

48. 13 April 1912, Van Deventer, *Kröller-Müller,* p. 52.

49. Ibid., pp. 52–54.

50. 14 April 1912, ibid., p. 56.

51. One of the works is no longer attributed to Van Gogh, see ten Berge et al., *The Paintings of Vincent van Gogh,* p. 443.

52. Herbert Henkels, "Cézanne en Van Gogh in het Rijksmuseum voor Moderne Kunst in Amsterdam: De collectie van Cornelis Hoogen-dijk (1866–1911)," *Bulletin van het Rijksmuseum* 41 (1993), pp. 255–256.

53. Van Deventer, *Kröller-Müller,* p. 64.

54. Jos ten Berge, "The Enthoven Mystery," in ten Berge et al., *The Paintings of Vincent van Gogh,* p. 426.

55. Van Deventer, *Dr. H. P. Bremmer,* p. 16. The names of the American acquaintance and museum remain unknown. With thanks to Hildelies Balk.

56. "Der Sammler," *Kunst und Künstler,* March 1912.

57. 24 March 1912, Van Deventer, *Kröller-Müller,* p. 51.

58. Ibid., p. 60.

59. Letter from Helene Kröller-Müller to Dr. Christian Bruhn, 14 February 1936, Kröller-Müller Museum Archive. Bruhn was a dentist and founder of the Westdeutsche Kieferklinik (West German Orthodontics Clinic).

60. Letter from Helene Kröller-Müller to Van Deventer, 7 September 1911, ibid., p. 48.

61. 28 June 1910, ibid., p. 41.

62. Ibid.

63. Ibid., p. 27.

64. 18 November 1910, ibid., p. 43.

65. Ibid.

66. Hermann Muthesius, *Das Englische Haus* (Berlin: E. Wasmuth, 1908).

67. Letter from Helene Kröller-Müller to Van Deventer, 7 September 1911, Van Deventer, *Kröller-Müller,* p. 47.

68. In an interview Mies van der Rohe told Eifler-Conrads that approximately fifty Van Goghs hung in the office and that he was forced to become acquainted with Van Gogh's work. Around this time Helene Kröller-Müller owned only twenty-eight Van Gogh paintings, and it seems unlikely that they would all have hung in Mies's office. It is plausible that some works of Van Gogh hung in the office, which Van Deventer had previously occupied. See Franz Schulze, *Mies van der Rohe, A Critical Biography* (Chicago: University of Chicago Press, 1985), p. 61.

69. This tramline would eventually also pass by their new house. See Johannes van der Wolk, *De Kröllers en hun architecten* (Otterlo: Rijksmuseum Kröller-Müller, 1992), p. 48.

70. 5 April 1913, Van Deventer, *Kröller-Müller,* p. 59.

71. Ibid., p. 60.

72. Ibid.

73. Helene Kröller-Müller shared a passionate love for Florence with Berlage. They sent Anton a postcard of the Palazzo Vecchio. The prominent tower of the St. Hubertus Hunting Lodge bears a similarity to the Florentine building. See ibid., p. 58.

74. Ibid., p. 73.

75. Berlage had previously designed houses with thatched roofs: Villa Roland Holst (1902–1913) and Villa Polak (1905). See Sergio Polano, ed., *Hendrik Petrus Berlage* (Milan: Electa, 2002; distributed by Phaidon), pp. 170–171 and 179.

76. Van Deventer, *Kröller-Müller,* p. 70.

77. Letter from Helene Kröller-Müller to Van Deventer, 25 October 1919, ibid., p. 83.

78. Ibid., p. 87.

79. Including the entrance and the furnishings of Holland House and the completion of the interior and some furniture for the St. Hubertus Hunting Lodge. See ibid., p. 99.

80. Letter from Helene Kröller-Müller to Van Deventer, 4 September 1921, ibid., pp. 88–89.

81. Ibid., p. 98. The doctor's name comes from a letter dated 7 July 1928 from Helene Kröller-Müller's secretary to Helene Kröller-Müller, Kröller-Müller Museum Archive.

82. Van Deventer, *Kröller-Müller,* p. 121.

83. At the beginning of the 1950s Van de Velde extended the building with a large sculpture gallery, four small picture galleries, and an auditorium. In 1977 a new wing designed by Wim G. Quist was opened.

Works of art give rise to narratives of various kinds that are shaped by conditions of presentation and reception. On the simplest level, artworks can be interpreted as individual objects or as groups of objects that might be related to one another in many different ways. They can for example be organized according to their inherent characteristics, such as medium, subject matter, or formal qualities; alternatively, they can be arranged according to their historical origins, in which case one might focus on the artists responsible, or the period, place, and circumstances in which the works were created. Art collections also constitute narratives, ones in which patronage preferences as well as market forces and institutional histories offer insights into the circulation and reception of works of art. Of course, these examples do not exhaust the alternatives, nor are these genres of art historical storytelling necessarily distinct from one another; some of the best chronicles unfold across multiple registers simultaneously, like a musical canon in which the thematic lines adumbrate and enrich one another.

The collection of modern art brought together by Helene Kröller-Müller is an excellent case in point, for it gives rise to many different stories, including the ones Mrs. Kröller-Müller herself told in displays she planned in her home, a series of lectures she gave in 1923–1924, and a related book published in 1925.[1] The selection of highlights in the present exhibition conveys another narrative, suggesting through its title and chronological organization that a coherent art historical trajectory can be traced in the development of stylistic form that appears to begin with Vincent van Gogh and culminate in the work of Piet Mondrian. A different display strategy could be deployed in order to destabilize this notion, as was the case in 1987, when the Kröller-Müller Museum installed a much larger and more diverse cross-section of the collection in the order in which the works had been acquired by Mrs. Kröller-Müller (fig. 1). On that occasion, patronage and collecting provided the narrative structure, replacing the more conventional installation strategy characterized by an unfolding progression of styles. The result was unsettling, but perhaps for that very reason also illuminating, as R. W. D. Oxenaar, former director of the Museum, has recalled: "The order seemed arbitrary.... There were unexpected juxtapositions and unusual opportunities for comparison. Old art and the avant-garde were jumbled up together, the important and unimportant. International and national works were put next to local, and major works by major artists jostled good work by

NANCY J. TROY

# Telling Tales: The Kröller-Müller Collection and the Narrative of Modern Art

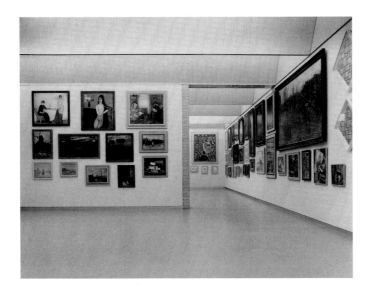

Fig. 1 Exhibition installation, 1987, Kröller-Müller Museum.

modest artists."[2] Seeing the works installed in this manner encouraged the viewer to experience the fortuitous and idiosyncratic aspect of Mrs. Kröller-Müller's collecting habits. Although these qualities are unavoidable in the collecting process, they are typically downplayed in the organization of a collection for the purposes of exhibition or publication, where a more familiar governing principle (typically determined by style, subject matter, or national origin) tames the unruly accidents of acquisition to forge what is widely regarded as a more logical, coherent, and ultimately more readily comprehensible order. The Kröller-Müller Museum's 1987 exhibition remains a particularly valuable alternative to the dominant model for presenting the history of modern art because the unfamiliar and seemingly chaotic aspect of its unusual arrangement allows us to appreciate the degree to which our normative understanding of modernism—according to which the Kröller-Müller collection is presented in the current exhibition—has been structured as a narrative of stylistic development that privileges form over and above the vicissitudes of patronage and collecting.

Any effort to appreciate the uniqueness of the Kröller-Müller collection must take into account the fact that it is not compre-

hensive but focussed, personal, subjective, sometimes eccentric or seemingly contradictory. In this respect it parallels the smaller and in many ways quite different, but equally idiosyncratic, collection of modern art assembled primarily in the 1920s and 1930s by the American painter and patron of the arts Katherine S. Dreier. Even the brief comparison that this essay can provide between these two powerful female personalities and the modern art collections to which they devoted their energies reveals how insights into patronage and collecting might be marshaled to challenge art history's dominant, style-based paradigm. That paradigm of progressive formal development was fully articulated in the modernist context for the first time in the influential *Cubism and Abstract Art* exhibition at New York's Museum of Modern Art in 1936. The authoritative formal logic displayed by the exhibition's organizer, Alfred H. Barr, Jr., in tracing an evolutionary development from Cubism to abstract art continues to be so convincing that it is difficult, even today, to see it as simply one among many narrative alternatives. This essay, which responds to the peculiar features of Helene Kröller-Müller's collection, provides the occasion not only to highlight her patronage practices by comparison with those of her near contemporary Katherine Dreier but also to suggest how a focus on collecting, rather than stylistic development, allows for tales other than the one narrated by Barr to be told about the history of modern art.

The inception of the Kröller-Müller collection in the early twentieth century was predicated on the availability of significant financial resources to support a rapidly growing commitment to art as an expression of spiritual and ethical values. The money came from the family firm of Wm. H. Müller & Co., founded by Helene Müller's German father but headed from 1889 onward by her Dutch husband, Anton Kröller. Under his leadership, the mining and shipping company, headquartered by the early 1900s at Lange Voorhout 3 in The Hague, grew significantly to encompass operations across Europe, from southern Spain to northern Sweden, in South America, and especially in North Africa; in less than thirty years—by the mid-teens—the

Kröller-Müllers were among the wealthiest private citizens in the Netherlands.[3] Although Helene drew an income from the company, in which she headed the Department of Buildings and became a partner in 1913, the vast majority of funds for the purchase of works of art was contributed by her husband. In addition, not only was her art adviser, H. P. Bremmer, on the company payroll,[4] but Müller & Co. was a significant source of support for at least one artist, Bart van der Leck, and for the several architects involved over the years with various projects for housing the collection.[5] As the company grew and prospered, particularly during the first two decades of the twentieth century, Mrs. Kröller-Müller's collecting activity was at its most intense; when the firm began to feel the impact of the European financial crisis that followed the end of the First World War, and when the company was especially hard-hit by the Depression, the losses were reflected in belt-tightening and eventually in greatly reduced levels of patronage and collecting.

Given the crucial role played by the Müller firm in enabling Helene Kröller-Müller to amass her extraordinary art collection, it is noteworthy that the discursive environment she created around the works of art was largely divorced from the realities of daily experience. This is especially evident in her conception of art as the emotion-laden extrusion of a recurring struggle between the physical and spiritual, real and ideal, representational and abstract. In her emphasis on art's spiritual and emotional dimensions, she was indebted in part to her mentor, H. P. Bremmer, a painter who in the mid-1890s had begun to teach art appreciation courses in his home in The Hague; Helene Kröller-Müller and her husband attended for the first time, together with their daughter, in the winter of 1906–1907.[6] The classes, which Bremmer was by then offering in numerous Dutch cities, involved presentations in which he would focus on the formal and expressive characteristics of individual art objects. Occasionally, instead of showing reproductions, Bremmer would bring to his classes original works of art by contemporary artists whom he knew or was supporting on a regular basis; his lessons in "aesthetic appreciation" virtually guaranteed the sale of these works to his wealthy bourgeois pupils, whose devotion to their teacher was so intense that they came to be known as Bremmerites. Out of this milieu, Helene Kröller-Müller quickly emerged as Bremmer's most enthusiastic follower; by 1908 the Sunday classes in Bremmer's home in which she was enrolled had turned into private, Friday evening sessions for the Kröller-Müller family in their stately mansion outside The Hague.

As a matter of course the Kröller-Müllers had by this time already amassed a goodly number of decorative objects as well as the occasional oil painting. Shortly after coming into contact with Bremmer, Mrs. Kröller-Müller began buying more assiduously, not only Old Master paintings but works by nineteenth-century Dutch artists, many of whom are today little known outside of the Netherlands. She also patronized contemporary Dutch artists in Bremmer's circle, including Willem van der Nat, Tjitske G. M. van Hettinga Tromp, and Jan A. Zandleven. The much more familiar name of Vincent van Gogh jumps out as a striking departure. Mrs. Kröller-Müller made her first purchase of a painting by Van Gogh in 1908 (see page 49, fig. 1),[7] and many others followed in rapid succession. In total she collected more than 90 paintings and 185 works on paper by Van Gogh, and these formed the heart of her collection, even as she subsequently added hundreds of important works by modern and contemporary French, Belgian, and Dutch artists to that essential core.[8]

Katherine Dreier was also drawn early in her career as a collector and patron of the arts to the work of Van Gogh, which she discovered in the Cologne Sonderbund Exhibition of 1912. Acting immediately upon her newfound enthusiasm, Miss Dreier not only purchased one of Van Gogh's paintings but also went to Holland to learn as much as possible about the artist, managed to meet his sister, and eventually translated the sister's published recollections into English.[9] The parallel with Helene Kröller-Müller's early commitment to Van Gogh is of course striking, but the differences between the two women that are hinted at in Miss Dreier's headstrong activism quickly become apparent.

Eight years younger than Helene Kröller-Müller, Katherine Dreier was born in Brooklyn in 1877 into a comfortable middle-class family of German immigrants who by the turn of the century would best be described as affluent, if not really wealthy.[10] (Certainly Katherine Dreier's resources never approached those available to Helene Kröller-Müller.) Raised in an atmosphere of deep respect for European (especially German) culture and throughout her life actively engaged in social and humanitarian causes, Miss Dreier was a Theosophist committed to modern art as an expression of spiritual and moral values, a conception not very different from Mrs. Kröller-Müller's definition of art as "the emotional objectivization of the spiritual Self."[11] But Miss Dreier, unlike Mrs. Kröller-Müller, was a practicing artist herself, and her activities as a patron, apart from her high esteem for Van Gogh, were devoted to the work of her contemporaries, artists from America and throughout Europe who reached maturity after 1900. These formed the exclusive domain of the Société Anonyme, Inc., Museum of Modern Art, the organization that Miss Dreier formed in 1920 with the support of Marcel Duchamp and Man Ray. (The name itself constitutes a Dada gesture, since the French phrase is translated not as "anonymous society"—as Man Ray originally assumed—but rather as "incorporated," which is redundantly doubled by the English abbreviation.) Support of contemporary artists and architects was an important aspect of Mrs. Kröller-Müller's patronage, but her collection ranges from the Renaissance to the present and includes both Chinese and Dutch ceramics in addition to the vanguard modernists from Belgium, France, and the Netherlands (even Germany and Italy are not included) whose work is highlighted in the present exhibition.

Katherine Dreier's passionate advocacy of contemporary art in lectures, publications, and the numerous exhibitions she organized under the aegis of the Société Anonyme was pursued with the advice and moral support of Marcel Duchamp, whom she met in New York in 1916. The mutually respectful relationship they maintained until Miss Dreier's death in 1952 is an especially intriguing aspect of the Société Anonyme, given the sharp contrast between her activism and Duchamp's self-conscious withdrawal from public engagement in all aspects of the art world (which also distinguishes him sharply from Bremmer, who not only was an artist, critic, and pedagogue but also bought and sold works of art and frequently intervened in the art market on behalf of his artist protégés). Miss Dreier's patronage and the collection of the Société Anonyme expressed her commitment to modern art as a means of social, moral, and spiritual betterment. Her enthusiastic organization of dozens of exhibitions was designed not only to introduce the most up-to-date artistic trends to diverse, if generally disinterested, audiences but also to advance the careers of contemporary artists throughout Europe and America. The Société Anonyme collection developed out of these efforts, as Miss Dreier realized that it would be easier to mount exhibitions if the works were readily available in the organization's own collection, or she simply acquired works that failed to sell, rather than going to the trouble and expense of returning them to the artists. She personally visited and corresponded with the artists whose reputations she sought to establish or enhance, including Constantin Brancusi, Alexander Calder, Wassily Kandinsky, Paul Klee, Fernand Léger, Mondrian, and Kurt Schwitters, among many dozens of others, most often borrowing or purchasing their work directly, rather than working through the mediation of dealers, and she never bought at auction. In this respect, she differed markedly from Mrs. Kröller-Müller, whose collection was formed at a distance from the vast majority of artists involved, generally through purchases from dealers and auctions, or through the intervention of H. P. Bremmer. The salient exception to this general rule was the painter Bart van der Leck, who worked for Mrs. Kröller-Müller for several years, beginning in 1914.

What distinguishes Katherine Dreier as an important patron of modern art is the fact that her principal commitment was not to collecting, although at the end of her life she was concerned to preserve the integrity of the Société Anonyme collection, comprising some 800 objects, and to make it as representative as possible. Far more important as far as Miss Dreier was concerned was the

need to educate the American public about the spiritually based, primarily abstract approach to modernism that she esteemed and to support the struggling contemporary artists whose work responded to these criteria. Mrs. Kröller-Müller, on the other hand, was not particularly committed to supporting struggling artists, and she was wary of non-objective, abstract art, which she felt lacked the potential to arouse an imaginatively based, spiritual response in the viewer. She apparently felt entirely comfortable about withdrawing her support from both Van der Leck and Piet Mondrian when she felt their latest, non-naturalistic work in the late teens no longer elicited an emotional response from the viewer and therefore failed to address art's necessary spiritual dimension. This episode merits scrutiny because it indicates the degree to which Mrs. Kröller-Müller's patronage could become a tool for intervening in the creative process and, in the case of Van der Leck, ultimately had an impact on the art historical value attached to the artist's work. Here, patronage becomes the determining factor in the narrative flow of modern art, working to deflect artistic development to its own purposes.

It was through Bremmer that Van der Leck met Mrs. Kröller-Müller, who purchased her first painting by the artist from Bremmer in 1912 (fig. 2). In July of that year Van der Leck entered into a contract with the art educator according to which Bremmer would provide the artist with a regular stipend in return for a specified number of small paintings or drawings. In practice, Van der Leck produced few works each year and the majority of those went to Bremmer, who funded the artist's subsidy by selling the paintings to pupils in his courses, particularly Mrs. Kröller-Müller, who has been described as a "silent partner" behind Bremmer's support of Van der Leck.[12] In addition to his direct subsidies, over the years Bremmer promoted the artist by writing extensively about Van der Leck's art and by securing gallery showings on the artist's behalf. With brief interruptions, this mutually beneficial but ultimately problematic business relationship lasted for more than three decades, until 1945.[13] For several years of that period, however, beginning in June 1914, Van der Leck was on the payroll of the Kröller-Müller family firm, where through Bremmer's intervention Mrs. Kröller-Müller hired him to work in the Buildings Department, which was supervised by the architect H. P. Berlage. The projects Van der Leck pursued under these circumstances called upon his long-standing commitment to a renewal of socially responsible, communal art to be realized through applied

Fig. 2 Bart van der Leck, *Hussars*, 1911, oil on canvas, Kröller-Müller Museum.

designs and works endowed with the monumentality of mural paintings. Nevertheless, he very quickly resented what he considered to be the subservience of his contributions to Berlage's architecture, and he chafed under the supervision of the architect. On 12 February 1916 he informed Mrs. Kröller-Müller that he no longer wanted to be involved in "painting old houses . . . I have absolutely no desire to be a foreman painter like this."[14] She immediately responded by canceling several assignments related to Berlage's architectural projects and changing the terms of his contract so that Van der Leck would thenceforth be supported not by the company but by Mrs. Kröller-Müller personally; in return, she would receive the majority of his output as an independent artist.

Beginning around 1912, Van der Leck in his easel paintings had gradually been developing a characteristic imagery of simplified, planar, and increasingly abstract figural forms deployed upon a white surface. In a progression that is evident in the series of works that he produced on the basis of *Leaving the Factory* (see page 101, fig. 4, and cat. 48), a subject Van der Leck first handled in a 1908 drawing, Van der Leck schematized the figures and their urban setting, reducing his palette and regularizing his flattened forms. By 1917 he was taking each successive composition in the series to the next stage of abstraction by obscuring recognizable elements with overlays of white paint in a manner that sharpened the underlying geometric forms and generalized the relationships of the representational imagery, which was increasingly difficult to identify. Similarities with the contemporaneous work of Piet Mondrian (whom Bremmer—and Mrs. Kröller-Müller as silent partner—began supporting in March 1916, only a month or two before Van der Leck and Mondrian first met) were evident in Van der Leck's paintings and in the poster Mrs. Kröller-Müller commissioned him to design that year for the Volksuniversiteit, where she was a member of the Board of Governors (fig. 3). The debt to Mondrian that Bremmer and Mrs. Kröller-Müller discerned in Van der Leck's work disturbed the artist's two most ardent patrons, who worried that the abstractness of his work lacked the spiritual motivation they associated with Mondrian's approach.

Fig. 3  Bart van der Leck, *Design for Poster for Volksuniversiteit,* 1916, ink and pencil on paper, Kröller-Müller Museum.

"The influence of Mondrian is strongly marked here," Bremmer wrote of the poster design in October 1916, "although if someone had presented it to me as something by Mondrian I would nevertheless not have accepted it and would definitely have seen that this must be somebody else's work."[15] Shortly thereafter Mrs. Kröller-Müller admonished the artist: "Take care that you do not follow too closely the path of someone else which has grown from his inmost being. . . . But you know what I think! Mondrian always reveals a mood and that is why he fascinates us, even though we cannot link any further concepts to his work. But you give us a fact as an abstraction which you interpret in lines. There is no mood-filled moment, nor any mystical emotion."[16]

Mrs. Kröller-Müller's critique of Van der Leck's abstract style is complicated by the fact that this development in his easel paintings was not unrelated to the work he was doing for the Kröller-

Müllers in collaboration with Berlage, about which he was still complaining at the end of 1916.[17] In a letter to Mrs. Kröller-Müller, he discussed the abstraction of his painted work in relation to its position within a larger architectural setting: "This work now seems suitable to me for architecture.... The renewal of painting starts at the treatment of the plane which the architect creates."[18] Mrs. Kröller-Müller was, however, not convinced; she continued to see the problem in terms of the spirituality, or mood, that in her estimation Mondrian's paintings still conveyed but Van der Leck's did not. Geometric abstraction, she felt, is appropriate to architecture but not to easel painting, where a representational element, however illusory, is necessary to engage the viewer's imagination: "I still maintain that your abstraction applies only to the object and does not express a mood, as in Mondrian. If one wishes to go so far as to arrive at an abstraction and dissects the subject into ratios and lines—yes, then one must build and no longer be a painter. The totally abstract subject is no longer fascinating because imagination cannot hold on to it."[19] As a result of doubts such as these, which Bremmer clearly shared, Bremmer decided that he could no longer count on finding buyers for the paintings by Van der Leck that he received in exchange for paying the artist a regular stipend, and, like Mrs. Kröller-Müller, who cancelled her contract in January 1918, he discontinued Van der Leck's funding in February 1919.

Shortly thereafter, Bremmer and Mrs. Kröller-Müller concluded that Mondrian too had come to a dead end in his work. Before 1917 it had always been possible to discern a naturalistic subject as the basis for Mondrian's increasingly abstract compositions. The large *Composition in Black and White* (cat. 81), which Mrs. Kröller-Müller acquired the year it was completed, could still be understood in relation to the pier-and-ocean source of the 1915 *Composition No. 10* (cat. 80). One might reasonably, though more tenuously, extend this formally based, visual connection to the 1917 *Composition in Color B* (cat. 82), purchased from Bremmer the same year. But in his subsequent work, such as the diamond-shaped paintings of 1919 (cats. 83, 84), Mondrian obviously had

no recourse to any source in nature. Instead he pursued what appeared to Bremmer and Mrs. Kröller-Müller to be an all too rationally motivated and anti-naturalistic, systemic mode of composition that left the two of them cold; they ended their support for the painter on 1 January 1920. Learning of this in early February in a letter from Bremmer, Mondrian "flew into a panic," according to the art historian Joop Joosten. "He had to consider the possibility, he wrote on February 9 to [the artist Theo] van Doesburg, that he would have to stop painting." By early March, however, Mondrian had regained his composure, writing: "I was awfully desperate for a while where my financial existence was concerned, but now I again have the courage to persevere."[20]

Mondrian's uncertain finances were obviously a serious concern to the artist but they did not prevent him from continuing to develop the abstract style that characterized his work from the late teens onward, despite the withdrawal of regular support from Bremmer and Mrs. Kröller-Müller. In Van der Leck's case, the withdrawal of support appears to have elicited a different response. In 1918, he had painted *The Horseman* (fig. 4), a work in which the subject is easily recognizable, but other paintings that followed in the next two years appear entirely abstract, although in some instances a naturalistic source can be identified on the basis of preliminary drawings.[21] The lack of any discernible connection to a natural source for the subject matter of these works is what provoked first Mrs. Kröller-Müller and then Bremmer to withdraw their support. It is difficult to imagine that this gesture had no impact on Van der Leck's development over the next two years, during which he gradually returned to reality-based painting, a process that accelerated in 1920, after Bremmer and Mrs. Kröller-Müller renewed their funding in the spring.[22] Van der Leck created his last entirely abstract easel painting in 1921.

Given these circumstances, as the art historian Cees Hilhorst has pointed out, it is impossible to avoid the question of what effect patronage had on Van der Leck's aesthetic development: "It seems safe to say that his contact with Bremmer was certainly a formative influence during the early stages of Van der Leck's

Fig. 4 Bart van der Leck, *The Horseman*, 1918, oil on canvas, Kröller-Müller Museum.

theoretical and stylistic development.... This doesn't necessarily mean that Bremmer intentionally pointed the artist toward one path or another, but his influence catalyzed the artist's choices."[23] And, it seems reasonable to suggest, the same would be true of Bremmer's silent partner, Mrs. Kröller-Müller. As Hilhorst has concluded, when the funding provided by these two supporters was withdrawn, "Van der Leck then quickly decided which side his bread was buttered on."[24]

Although Van der Leck's return to figuration enabled the artist to secure the ongoing support of his most important patrons, in the end this turned out to be a decidedly mixed blessing. Collecting of Van der Leck's paintings continued to be restricted largely to Mrs. Kröller-Müller or other Bremmer pupils—through inheritance the work has remained ever since in Dutch collections—and few critics apart from Bremmer discussed the artist in any depth. "The consequences of this are still noticeable today in the relative lack of interest in Van der Leck's work on the part of foreign collectors and art historians," Hilhorst has noted. "At the end of his life Van der Leck was disappointed that he had so few followers amongst his colleagues. He seems however to have contented himself with a semi-isolated existence in het Gooi [the area around Laren where he lived in the heart of the Netherlands] and he was unable or unwilling to exchange his relative financial security for forays into the international art world."[25] The resulting difference between Van der Leck's limited stature and the art historical esteem accorded to Mondrian could hardly be more striking.

None of this is to say that Van der Leck would have achieved the same critical standing as Mondrian if he had only resisted the pressure of his patrons and continued to work in an abstract style. But the example provided by these two artists' interaction with Bremmer and Mrs. Kröller-Müller does suggest that patronage and collecting not only might influence the choices that an artist makes but can also have an unanticipated impact on the importance that the oeuvre is eventually accorded in the narrative of art history. When the Kröller-Müller collection is scrutinized as

one such narrative, Van der Leck might arguably (though implausibly) emerge as a far more significant artist than Mondrian, judging from the fact that Mrs. Kröller-Müller purchased 472 works by the former and just nine by the latter.[26] Indeed, according to the numbers, Van der Leck would have to be considered on a par with Van Gogh, whose work is represented by well over 250 examples in the Kröller-Müller collection. A numerical mode of assessment thus foregrounds the idiosyncrasies that make Helene Kröller-Müller's collection so interesting, both as a document of her patronage patterns and practices and as a revelation of alternative ways in which the history of modern art might be recounted.

The Kröller-Müller collection contains exceptionally important paintings by such artists as Gris, Léger, and Seurat—in addition to Van Gogh and Mondrian—who have long been considered masters of modernism. There are equally significant works by other influential exponents of the modernist paradigm, including Maurice Denis, Henri Fantin-Latour, Odilon Redon, Théo van Rysselberghe, Paul Signac, and Jan Toorop, among many others. But the holdings also include hundreds of works by dozens of artists who never achieved a comparable level of international recognition. Nevertheless, according to Mrs. Kröller-Müller herself, the collection did not develop haphazardly; each work was chosen for a reason and a thread runs throughout: "The different artforms that are represented in it are not accidental but a steady development from the concrete representation to the Absolute."[27] In her 1925 book, she set out the terms of the narrative that she intended her collection to trace: "My point of departure will be the Realism of the years 1870–1890 that formed such a sound basis for a regular development of art toward the Idealism of our own day."[28] Her initial aim in forming her collection, she wrote, was to show that the representational element in art was important only insofar as it elicited the emotional expression of the artist, which is essentially abstract. Because she considered emotional expression to be common to both representational and abstract art, she was convinced that "abstract art is not something

incomprehensible but has always existed. For that reason one finds New and Old side by side here. Through the old I wanted to affirm the rightness of the new."[29] With the widespread acceptance of abstraction as she appreciated the term—that is, as it applied, for example, to Picasso's Cubism, to Mondrian's early work, or to the great majority of works by Van der Leck, in all of which a naturalistic subject could be discerned—"it was time to show that abstract art is not the only valid art, and that all abstraction, including abstract art, finds its roots in reality."[30] Although chronological development from realism to abstraction appears to motivate Mrs. Kröller-Müller's exposition, she was at pains to point out the underlying commonality of all approaches to artistic expression: "Art is not about the object, but all art is a struggle with the object, because all art is concerned with how the object is seen, how it is felt and how it is represented. In other words: what emotion comes to the fore in its representation? Has the emotion fought out the battle in a concrete sense, or has it triumphed in an abstract sense?"[31] Clearly, these questions can be addressed to works of art spanning the full spectrum of Mrs. Kröller-Müller's collection. But the questions themselves arise from the particular circumstances in which she amassed her collection during the early twentieth century, and it is therefore understandable that they might differ significantly from the issues and concerns that have motivated other collections of modern art and the narratives that they, in turn, have spawned. If we compare the Kröller-Müller paradigm with Katherine Dreier's Société Anonyme, we discern not only that they both departed in significant ways from the modernist canon but also that their collections reflect different approaches to the ways in which patronage and collecting can intervene to chart the course of modernism's narrative.

If we now bracket Katherine Dreier and the Société Anonyme, which never managed to establish the museum of modern art promised in its full title (the collection was donated to the Yale University Art Gallery in 1941), it makes sense to compare the Kröller-Müller paradigm of modernism to the most influential

alternative, New York's Museum of Modern Art, where we find at least as many differences between the collections as there are similarities. The masters of French, Dutch, and Belgian modernism are amply represented in both collections, but the Museum of Modern Art also includes the work of a much broader spectrum of early-twentieth-century European and American art. In addition, the latter collection encompasses a wide range of media including photography, architecture, design, and film, all of which were envisioned as part of the Museum's mandate when it was founded in 1929. Yet the Museum of Modern Art had no collection whatsoever at the time of its establishment; the first painting was acquired only in 1930.[32] By the time of its fifth anniversary in 1934 the collection still comprised fewer than 100 objects, and there were no dedicated acquisition funds until the following year. According to Kirk Varnedoe, exactly what was meant by the term "modern" changed over time as a result of "a patch-work of pragmatic accommodations and particular contingencies," rather than institutional policy or objective, historical determination.[33] During the first two decades of its existence, the nature of the Museum's growing collection was a hotly debated issue, with some trustees arguing that, in order to maintain an emphasis on the ever-changing contemporary scene, works should remain in the Museum of Modern Art only until they attained the status of "classics," at which point they should be passed along to institutions devoted to recognized historical masterworks, such as the Metropolitan Museum of Art. Not until 1953 was there a formal decision to constitute a permanent collection of masterworks within the Museum of Modern Art itself. By that time, as Alan Wallach has noted, the Museum of Modern Art was well advanced on the path of constituting its particular history of modernism:

> Drawing upon then current aesthetic discourses, it subjected a heterogeneous set of materials (paintings by El Lissitzky and Matisse, films by Dziga Vertov and the Marx Brothers, etc.) to the systematizing and

taxonomical procedures that characterize the museum as a cultural institution. This involved the division and classification of materials according to media (painting, sculpture, photography, film, etc.) and, through the application of aesthetic criteria, their further classification by style. At the beginning, these criteria were not altogether fixed. A study of MoMA during the 1930s would reveal a process of experimentation, of trial and error out of which emerged a complex modernist aesthetic construct based on Bauhaus architecture and design, fauvism (with an emphasis on Matisse), cubism (Picasso and Braque), and surrealism. In the process, MoMA produced a history of modernism that justified this aesthetic, that made it seem historically inevitable.[34]

Numerous authors have pointed to the 1936 exhibition *Cubism and Abstract Art* and its catalogue as a key episode in the naturalization of the Museum of Modern Art's paradigm of a chronological, formalist development across the international European avant-gardes, beginning with Impressionism and proceeding on a complicated path through various post-cubist and expressionist styles to culminate in contemporary "geometrical" and "non-geometrical" forms of abstraction.[35] *Cubism and Abstract Art*, whose logic was summarized visually in the flowchart that Barr produced for the jacket of the catalogue (fig. 5), is introduced here to provide a sense of how Barr organized the unfolding history of modernism in a didactically driven, chronological survey that offered an enduring prototype of the genre. The fact that the Kröller-Müller collection was represented by eight paintings (two by Picasso and six by Mondrian) in the Museum of Modern Art exhibition only begins to suggest the commonalities that exist between the art historical narratives produced by these two institutions. But much more interesting are the distinctive features of those narratives, the particular conditions to which they responded, and the richness of the history of modern art that each of them conveys. Certainly, access to substantial wealth and a

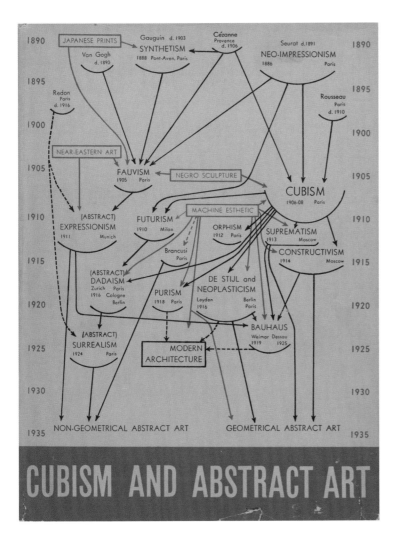

Fig. 5 Alfred H. Barr, Jr., flowchart, reproduced on the jacket of the original edition of the catalogue *Cubism and Abstract Art* (New York: Museum of Modern Art, 1936).

commitment to modernism are essential to both institutions, but whereas the Museum of Modern Art was structured from its inception according to a corporate model with a board of trustees to whom the director and other employees were responsible, the Kröller-Müller Museum is rooted in the deeply personal inclinations of the individual who provided the impetus and the rationale for the collection. Her choices, guided by Bremmer, are evident in the works of art she bought, the artists she patronized, and the architects whom she and her husband commissioned. That so many of these are today counted among the greatest exponents of modern art in the trajectory from Van Gogh to Mondrian testifies to the acuity of her aesthetic vision and personal taste; that many more works in her collection today seem less central to the familiar, narrative unfolding of modernism suggests that the possibilities for retelling the story of modern art on the basis of the Kröller-Müller collection have not yet been exhausted. For it remains to be seen if a conceptual framework can be devised to accommodate the awkward complexity of Mrs. Kröller-Müller's predilections as well as the acknowledged greatness of her collection.

## Notes

1. Mevr. H. Kröller-Müller. *Beschouwingen over problemen in de ontwikkeling der moderne schilderkunt* (Hoenderloo, 1925).

2. R. W. D. Oxenaar, "The Collection from 1907 to 1938," in *Kröller-Müller: The First Hundred Years,* trans. J. W. Watson and L. J. M. Coleman-Schaafsma (Haarlem: Joh. Enschedé en Zonen, 1989), pp. 139–140.

3. For a brief summary of the financing and development of the firm, see S. van Deventer, *Kröller-Müller: de geschiedenis van een cultureel levenswerk* (Arnhem: J. S. R. van Deventer, 1956), pp. 59–60, 62–63, 68.

4. Van Deventer, *Kröller-Müller,* p. 60.

5. See Johannes van der Wolk, *De Kröllers en hun architecten* (Otterlo: Rijksmuseum Kröller-Müller, 1992), and Wim de Wit's essay in this catalogue, p. 114.

6. For my discussion of Bremmer I am especially indebted to Cees Hilhorst, ed., *Vriendschap op afstand: De Correspondentie tussen Bart van der Leck en H. P. Bremmer* (Bussum: Uitgeverij Thoth, 1999).

7. See the entry for *Edge of a Wood* of 1883, identified as the first work by Van Gogh to enter the Kröller-Müller collection, in Jos ten Berge et al., *The Paintings of Vincent van Gogh in the Collection of the Kröller-Müller Museum,* ed. Toos van Kooten and Mieke Rijnders (Otterlo: Kröller-Müller Museum, 2003), pp. 39–41.

8. For a discussion of works by Van Gogh in Mrs. Kröller-Müller's collection, see ibid. as well as Piet de Jonge's essay in this catalogue, p. 48.

9. Ruth L. Bohan, *The Société Anonyme's Brooklyn Exhibition: Katherine Dreier and Modernism in America* (Ann Arbor: UMI Research Press, 1982), p. 7.

10. On Dreier and the Société Anonyme, see Bohan, *The Société Anonyme's Brooklyn Exhibition,* and Robert L. Herbert et al., *The Société Anonyme and the Dreier Bequest at Yale University: A Catalogue Raisonné* (New Haven and London: Yale University Press, 1984).

11. Kröller-Müller, *Beschouwingen,* quoted in English in Johannes van der Wolk, "Kröller-Müller: One Hundred Years," in *Kröller-Müller: The First Hundred Years,* p. 71.

12. Van der Wolk, "Kröller-Müller: One Hundred Years," p. 23, where the term is mistranslated as "sleeping partner."

13. See Hilhorst, *Vriendschap op afstand,* for a detailed and insightful discussion of this relationship.

14. Bart van der Leck, letter to Helene Kröller-Müller, quoted in English in Van der Wolk, "Kröller-Müller: One Hundred Years," p. 32.

15. H. P. Bremmer, letter to Bart van der Leck, quoted in English in Van der Wolk, "Kröller-Müller: One Hundred Years," p. 33.

16. Helene Kröller-Müller, letter to Bart van der Leck, quoted in English in Van der Wolk, "Kröller-Müller: One Hundred Years," pp. 32–33.

17. Van der Leck's negative experience with Berlage prompted him to write two position papers on the relationship between painting and architecture that were published in *De Stijl.* See B[art] van der Leck, "De Plaats van het moderne schilderen in de architectuur," *De Stijl* 1 (October 1917), pp. 6–7; and "Over schilderen en bouwen," *De Stijl* 1 (February 1918), pp. 37–38.

18. Bart van der Leck, letter to Helene Kröller-Müller, 18 December 1916, quoted in English in Van der Wolk, "Kröller-Müller: One Hundred Years," p. 35.

19. Helene Kröller-Müller, letter to Bart van der Leck, 4 January 1917, quoted in English in Van der Wolk, "Kröller-Müller: One Hundred Years," p. 35.

20. Joop M. Joosten, *Catalogue Raisonné of the Work of 1911–1944*, vol. 2 of Joop M. Joosten and Robert P. Welsh, *Piet Mondrian: Catalogue Raisonné* (New York: Harry N. Abrams, 1998), p. 117. Mondrian's letter to Van Doesburg is quoted in English by Joosten.

21. See the discussion of these paintings in Cees Hilhorst, "Bart van der Leck," in Carel Blotkamp et al., *De Stijl: The Formative Years, 1917–1922*, trans. Charlotte I. Loeb and Arthur L. Loeb (Cambridge: The MIT Press, 1982), pp. 169–178.

22. According to Hilhorst, payments from Bremmer resumed and Mrs. Kröller-Müller committed her support for a year, but after June 1921, she was no longer contractually obligated to buy his work, although she continued to do so. Hilhorst, *Vriendschap op afstand*, p. 59.

23. Ibid., p. 69.

24. Ibid., p. 70.

25. Ibid., p. 72.

26. Including subsequent additions, the Kröller-Müller Museum today holds 496 works by Van der Leck and 13 works by Mondrian in its collection. My thanks to Piet de Jonge for this information.

27. Kröller-Müller, *Beschouwingen*, p. 17.

28. Ibid.

29. Ibid., p. 38.

30. Ibid.

31. Ibid., p. 123.

32. On the history of the Museum's collection, see Alfred H. Barr, Jr., "Chronicle of the Collection of Painting and Sculpture," in *Painting and Sculpture in the Museum of Modern Art 1929–1967* (New York: The Museum of Modern Art, 1977), pp. 619–650; and Kirk Varnedoe, "'The Evolving Torpedo': Changing Ideas of the Collection of Painting and Sculpture of The Museum of Modern Art," in *The Museum of Modern Art at Mid-Century: Continuity and Change* (New York: The Museum of Modern Art, 1995), pp. 13–72.

33. Varnedoe, "'The Evolving Torpedo,'" p. 14.

34. Alan Wallach, "The Museum of Modern Art: The Past's Future," in *Exhibiting Contradiction: Essays on the Art Museum in the United States* (Amherst: University of Massachusetts Press, 1998), p. 74.

35. See, for example, Mary Anne Staniszewski, *The Power of Display: A History of Exhibition Installations at the Museum of Modern Art* (Cambridge: The MIT Press, 1998), pp. 74–78.

THROUGH THE LESSONS OF THE ART HISTORIAN and teacher H. P. Bremmer, Helene Kröller-Müller developed a particular penchant for the work of Vincent van Gogh. She had a great appreciation for his use of color and his passionate character. She also recognized in him her own struggle with religious faith and her love of literature and Japanese art. Both were also prolific letter writers. Mrs. Kröller-Müller was especially interested in the painter's life and owned a large number of books about him. She regularly read the three-volume German edition of his letters. The knowledge that she acquired about the artist from the literature helped her choose the works for her collection.

In 1908 Mrs. Kröller-Müller bought her first painting by Van Gogh, a relatively unremarkable early work entitled *Edge of a Wood* (fig. 1). Her second acquisition in that year, however, from the art dealer C. M. van Gogh in Amsterdam, would remain one of the highlights of her collection: *Four Sunflowers Gone to Seed* (fig. 2). That she alternately bought early and late works by her favorite artist is typical of the manner in which she built her collection and her wish to form a representative survey of work from all periods of Van Gogh's oeuvre. This determination became especially apparent in 1912 when, during a number of visits to Paris, she acquired no less than twenty paintings by Van Gogh. On 13 April she bought, among others, *La Berceuse (Portrait of Madame Roulin)* (cat. 5) at Galerie Bernheim-Jeune and *Olive Grove* (cat. 4), together with four other paintings from Eugène Druet. Earlier that month she had already bought eight Van Goghs from Amédée Schuffenecker, including *Pine Trees at Sunset* (cat. 8).[1] Shortly afterward, she bought *The Good Samaritan (after Delacroix)* (cat. 12) and *Portrait of Joseph Roulin* (cat. 6), as well as other works by Van Gogh.

In Arles, Van Gogh befriended Joseph Roulin, a postal clerk at the local railway station, whom he painted no less than six times. In his letters, the artist wrote enthusiastically about Roulin's distinctive head. Roulin was a great support when, on 23 December 1888, Van Gogh cut off part of his ear and was admitted to a hospital. The extent of their friendship is apparent from Van Gogh's three concurrent versions of Roulin's portrait: one for Roulin, the second for his wife when Roulin was away in Marseilles and she remained in Arles, and the third for the artist.[2] The second painting eventually found its way into Mrs. Kröller-Müller's collection. In this painting the outspoken republican Roulin sits in his blue uniform against a green background with flowers. The red poppies, the white roses and daisies, and the blue cornflowers can be seen as a reference to the French tricolor. Van Gogh painted Roulin's whole family a number of times: the children Armand, Camille, and Marcelle as well as his wife Augustine. Helene Kröller-Müller also owned a portrait of Mrs. Roulin: *La Berceuse,* the woman rocking a cradle (cat. 5).

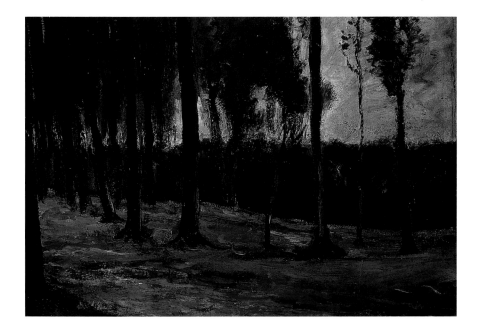

In June 1913 Mrs. Kröller-Müller sent Bremmer to Paris to bid for a number of works from the Nêmes collection at the auctioneers Manzi-Joyant. He acquired several works, including the remarkable *Still Life with a Plate of Onions* (cat. 9) that Van Gogh painted at the beginning of January 1889, when he had just been discharged from the hospital: "Tomorrow I shall start work again. I shall begin with one or two still lifes to reaccustom myself to painting."

Each object in the painting has a biographical significance: the bottle of absinthe, the coffeepot, and the tobacco refer to Van Gogh's favorite stimulants. The onions and the medical almanac admit that he should lead a healthier life. The candle, the red sealing wax, and the letter show the means by which he keeps in contact with others.[3] The painting reflects Paul Gaugin's compositional experiments. The influence of Japanese prints is apparent in the manner in which the objects are cropped at the painting's corners and edges.

In 1914 Bremmer was commissioned to buy eight other works by Van Gogh for Mrs. Kröller-Müller, this time from J. Williame in Châteauroux. One of these was *Café Terrace at Night (Place du Forum)* (cat. 3). It depicts a popular terrace on one of the squares in Arles's historical center, not far from the Yellow House where Van Gogh lived.

At the beginning of the twentieth century, important collections regularly came under the hammer at the Frederik Muller auction house in Amsterdam. Helene Kröller-

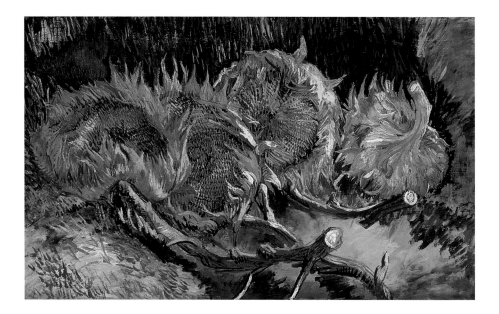

Fig. 2 Vincent van Gogh, *Four Sunflowers Gone to Seed*, 1887, oil on canvas, Kröller-Müller Museum.

Müller purchased many works there, and not only those by Van Gogh. In 1919 she bought his *Self-Portrait* from 1887 (cat. 2) from the sale of Théa Sternheim's collection. On 18 May 1920 the collection of Lodewijk Cornelis Enthoven was offered for sale. This extraordinary collection included paintings by Eugène Delacroix, Gauguin, Edouard Manet, and Odilon Redon in addition to forty-eight works by Van Gogh. There were many early works such as *Loom with Weaver* (cat. 1) and extremely fine later works such as *The Garden of the Asylum at Saint-Rémy* (cat. 7). Two years later, at the same auction house, she acquired *Tree Trunks in the Grass* (cat. 11) from the sale of the collection of B. Veth.

Anton Kröller did not concern himself very much with his wife's art purchases. Nonetheless, he did buy a few paintings himself. At the Sonderbund, a large exhibition in Cologne in 1912, he bought *Sorrowing Old Man ("At Eternity's Gate")* (cat. 10).[4] On 15 May 1913 he presented it to his wife in honor of their twenty-fifth wedding anniversary, together with *Portrait of Mlle Eva Callimaki Cartagi* by Henri Fantin-Latour (cat. 33).

Within fourteen years Helene Kröller-Müller assembled almost 100 paintings and 180 drawings by Van Gogh.[5] In addition to a self-portrait, her collection includes depictions of the peasants and weavers in Brabant and the Dutch and French landscapes that inspired him. Van Gogh's immediate surroundings are represented by portraits of friends and the garden of the asylum to which he had himself committed. These works give an overview of the life of her favorite painter.

## Notes

1. One of these is no longer attributed to Van Gogh.

2. Jos ten Berge et al., *The Paintings of Vincent van Gogh in the Collection of the Kröller-Müller Museum,* ed. Toos van Kooten and Mieke Rijnders (Otterlo: Kröller-Müller Museum, 2003), pp. 265–271.

3. Ibid., pp. 261–264.

4. A special section was reserved for Van Gogh's work in this exhibition. It is probable that all thirty-five Van Goghs that Helene Kröller-Müller owned at that point were included in the exhibition. Anton Kröller also bought Van Gogh paintings from the Berlin-based dealer Paul Cassirer.

5. It is certain that Helene Kröller-Müller bought 97 paintings by Van Gogh. Six of these are no longer attributed to Van Gogh and seven were given to family and friends. The Kröller-Müller Museum has 84 paintings purchased by Mrs. Kröller-Müller, two works purchased after her death, and one painting on long-term loan from a private collection.

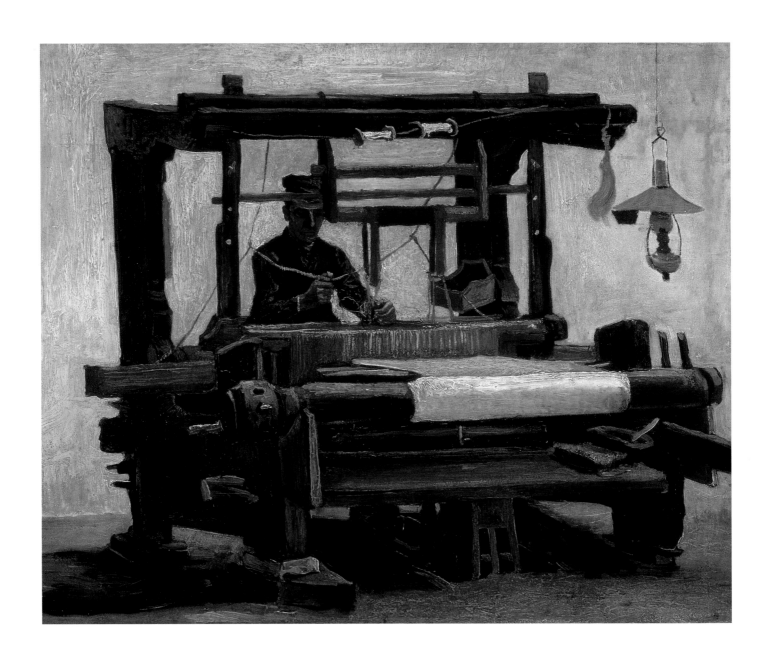

1 VINCENT VAN GOGH *Loom with Weaver* 1884, oil on canvas, 26⅞ × 33⅛ inches

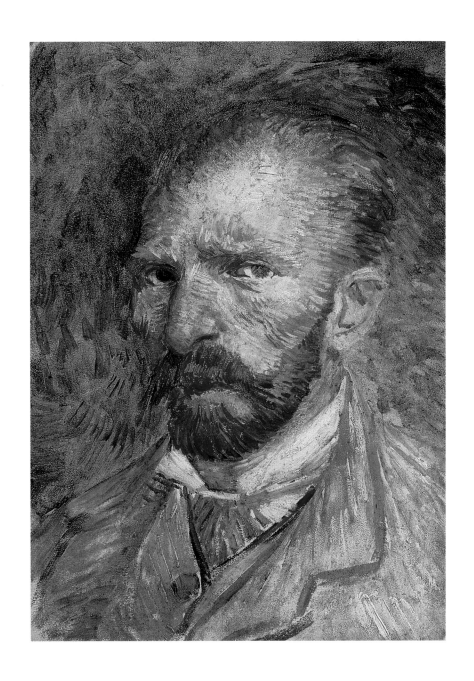

2  VINCENT VAN GOGH  *Self-Portrait*  1887, oil on cardboard, 12⅞ × 9½ inches

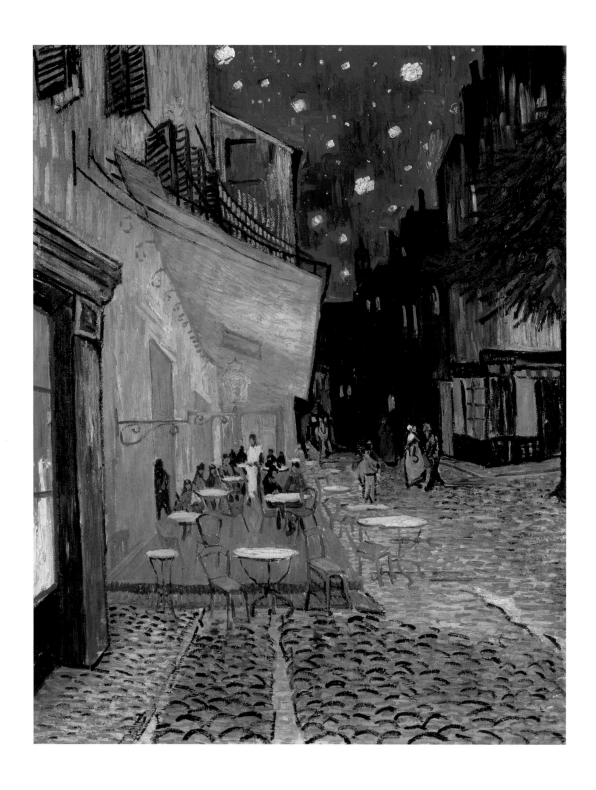

3 VINCENT VAN GOGH *Café Terrace at Night (Place du Forum)* 1888, oil on canvas, 31¾ × 25⅝ inches

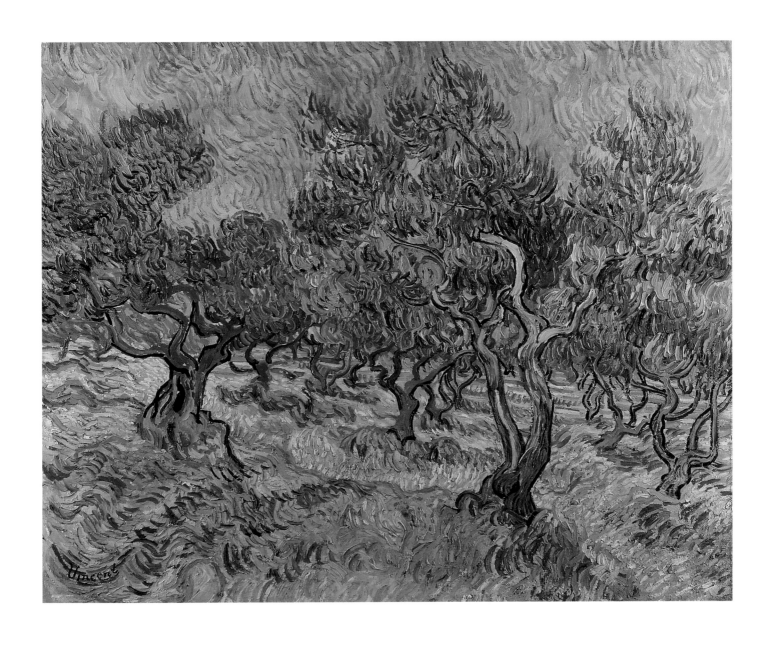

4  VINCENT VAN GOGH  *Olive Grove*  1889, oil on canvas, 28½ × 36⅛ inches

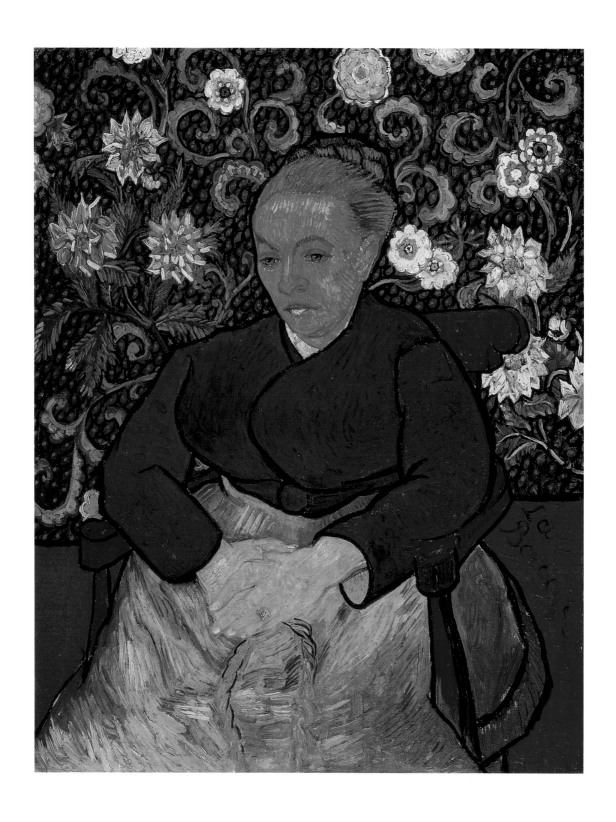

5  VINCENT VAN GOGH  *La Berceuse (Portrait of Madame Roulin)*  1889, oil on canvas, 35¾ × 28⅜ inches

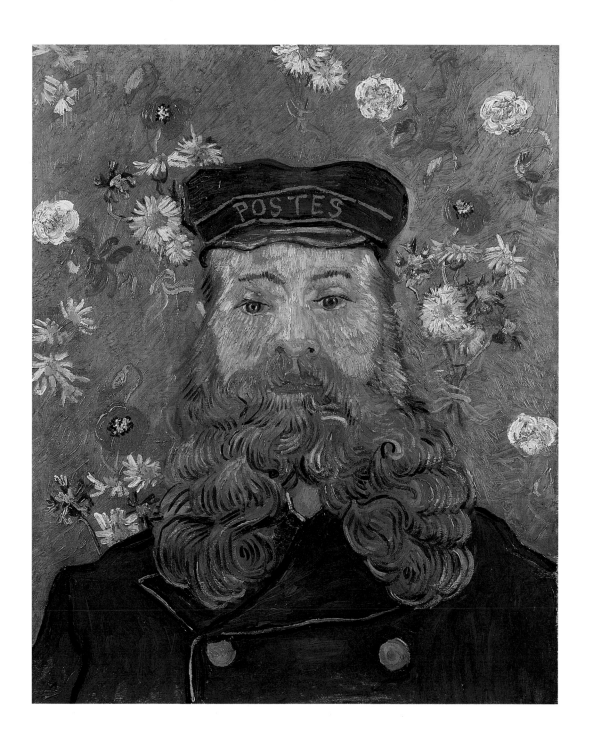

6  VINCENT VAN GOGH  *Portrait of Joseph Roulin*  1889, oil on canvas, 25½ × 21¼ inches

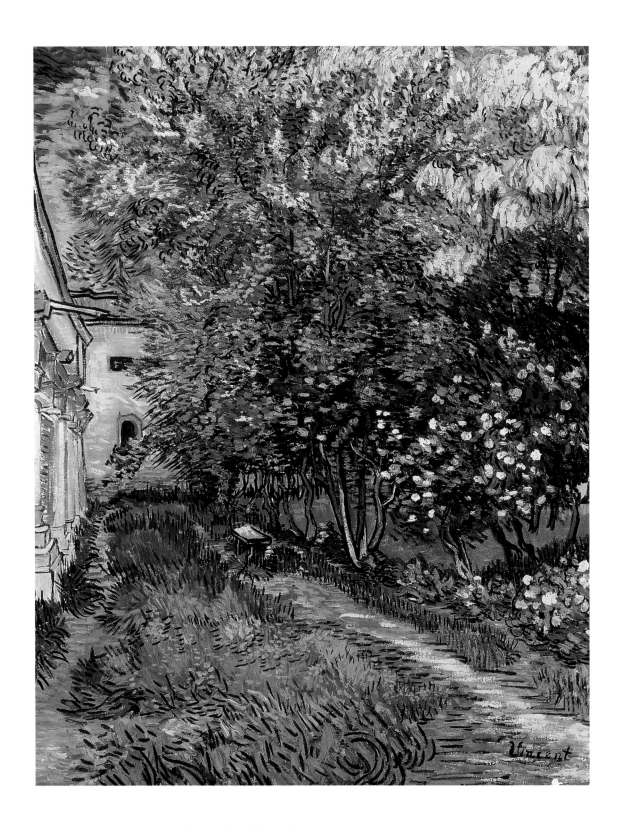

7 VINCENT VAN GOGH *The Garden of the Asylum at Saint-Rémy* 1889, oil on canvas, 36 × 28¼ inches

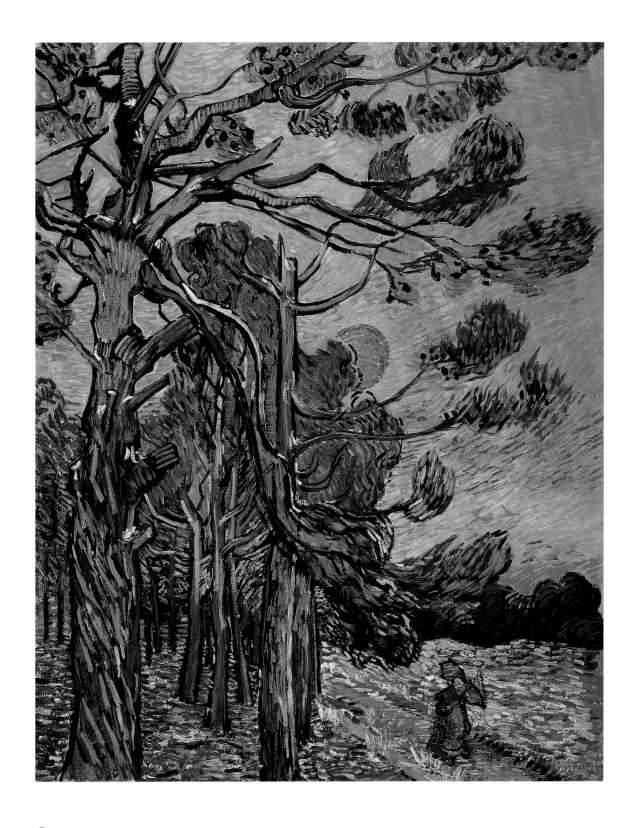

8  VINCENT VAN GOGH  *Pine Trees at Sunset*  1889, oil on canvas, 36 × 28¼ inches

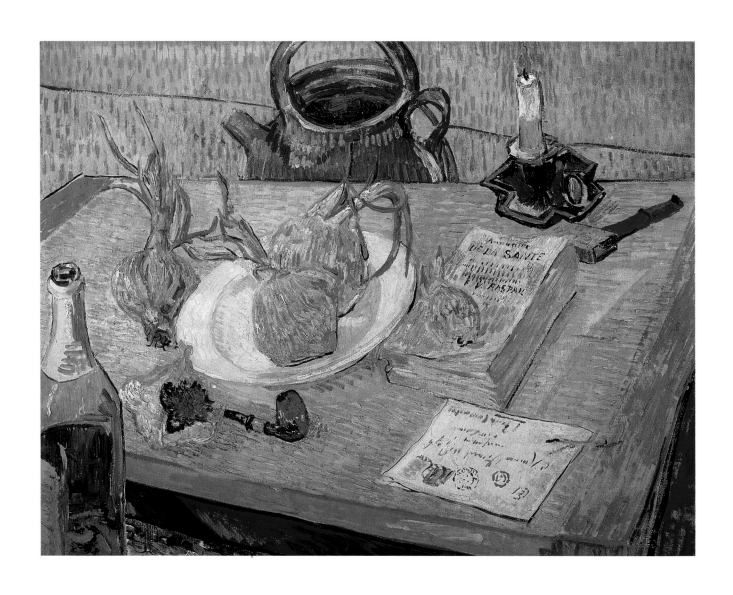

9  VINCENT VAN GOGH  *Still Life with a Plate of Onions*  1889, oil on canvas, 19½ × 25¼ inches

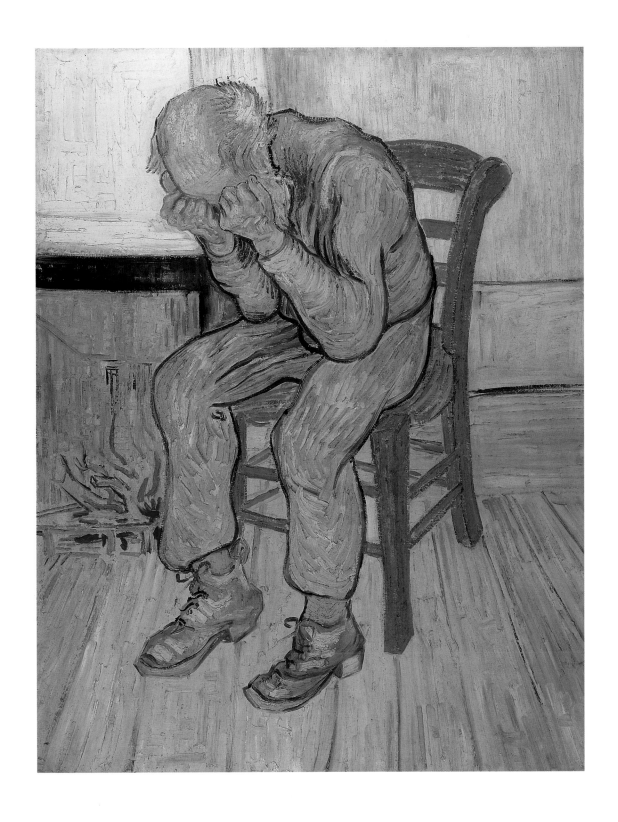

10 VINCENT VAN GOGH *Sorrowing Old Man ("At Eternity's Gate")* 1890, oil on canvas, 32⅛ × 25¾ inches

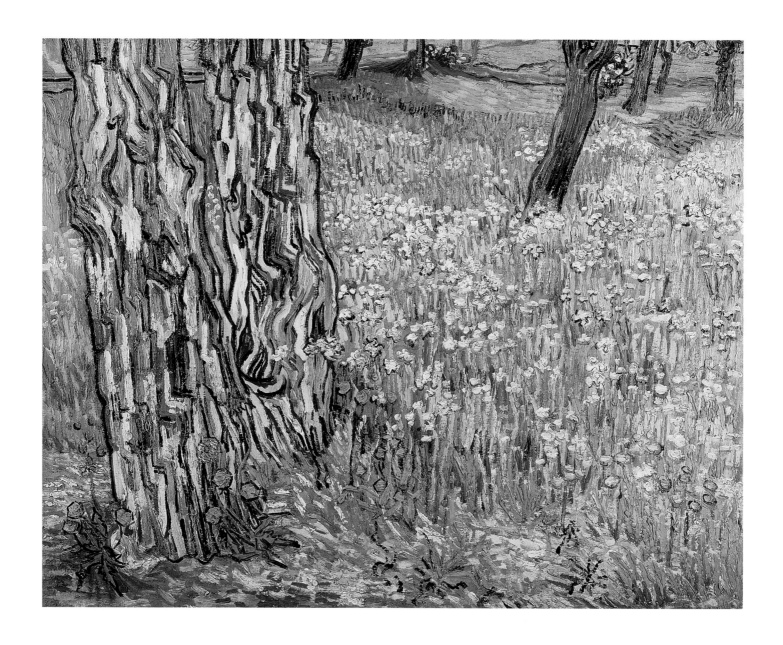

11  VINCENT VAN GOGH  *Tree Trunks in the Grass*  1890, oil on canvas, 28½ × 36 inches

12　Vincent van Gogh　*The Good Samaritan (after Delacroix)*　1890, oil on canvas, 28¾ × 23½ inches

13   VINCENT VAN GOGH   *Corner of a Garden*   1881, ink, chalk, and pencil on paper, 17½ × 22¼ inches

14 VINCENT VAN GOGH *Windmills at Dordrecht* 1881, chalk, pencil, and watercolor on paper, 10¼ × 23⅝ inches

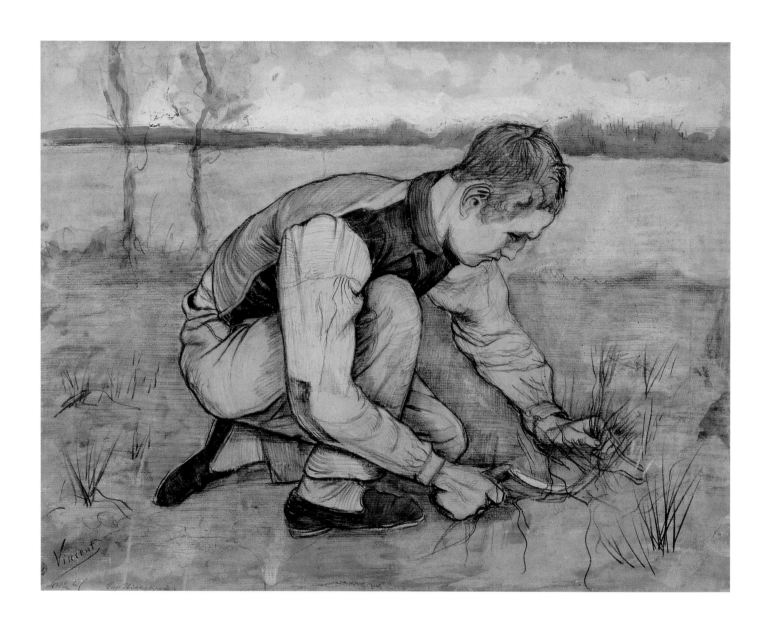

15 VINCENT VAN GOGH *Young Man with Sickle* 1881, chalk and watercolor on paper, 18½ × 24 inches

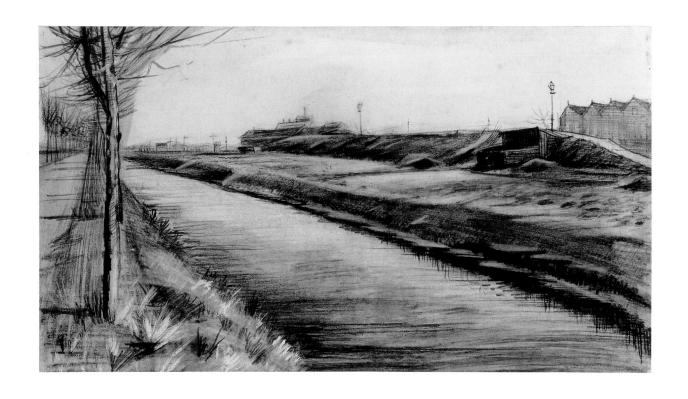

16 VINCENT VAN GOGH *Behind the Schenkweg* 1881–1883, ink, pencil, and paint on paper, 7½ × 13⅛ inches

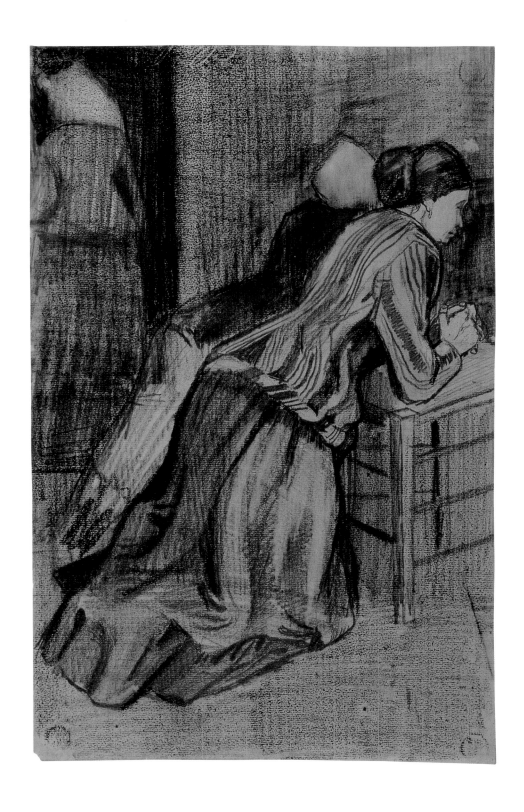

17 VINCENT VAN GOGH *Woman Praying* 1881–1883, ink, chalk, and watercolor on paper, 17 × 11¼ inches

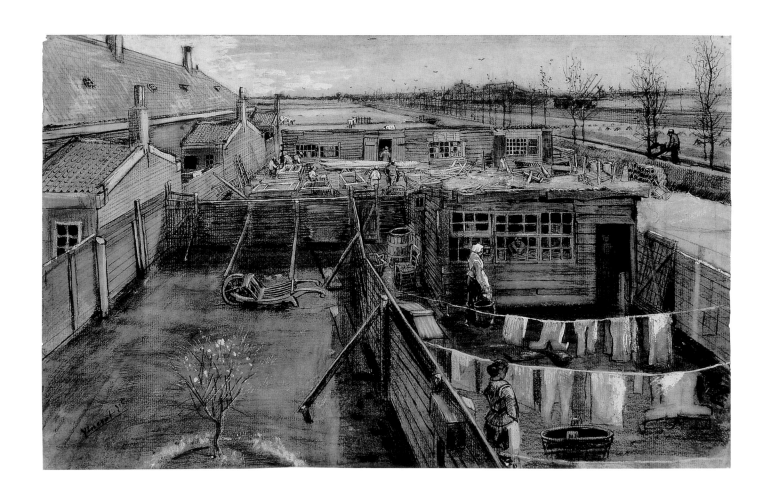

18  VINCENT VAN GOGH  *Carpenter's Yard and Laundry*  1882, chalk and watercolor on paper, 11¼ × 18½ inches

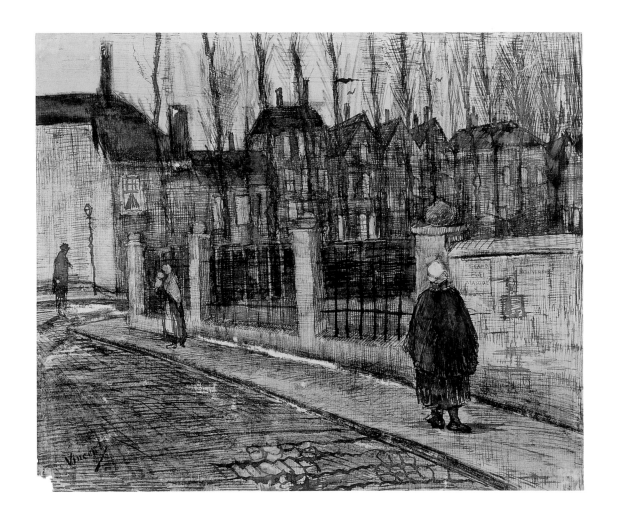

19 VINCENT VAN GOGH *In the Old Town (The Paddemoes)* 1882, ink and pencil on paper, 9⅞ × 12⅛ inches

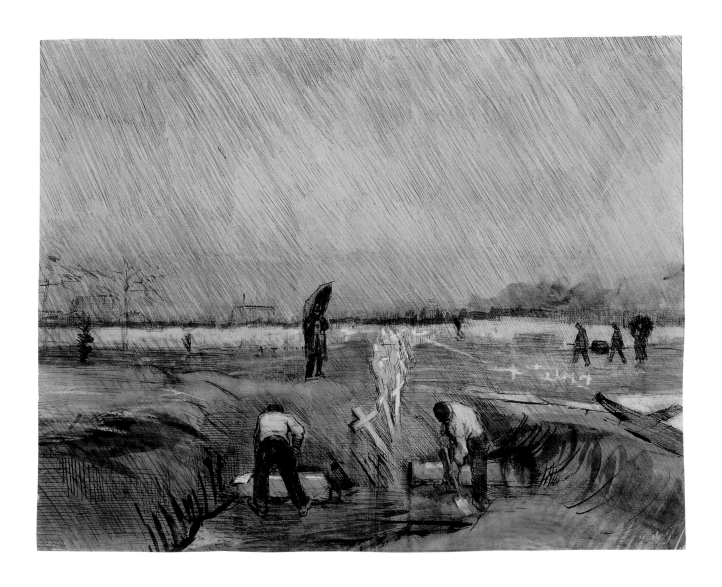

20 VINCENT VAN GOGH *Cemetery in the Rain* 1886, ink and paint on paper, 14⅜ × 18⅞ inches

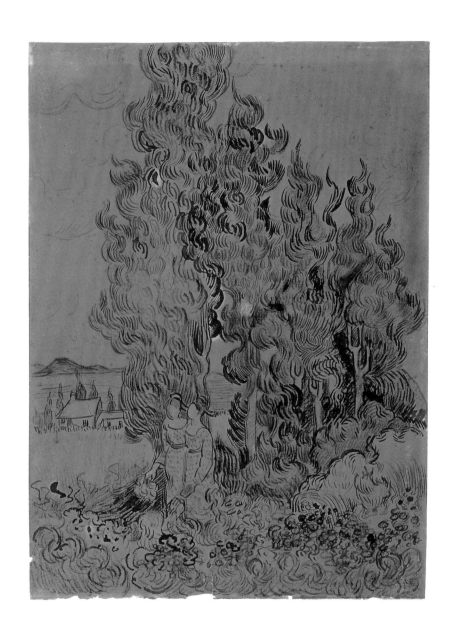

21 VINCENT VAN GOGH *Cypresses* 1889, ink and chalk on paper, 12⅛ × 9 inches

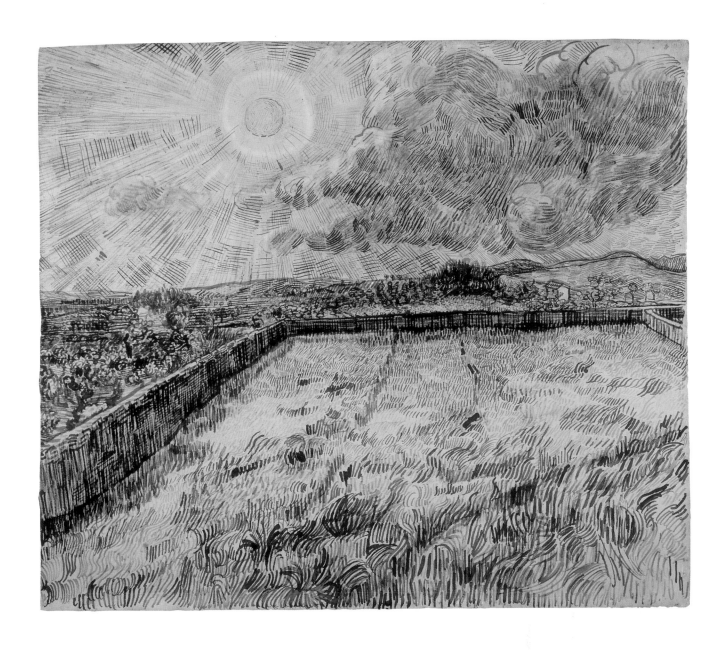

22 VINCENT VAN GOGH *Wheat Field with Sun and Clouds* 1889, ink, charcoal, and chalk on paper, 18¾ × 22¼ inches

H. P. B REMMER WAS ONE OF THE primary reasons that the Kröller-Müller collection came to be a leading repository of works by Neo-Impressionist and Symbolist artists. An artist who found his true vocation as an art critic and teacher of art appreciation classes, Bremmer met Helene Kröller-Müller in 1905 and quickly became her closest and most influential adviser during the formation of her collection. As a young artist, Bremmer would not have had to go far afield to see Neo-Impressionist works firsthand. In 1892 the artist Jan Toorop organized an exhibition of Neo-Impressionist paintings in The Hague, and it was probably Toorop, based in The Hague since 1886, who introduced the young artist to Neo-Impressionist technique between 1893 and 1895.[1] The effect on Bremmer was lasting. His *Fir Trees (Harskamp)* (cat. 32), painted in 1912, shows the continued influence of pointillist technique long after his student days of the 1890s. Bremmer later gave this painting, which he considered one of his best, to Mrs. Kröller-Müller as a token of his esteem.

Bremmer was just one of a number of Dutch and Belgian artists who embraced Neo-Impressionism in the 1880s and 1890s. The movement made its way northward via the exhibitions in Brussels of the Franco-Belgian avant-garde group Les Vingt (The Twenty), which, beginning in 1887, featured the works of Georges Seurat and Paul Signac. Their paintings, especially Seurat's *La Grande Jatte* (fig. 1), had a profound effect on such Belgian and Dutch artists as Théo van Rysselberghe, Henry van de Velde, Jan Toorop, and Johan Thorn Prikker. Interestingly, both Toorop and Thorn Prikker moved easily between Neo-Impressionism and Symbolism. Thorn Prikker's *The Bride* (cat. 37) and Toorop's *The Three Brides* (cat. 36), both of 1892–1893, display the swirling arabesques typical of Art Nouveau and feature depictions of hauntingly mysterious women. By contrast, two of Toorop's later works, *The Connoisseur of Prints (Portrait of Dr. Aegidius Timmerman)* and *In the Dunes* (cats. 27, 29), are beautifully executed pointillist paintings. Toorop's ambivalence regarding the aesthetic relationship between Neo-Impressionism and Symbolism may have rubbed off on Bremmer, who seemed equally supportive of Mrs. Kröller-Müller's collecting of both Neo-Impressionist and Symbolist works.

Bremmer's experience as a practicing Neo-Impressionist artist must have shaped his perception of the importance of that movement in the development of modern art, a view he passed on to Mrs. Kröller-Müller, who collected Neo-Impressionism voraciously. Her enthusiasm was stimulated by visits to leading artists of the movement. In 1912, Bremmer and Mrs. Kröller-Müller visited Signac in Paris. She bought two paintings from the artist, one by Seurat and the other by Signac,[2] which are similar to the paintings of harbor scenes by Signac and Seurat in this exhibition (cats. 24–26). She also bought one of Signac's masterpieces, *Breakfast* (cat. 23), which was shown in Brussels at the exhibition

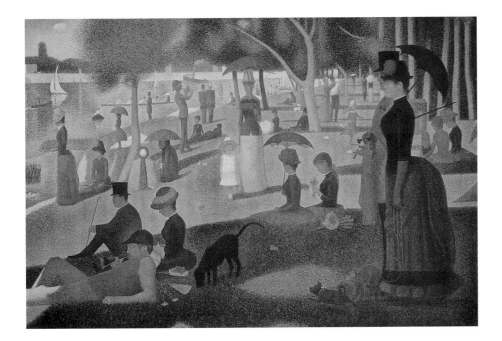

Fig. 1  Georges Seurat, *A Sunday on La Grande Jatte*, 1884–1886, oil on canvas, The Art Institute of Chicago, Helen Birch Bartlett Memorial Collection.

of Les Vingt in 1888. As the recent retrospective exhibition of Signac's work has shown, *Breakfast* is a pointillist reinterpretation of a painting by the Impressionist artist Gustave Caillebotte (fig. 2), exhibited in Paris in 1876.[3]

A letter describing her 1912 visit to Signac gives important clues to how Mrs. Kröller-Müller, following Bremmer's lead, interpreted the work of the Neo-Impressionists, particularly Seurat. Contrary to the prevailing view that Seurat's pointillist technique derived from an interest in creating a rational, almost scientific approach to painting, she believed that Seurat "created pointillism in order to achieve a spiritualization of art: applying the colour to the canvas point by point in order to look at things more calmly, more deeply."[4] This remark echoes Bremmer's vaguely Kandinskian view that Pointillism was an important step towards the spiritual purification of art. In 1922 Bremmer reiterated the notion that Pointillism "is nothing other than a system whereby the spiritual attitude of the artists is expressed in confrontation with reality."[5]

Mrs. Kröller-Müller's high opinion of Neo-Impressionism was later reinforced by her association with Henry van de Velde, a painter, designer, and architect who would design her museum. A member of Les Vingt, he was deeply influenced by the work of Seurat and went through a brief period when he experimented with pointillist technique, producing such paintings as *Twilight* (cat. 30). Van de Velde soon gave up painting to focus on architecture and design. He first met the Kröller-Müllers in 1919. He was introduced

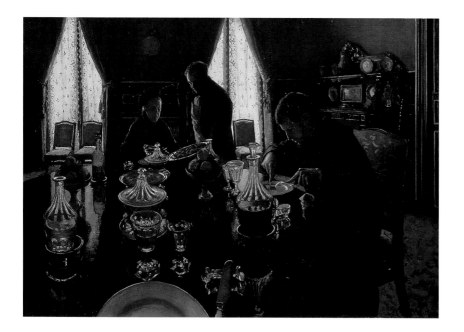
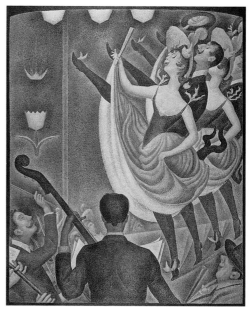

Fig. 2  Gustave Caillebotte, *Luncheon,* 1876,
oil on canvas, Private collection.

Fig. 3  Georges Seurat, *Le Chahut,* 1889–1890,
oil on canvas, Kröller-Müller Museum.

by Karl Ernst Osthaus, a German patron who founded the Folkwang Museum in Hagen,
which Van de Velde had remodeled in 1902. Van de Velde had been a keen admirer of
Seurat and in the late 1890s became intimately familiar with Seurat's painting *Le Chahut*
(fig. 3), then installed in the Parisian offices of *L'Art Décoratif,* which he had designed.
When the opportunity arose to purchase Seurat's *Le Chahut* at auction in Paris in 1922,
Van de Velde strenuously and successfully encouraged Mrs. Kröller-Müller to seize it.[6]
He had also hoped to erect a monument to Seurat, but these plans were never realized.

The works of Van de Velde's good friend and fellow Belgian artist Théo Van Ryssel-
berghe are well represented in Mrs. Kröller-Müller's collection. Van Rysselberghe was
a founding member of Les Vingt and an ardent advocate of Neo-Impressionism. He
befriended Signac, whose influence may be seen in the choice of subject of Van Ryssel-
berghe's painting *A Crag near Roscoff in Brittany* (fig. 4). Signac had painted seascapes
the previous year at the Breton harbor of Portrieux (cat. 26). As the art historian Robert
Herbert has pointed out, however, the approaches of the two artists diverged: Signac
abstracts his view of the harbor, whereas Van Rysselberghe "wanted us to have a feeling
of real rocks being covered by real water, something that Signac cheerfully ignores."[7]
Similarly, Van Rysselberghe's large and sunny *A Family Gathering in an Orchard* (cat. 28),
painted in 1890, and *Fir Trees near St. Clair* (cat. 31), painted in 1917, present us with
pleasant and straightforward scenes of everyday life and the French landscape.

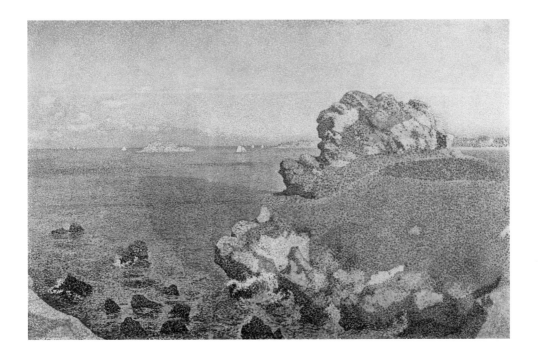

Fig. 4  Théo van Rysselberghe, *A Crag near Roscoff in Brittany*, 1889, oil on canvas, Kröller-Müller Museum.

In addition to bringing Neo-Impressionism to Belgium and Holland, the exhibitions of Les Vingt played a vital role in spreading the Symbolist aesthetic northward. The major Symbolist artists represented in Mrs. Kröller-Müller's collection exhibited with Les Vingt: Henri Fantin-Latour in 1885, Odilon Redon in 1890, and Maurice Denis in 1892. Given her essentially symbolist attitudes toward the development of modern art, it is easy to see the appeal of this approach to painting, which foregrounds the expressive and imaginary.

Mr. Kröller-Müller acquired Fantin-Latour's *Portrait of Mlle Eva Callimaki Cartagi* (cat. 33) in 1913 as a gift for his wife, to whom he believed the portrait bore an uncanny likeness (page 22, fig. 15). The fact that this would have been understood by the Kröller-Müllers as a symbolist effort is indicated in the following remarks by Bremmer, who lectured on the painting in 1922, "Here a piece of reality is, in fact, represented fairly simply. The strongly pronounced chiaroscuro is something incidental in the lighting. The splendour of this work is nothing other than a certain solemnity, an inner clarity, the serenity which emanates from an artist who expresses his vision on a fragment of reality."[8] Although they are paintings of inanimate subjects, Fantin-Latour's delicate *Still Life with Pot of Primroses* (cat. 34) and *Still Life with Peaches* (cat. 35) also convey a sense of solemnity and inner clarity.

A follower of Paul Cézanne and Paul Gauguin, Maurice Denis exhibited in the 1890s with a group that called themselves the Nabis (Prophets). His paintings never ventured into total abstraction, but he uttered one of the most radical artistic statements of his time: "Remember that a painting, before being a war horse, a female nude, or some kind of anecdote, is essentially a flat surface covered with colors assembled in a certain order."[9] In *April* (cat. 38), painted in 1892, one of four paintings depicting the seasons, with its emphasis on flat shapes and heavy contour lines, Denis follows through on his statement. In the 1890s, Denis's work delved into mystical Catholicism. *Harvest* (cat. 39) makes symbolic allusions to the fall of Adam and the expulsion from the Garden.

An artist who particularly captured Mrs. Kröller-Müller's imagination was Odilon Redon, whose fantastic visions are seen as forerunners of Surrealism (cats. 40, 41). In fact, she was so fascinated by the artist that in 1929 she organized an exhibition of his work in The Hague, where she explained: "Redon's art found little acceptance among his contemporaries. For a long time he went unrecognized. Many people even regarded it as the figurative language of a defective mind, for the realistic trend of the times seduced them again and again into extracting concrete representations from it without accepting the profound chiaroscuro and the deliberate vagueness of the forms as an abstract emotional utterance."[10] She eventually acquired dozens of paintings, pastels, drawings, and prints by Redon, making the Kröller-Müller Museum's holdings of works by this artist among the best in the world.

## Notes

1. Robert L. Herbert, *Neo-Impressionism* (New York: Solomon R. Guggenheim Foundation, 1968), p. 198.

2. R. W. D. Oxenaar, *Kröller-Müller: The First Hundred Years,* trans. J. W. Watson and L. J. M. Coleman-Schaafsma (Otterlo: Kröller-Müller Foundation, 1988), p. 23.

3. Marina Ferretti-Bocquillon et al., *Signac 1863–1935* (New York: The Metropolitan Museum of Art, 2001), pp. 125–127. The Metropolitan's exhibition catalogue refers to this painting as *The Dining Room, Opus 152.*

4. Oxenaar, *Kröller-Müller: The First Hundred Years,* p. 23.

5. Ibid., p. 64.

6. Ibid., p. 59.

7. Herbert, *Neo-Impressionism,* p. 181.

8. Oxenaar, *Kröller-Müller: The First Hundred Years,* p. 63.

9. Maurice Denis, "Définition du néotraditionnisme," *Le ciel et l'arcadie,* ed. Jean Paul Bouillon (Paris: Hermann, 1993), p. 5. ("Se rappeler qu'un tableau—avant d'être un cheval de bataille, une femme nue, ou une quelconque anecdote—est essentiellemente une surface plane recouverte de couleurs en un certain ordre assemblées.")

10. Oxenaar, *Kröller-Müller: The First Hundred Years,* p. 81.

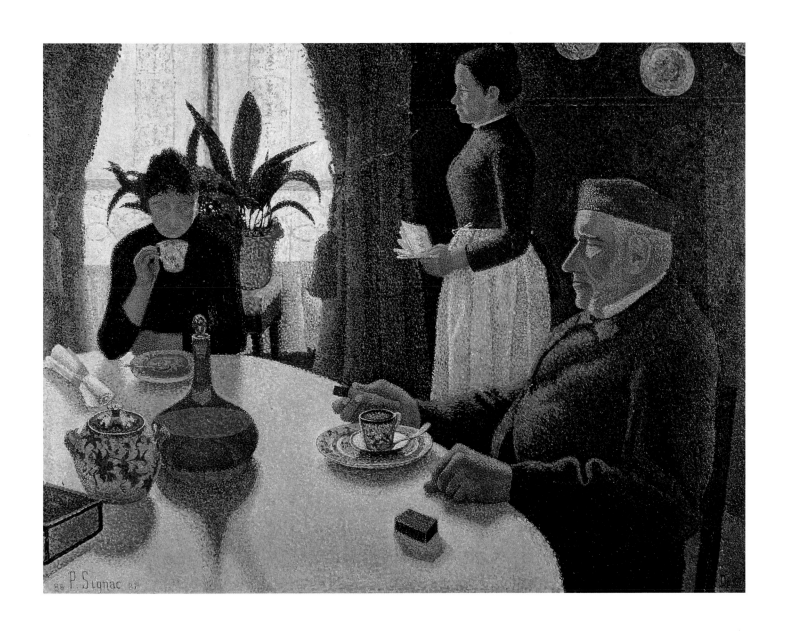

23 PAUL SIGNAC *Breakfast* 1886–1887, oil on canvas, 35¼ × 45⅞ inches

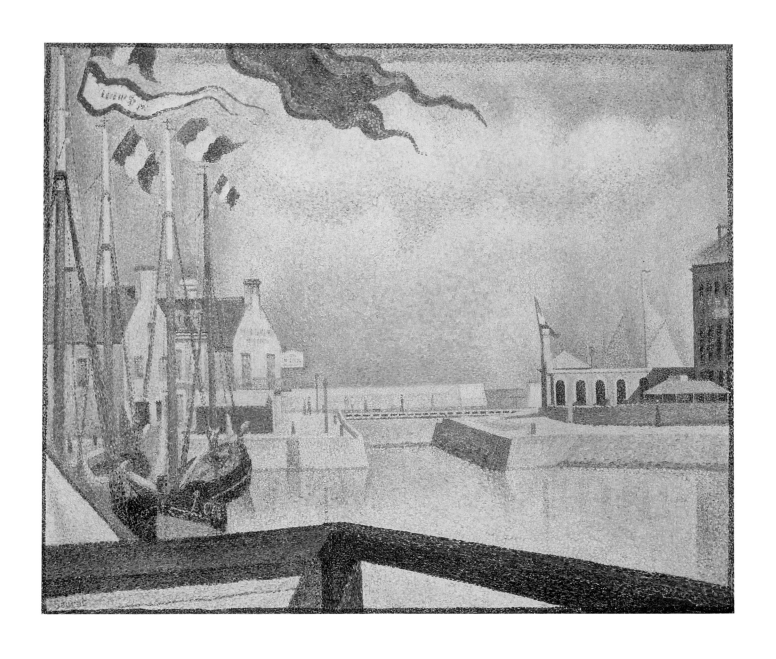

24   GEORGES SEURAT   *Sunday at Port-en-Bessin*   1888, oil on canvas, 26 × 32¼ inches

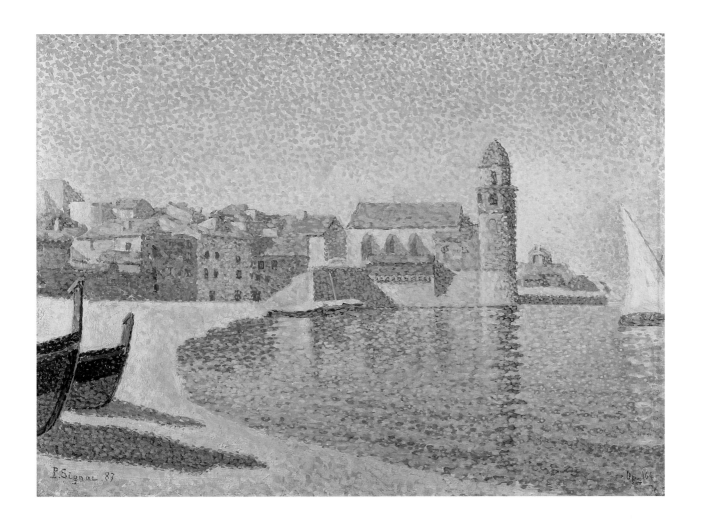

25 PAUL SIGNAC *View of Collioure* 1887, oil on canvas, 13 × 18 inches

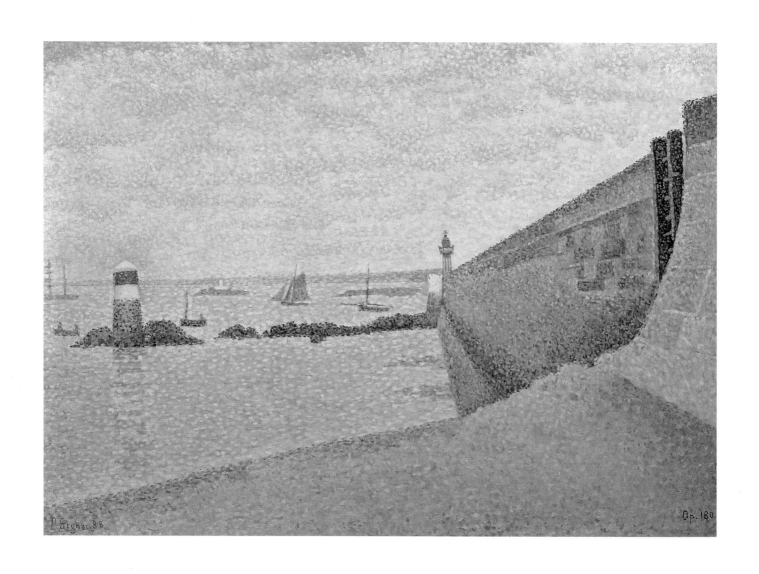

26 PAUL SIGNAC *The Jetty of Portrieux* 1888, oil on canvas, 18 × 25½ inches

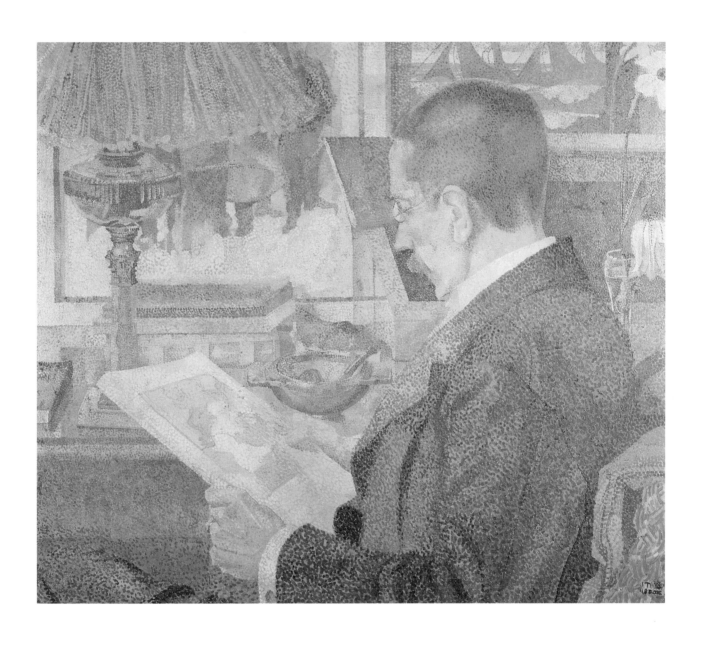

27 JAN TOOROP  *The Connoisseur of Prints (Portrait of Dr. Aegidius Timmerman)*  1900, oil on canvas, 26⅛ × 29⅞ inches

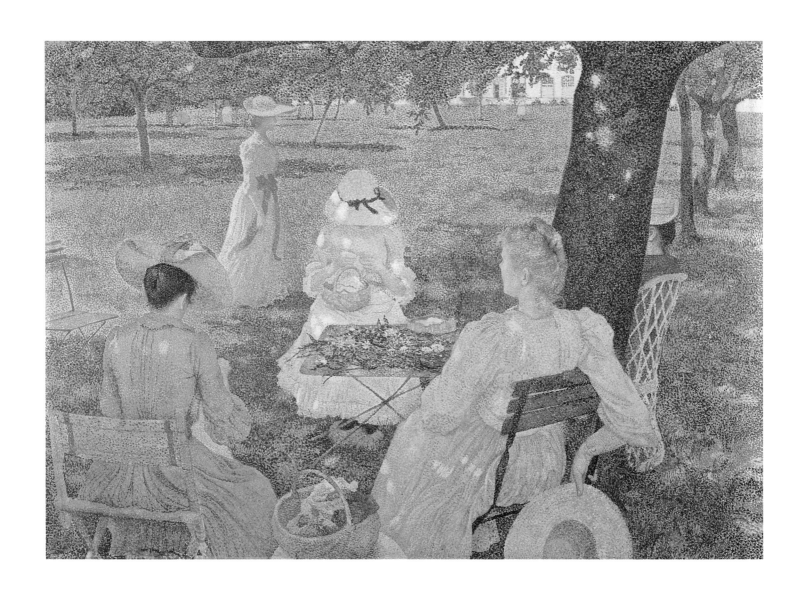

28   THÉO VAN RYSSELBERGHE   *A Family Gathering in an Orchard*   1890, oil on canvas, 45½ × 64¼ inches

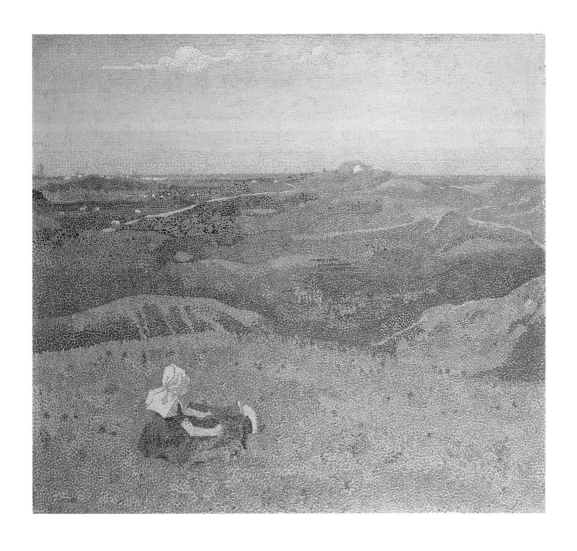

29  JAN TOOROP  *In the Dunes*  1903, oil on canvas, 21⅞ × 24 inches

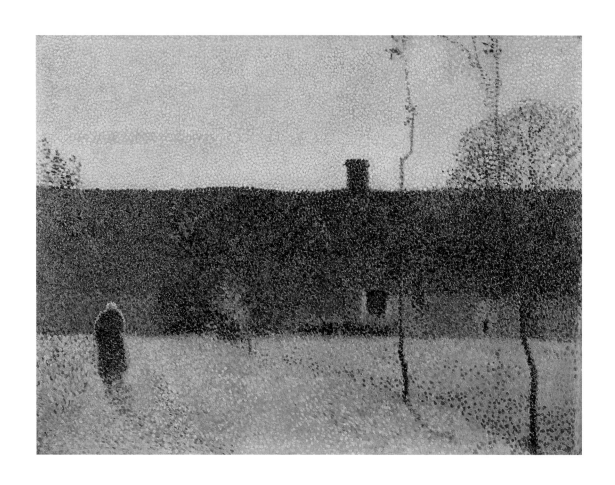

30  HENRY VAN DE VELDE  *Twilight*  ca. 1889, oil on canvas, 17¾ × 23⅝ inches

31  THÉO VAN RYSSELBERGHE  *Fir Trees near St. Clair*  1917, oil on canvas, 28¾ × 45¾ inches

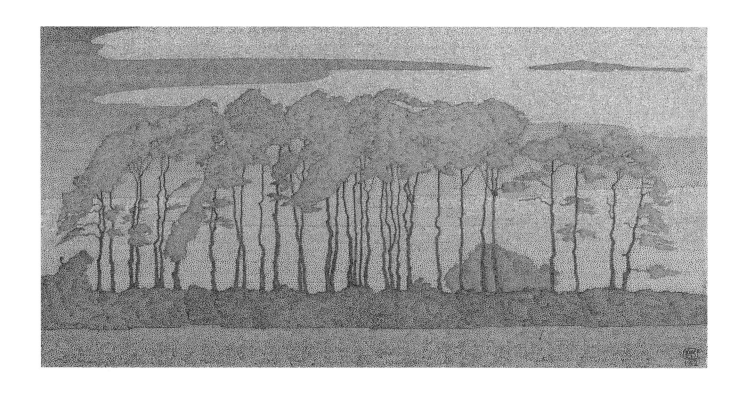

32　H. P. BREMMER　*Fir Trees* (*Harskamp*)　1912, oil on canvas, 9½ × 19 inches

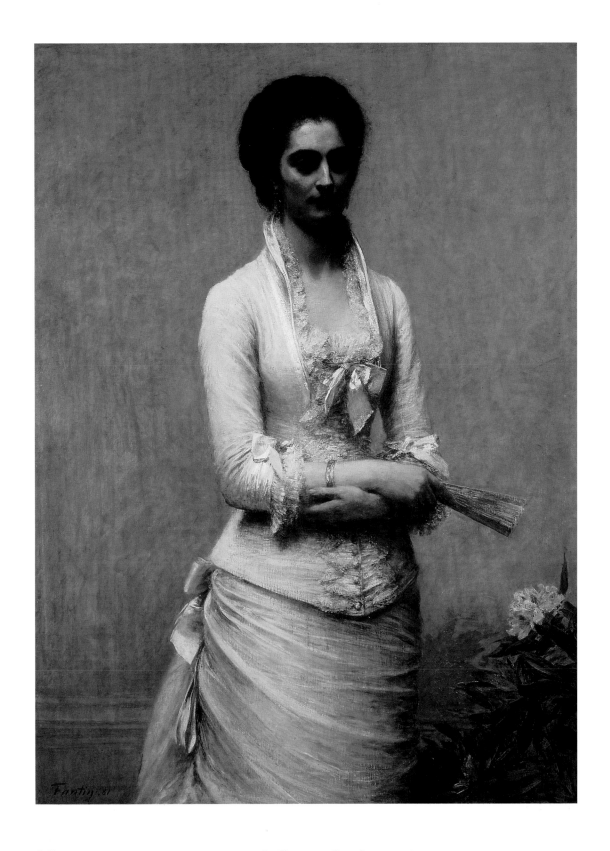

33   Henri Fantin-Latour   *Portrait of Mlle Eva Callimaki Cartagi*   1881, oil on canvas, 51½ × 38½ inches

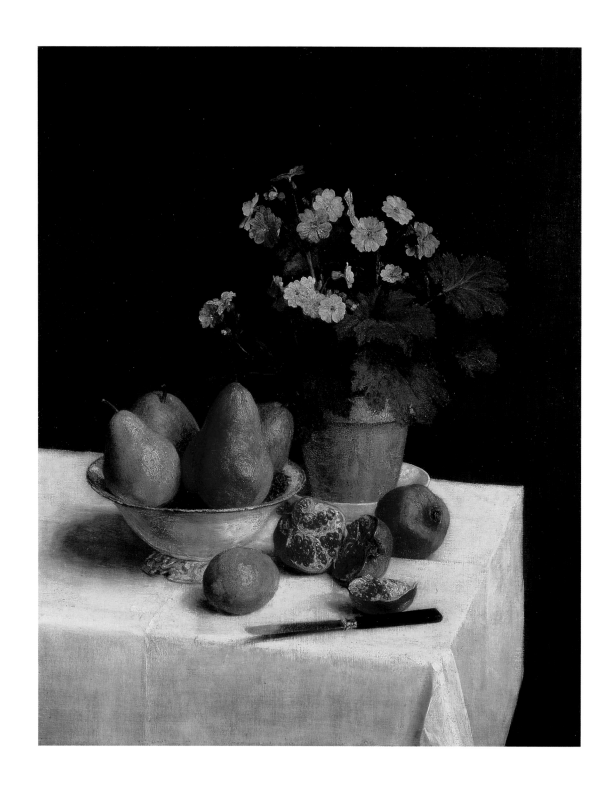

34 HENRI FANTIN-LATOUR *Still Life with Pot of Primroses* 1866, oil on canvas, 28¾ × 22¾ inches

35　Henri Fantin-Latour　*Still Life with Peaches*　1904, oil on canvas, 7¾ × 11¾ inches

36 JAN TOOROP *The Three Brides* 1892–1893, pencil and black and colored chalk on paper, 30¾ × 38½ inches

37 JOHAN THORN PRIKKER *The Bride* 1892–1893, oil on canvas, 58 × 34⅝ inches

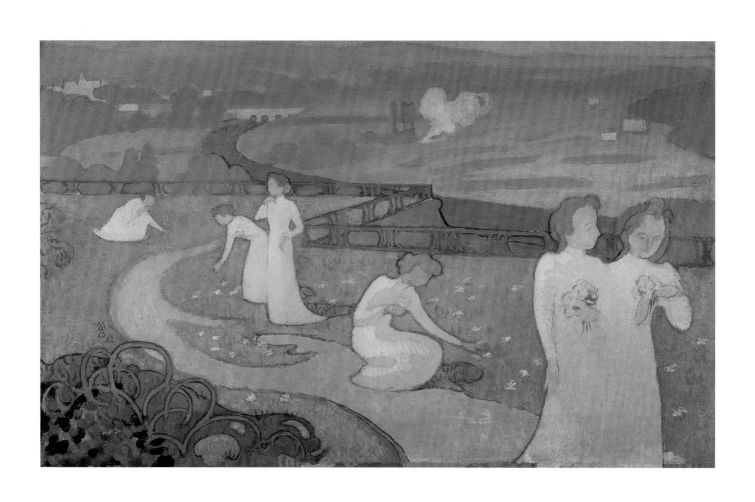

38 MAURICE DENIS *April* 1892, oil on canvas, 14¾ × 24 inches

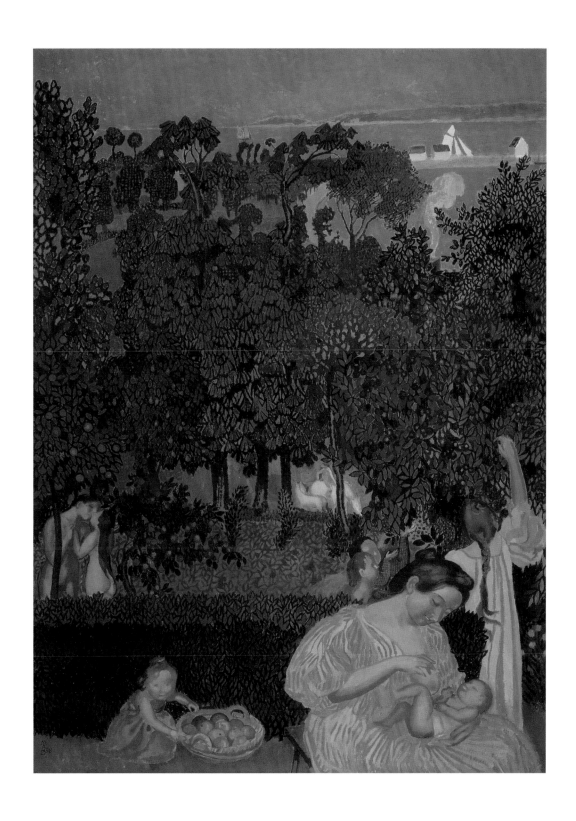

39  MAURICE DENIS  *Harvest*  1898, oil on cardboard, 39⅜ × 29½ inches

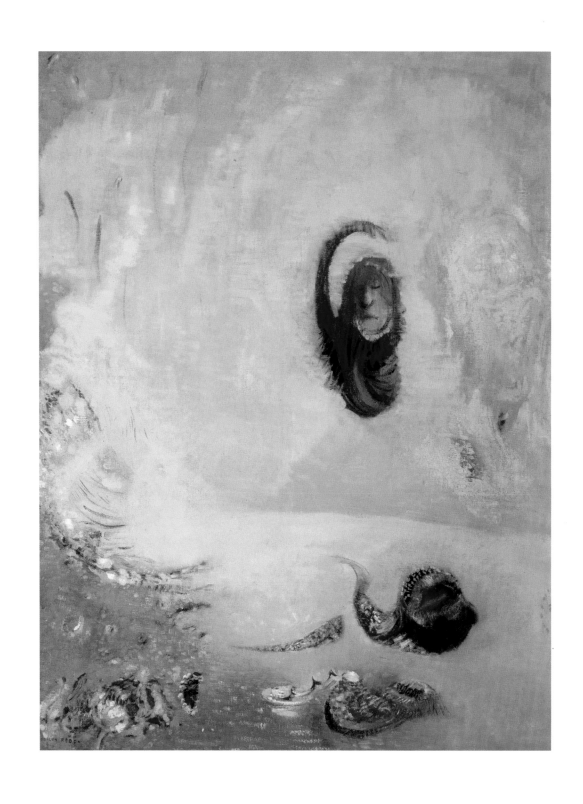

40  ODILON REDON  *Oannès*  ca. 1900–1910, oil on canvas, 25 × 20 inches

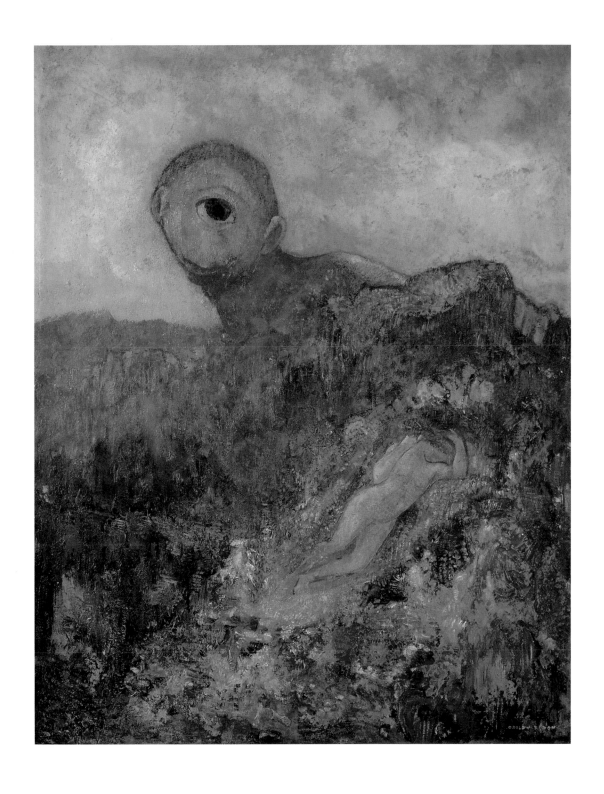

41 ODILON REDON *The Cyclops* ca. 1914, oil on cardboard mounted on panel, 26 × 20¾ inches

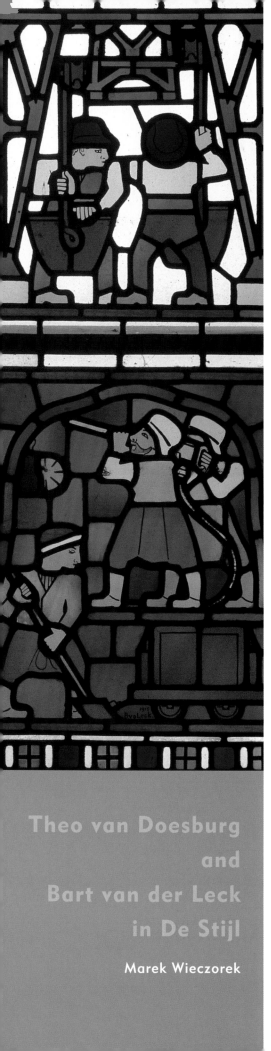

Theo van Doesburg
and
Bart van der Leck
in De Stijl

Marek Wieczorek

## De Stijl

THE PAINTERS THEO VAN DOESBURG and Bart van der Leck were both founders of the Dutch avant-garde movement De Stijl (The Style), which envisioned utopia through a merger of architecture with the visual and applied arts into an abstract and harmonious colored environment. One could scarcely imagine more different personalities, backgrounds, or artistic principles in artists striving for the same cause. Whereas Van Doesburg was the fiery leader and proselytizer who rallied his band of "collaborators" with great optimism, Van der Leck was a reserved pessimist who was already frustrated by failed collaborations with architects before founding De Stijl. Van Doesburg was at heart a romantic, avant-garde individualist who experimented with different styles and discovered the communal spirit only shortly before founding De Stijl in 1917. Van der Leck had been steadily involved since the early 1890s in "Communal Art," a Dutch variant of Art Nouveau that combined architecture with the other arts toward a higher social ideal.[1] The artist left the De Stijl group during its first year, due to various artistic disagreements, but also because architects were assigned a role that he feared would lead them to dominate the painters, as had happened in his collaborations with H. P. Berlage, a leading architect of his generation.

Van der Leck's contribution to De Stijl was nevertheless considerable, and he had much in common with the group, despite differences of opinion and his early departure.[2] In his naturalistic paintings of unpretentious, everyday "genre" subjects (1907–1915), he had already introduced what would become De Stijl's trademark primary colors and balanced geometric shapes, as well as a native Dutch sense of sobriety and simplicity (fig. 1). These qualities were very much appreciated by his patron, H. P. Bremmer, who advanced the artist's career by offering him a monthly allowance and publicizing his work. Bremmer transmitted his enthusiasm for Van der Leck to Helene Kröller-Müller, who likewise offered her patronage through commissions, acquisitions, and financial support.[3] Yet the artist's version of Communal Art, which found a kind of apotheosis in De Stijl, also took on highly abstract forms that—although still charged with public spirit and social commitment—became abstract beyond recognition (cat. 49). These works were less appreciated by his patrons, who were glad when the artist returned to mostly recognizable subjects after 1918 (cat. 50).[4] As Evert van Straaten noted, Van der Leck's lack of a broader international reputation may be due more to the lack of opportunity to build such a reputation—Bremmer and Mrs. Kröller-Müller collected the vast majority of his work, which she never lent—than a deliberate denial of his qualities by critics.[5]

## Communal Art

Between ages 15 and 23 (1891–1899), Van der Leck apprenticed at various stained-glass workshops, where he encountered Communal Art.[6] The complete integration of the applied arts with the building was meant to symbolize the social ideal of integrating the people—presumed to be closest to simple, honest ornamentation—with a democratic society that would thus reflect simplicity, beauty, honesty, and truth. In *The Fruit Seller* of 1913 (fig. 1), harmony is achieved not only through the peaceful subject, but also through the beginnings of abstraction in the form of balanced, diagonal color relations—for example, between the child's dress and the woman's blouse, and between the woman's apron and skirt and the man's shirt and jacket. The artist's working-class background and affinities surfaced in the stained-glass window *Mining Industry* (cat. 43), made for Wm. H. Müller & Co., Mrs. Kröller-Müller's husband's holding company for mining and shipping, which also commissioned a poster (cat. 44). Communal Art developed a fascination with the presumed harmony of Egyptian, Assyrian, Medieval, and so-called "primitive" civilizations, characterized by an integrated, monumental art in a flattened, linear style. *Mining Industry* celebrates labor as though it were a religious, "spiritual" activity in the condensed narrative style of pre-Renaissance murals or windows. Indeed, from 1904 to 1916, Van der Leck painted his figures mostly in frontal or profile views, uniform and hieratic poses, and used flat shadowless colors that harmonized with the walls of the building. He also began to develop a white ground and border within which the figures and the increasingly abstract shapes seem embedded (cats. 48, 49).[7]

The artist found in the writings of the esoteric nature philosopher Mathieu Schoenmaekers further justification for his move toward abstraction and monumental art, as did Piet Mondrian, his friend and colleague in De Stijl, who also lived in Laren. The two painters were "in the grip of Dr. Schoenmaekers's ideas [expressed in] a book on 'Plastic Mathematics,'" Van Doesburg wrote to a friend upon his first visit to Laren in 1916. "According to him, a work of art must always have a mathematical foundation."[8] Schoenmaekers's neologism *nieuwe beelding,* or Neoplasticism, would become a keystone for De Stijl artists, who rejected the "plasticity" or illusionistic spatial modeling of traditional painting for a new and abstract form of space, based on expansive, geometric planes. Van der Leck would title some of his works "mathematical images" and adapt the term "decomposition" (*ombeelden* or *beelden*) to describe his process of abstraction by way of reduction. He (and Mondrian) believed that the expansive and colorful "spatial planarity" of painting should stand in dynamic opposition to architecture's enclosing and colorless,

Fig. 1 Bart van der Leck, *The Fruit Seller,* 1913, oil on canvas, Kröller-Müller Museum.

space-limiting, wall planes.[9] Yet, for his commission to paint Mrs. Kröller-Müller's new Art Room in 1916 Van der Leck was left only with a narrow strip along the ceiling because Berlage had covered most of the walls with three massive brown cabinets and his own paneling and ornamentation. The painter's solution—intense primary color planes (red and blue)—was rejected by both his patron and the architect (cat. 45).[10] Most commentators called the artist stubborn. *Principled and rigorous* would be a better description, in keeping with the artist's method of "decomposition," and perhaps also *frustrated*, since Van der Leck did not have a chance to see his monumental designs executed until later in life. Van der Leck's paintings were made with the building in mind, yet his contribution was often treated as an afterthought.

Van Doesburg's turn to collaborative projects in the spirit of Communal Art came late and within a short time span. The self-taught artist had been a marginal figure in the Dutch art world until 1913, when he began to develop his art and criticism vis-à-vis international avant-garde movements. *Composition I (Still Life)* (cat. 42) represents a rite of passage of sorts into these movements and is the first painting assigned a number, a practice the artist would continue for works he considered important.[11] It reveals the influence of Schoenmaekers's new, "plastic" conceptualization of space through circle diagrams and expansive planes as well as Cubism and Paul Cézanne, who "arrived at form via color," as Van Doesburg wrote, "He finds the five basic mathematical forms—sphere,

cube, parallelepiped, cone, and pyramid—in all natural forms."[12] Van Doesburg would continue to experiment and measure himself against the great painters of the past and present, but also against his De Stijl colleagues. The year 1916 saw his first projects for monumental art, such as *Stained Glass Composition III* from 1917 (fig. 2), for a teacher's house by De Stijl architect Jan Wils. Perhaps in emulation of Van der Leck and Vilmos Huszár, Van Doesburg decomposed the figure of a skater (clearest in the lower left triangle) and rotated this form throughout the composition.[13]

## Integrating Abstraction

Van der Leck's abstract paintings cannot be seen as separate from his interior color and design projects and demonstrate a continued social concern. *Composition 1917, no. 4* (cat. 48) is the last work in a series of studies "decomposing" the motif "Leaving the Factory," which goes back as far as 1908–1910, when Van der Leck studied workers in the textile industry in Glanerbrug. Whereas the large 1910 painting *Leaving the Factory* (fig. 3) speaks of a drab, monotonous existence, the later studies (fig. 4) probably schematize the

Fig. 3 Bart van der Leck, *Leaving the Factory*, 1910, oil on canvas, Museum Boymans van Beuningen, Rotterdam.

Fig. 4 Bart van der Leck, Study for *Composition 1917* (*Leaving the Factory*), 1917, gouache on paper, location unknown.

Fig. 5 Bart van der Leck, *Design for a Carpet*, 1918, pencil and gouache on paper, Kröller-Müller Museum.

Fig. 6 Bart van der Leck, Study for *Composition 1918 no. 5*, 1918, black chalk on paper, Kunsthandel Monet, Amsterdam, J. P. Smid Collection.

Fig. 7 Bart van der Leck, Study for *Composition 1918 no. 5*, 1918, watercolor on paper, Private collection.

Fig. 8 Bart van der Leck, Study for *Composition 1918 no. 5*, oil on canvas, Hannema-de Stuers Foundation, the Netherlands.

relationship between the individual and collectivity, and social cohesion is conveyed abstractly through de-individualized lines and planes. As Rudolf Oxenaar recognized, Van der Leck's social conscience was not condemnatory but forward-looking, manifested through purely "plastic" means.[14] "Spatial planarity" means that planes acquire an expansive feel, and colors protrude or recede optically, as seen also in the beautifully sparse *Composition 1918 no. 4 (Design for Carpet)* (cat. 49), where diagonals add an even more dynamically expansive feel to the arrangement. This composition is also known as part of a design for a carpet (fig. 5) and may have a naturalistic basis, now lost, but perhaps not unlike that of the design in the upper right of the same carpet. This design was based on *Composition 1918 no. 5*, the next work in the series of paintings executed that year, but a further decomposed mirror image. The latter composition comes out of studies of two sheep, one standing, the other lying down to the left with its head turned, in front of a fence with a house or farm in the background (figs. 6, 7). In the final composition (fig. 8), the blue square and bars at the top are remnants of the sky, pierced by the two triangular elements indicating pitched roofs.[15] But such connections were too abstract for Mrs. Kröller-Müller, who expressed the hope that she would eventually appreciate this kind of work (which she never did).[16] She was pleased with Van der Leck's return to more easily recognizable motifs, as in *Still Life with a Wine Bottle* (cat. 50), works that became popular with a broader (often working-class) audience, as the artist had originally intended.

## Notes

1. For one of the first systematic accounts of Communal Art, also called *Nieuwe Kunst* or New Art, see Louis Gans, *Nieuwe Kunst: De Nederlandse Bijdrage tot de Art Nouveau* (Utrecht: Libertas, 1960). Gans draws explicit connections with De Stijl on pp. 134–135. See also Caroline Boot and Marijke van der Heijden, "Gemeenschapskunst," in *Kunstenaren der idee: Symbolistische tendenzen in Nederland, ca. 1880–1930*, ed. Carel Blotkamp (The Hague: Staatsuitgeverij, 1978), pp. 36–47.

2. As Cees Hilhorst noted, Van der Leck differed with De Stijl painter Vilmos Huszár on overlapping shapes; with Van Doesburg on oblique lines; and with Mondrian on separate forms. Cees Hilhorst, "Bart van der Leck," in *De Stijl: The Formative Years, 1917–1922*, ed. Carel Blotkamp, trans. Charlotte I. Loeb and Arthur L. Loeb (Cambridge: MIT Press, 1986), p. 179. See also Rudolf Oxenaar, *Bart van der Leck tot 1920: Een primitief van de nieuwe tijd* (The Hague: Interprint Sneldruk, 1976), pp. 185 ff.

3. Van der Leck's contract with Bremmer started on 1 July 1912 (with Mrs. Kröller-Müller as a silent partner) and would last, with brief interruptions, until October 1945. See Oxenaar, *Bart van der Leck tot 1920*, p. 199.

4. Bremmer wrote in 1946 that when Van der Leck arrived at complete abstraction, "the visual artist, in my opinion, has been almost completely repressed." In general, work from the De Stijl period is underrepresented in the Kröller-Müller collec-

tion, and Mrs. Kröller-Müller even sold some of these works or gave them to relatives when the collection was moved to Otterlo in 1938, as noted by Cees Hilhorst in "Bart van der Leck," p. 182.

5. Evert van Straaten, preface to *Bart van der Leck: "Een toepassend kunstenaar,"* ed. Toos van Kooten (Otterlo: Stichting Kröller-Müller Museum, 1994), p. 5.

6. For Van der Leck's training in applied arts and the visual arts at the State Academy (1900–1904), see Oxenaar, *Bart van der Leck tot 1920*, pp. 7–32.

7. Van der Leck in 1914–1916 even experimented with various materials, such as caseine paint (used earlier by architect Pierre Cuijpers on the walls of the Rijksmuseum) on "Eternite" (slabs of water-proofed asbestos cement), which he planned to sink into the wall so as to make the painting flush with the surface. Bremmer consulted with an architect, who expressed doubt concerning the durability and resistance to humidity of works placed into the wall. Van der Leck subsequently wrote to his patron that he had soaked one of his works in water for several months and allowed it to grow mold in his basement, reporting with glee that the work came out undamaged. See Cees Hilhorst, ed., *Vriendschap op afstand: De correspondentie tussen Bart van der Leck en H. P. Bremmer* (Bussum: Uitgeverij Toth, 1999), p. 87.

8. Letter cited in Joop M. Joosten, *Piet Mondrian: Catalogue Raisonné of the Work of 1911–1944*, vol. 2 of Joop M. Joosten and Robert P. Welsh, *Piet Mondrian: Catalogue Raisonné* (New York: Harry N. Abrams, 1994), p. 109.

9. Van der Leck's two essays in the journal *De Stijl* ("The Place of Modern Painting in Architecture," *De Stijl* 1 (October 1917), pp. 6–7; and "On Painting and Building," *De Stijl* 1 (February 1918), pp. 37–38) are full of terminology borrowed from Schoenmaekers and show affinities with Mondrian's ideas.

10. Van der Leck had initially admired Berlage and wrote "An Introduction to Stained Glass Painting," which was dedicated to the architect and led to correspondence with him and Antoon Derkinderen, the founder of Communal Art, who had collaborated on Berlage's famous Stock Exchange. See Oxenaar, *Bart van der Leck tot 1920*, p. 193.

11. See *Theo van Doesburg: Oeuvre Catalogue*, ed. Els Hoek (Utrecht: Centraal Museum, 2000), cat. no. 470, pp. 162–163.

12. Theo van Doesburg, "De revolutie in de schilderkunst" (The Revolution in Painting), *De Nieuwe Amsterdammer*, 11 November 1916, cited in *Theo van Doesburg, 1883–1931: Een documentaire op basis van material uit de schenking van Moorsel*, ed. Evert van Straaten (The Hague: Staatsuit-geverij, 1983), p. 65. It was not unusual to interpret French Post-Impressionism via esoteric sources. See Jan van Adrichem, "The Introduction of Modern Art in Holland, Picasso as *Pars Pro Toto*, 1910–1930," *Simiolus* 21 (1992), pp. 162–211. Van Doesburg visited Mondrian and Van der Leck in Laren on February 6, and *Composition I* was shown at the "De Anderen" exhibition at the Kunstzalen d'Audretch in The Hague from May 7 to June 7. Bremmer bought *Composition I* for Mrs. Kröller-Müller's collection, which Van Doesburg would visit later that year, confirming his intention to found a group with some of the artists represented there. See Hoek, ed., *Theo van Doesburg: Oeuvre Catalogue*, p. 162, and Van Straaten, ed., *Theo van Doesburg, 1883–1931*, p. 62.

13. The figure of a skater was first identified by Carel Blotkamp, "Theo van Doesburg," in Blotkamp, ed., *De Stijl: The Formative Years, 1917–1922*, p. 15.

14. Aside from emphasizing the relationship between the individual and collectivity, Oxenaar suggests that Van der Leck may have set the woman apart to indicate her social role of woman or mother. See *Bart van der Leck tot 1920*, pp. 41–42.

15. Jaap Bremer observed that the design was also meant for a cushion and appears in another interior design drawing of the same year. See Jaap Bremer, "Compositie 1918, no. 5," in *Bart van der Leck: "Een toepassend kunstenaar,"* p. 62. See also Hilhorst, "Bart van der Leck," p. 177.

16. See Hilhorst, "Bart van der Leck," p. 178.

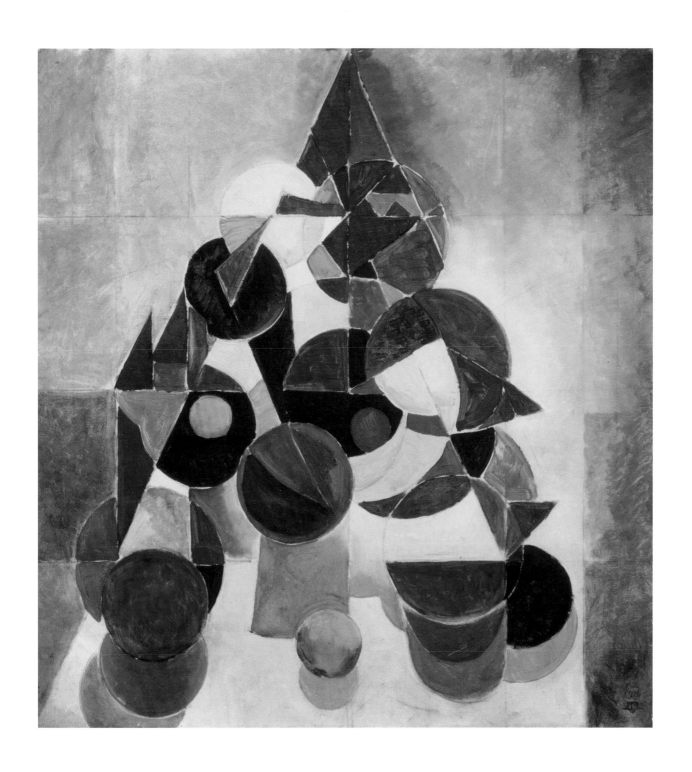

42 THEO VAN DOESBURG *Composition I (Still Life)* 1916, oil on canvas, 26⅜ × 25 inches

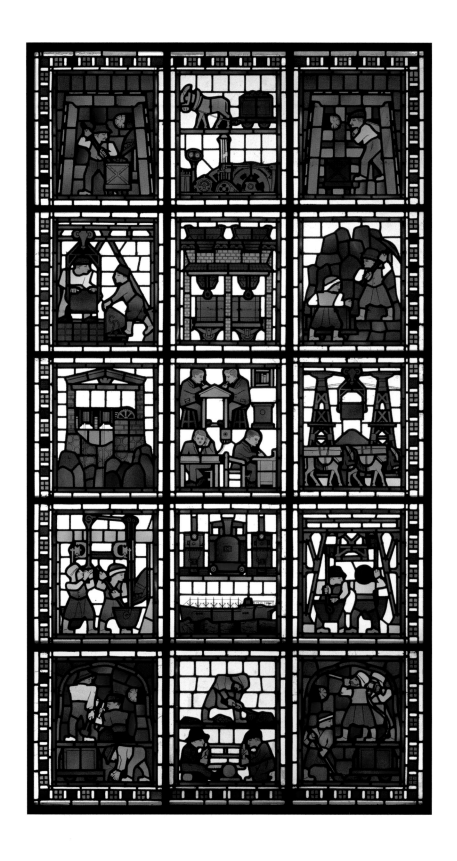

43  BART VAN DER LECK *Mining Industry*  1916, leaded glass, 145½ × 82½ inches

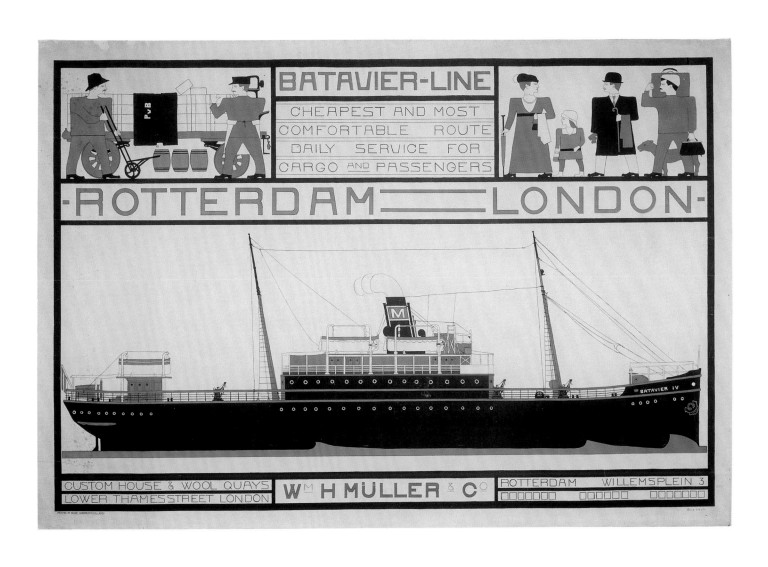

44 BART VAN DER LECK *Batavier Line* 1916, lithograph, 30½ × 45 inches

45　BART VAN DER LECK　*Color Study for Mrs. Kröller-Müller's Art Room*　1916–1917, gouache on paper, 27½ × 30¼ inches

46  Bart van der Leck  *Composition 1916 no. 4 (study)*  1916, gouache on paper, 47½ × 49 inches

47  BART VAN DER LECK  *Composition 1916 no. 4* (*study*)  1916, gouache on paper, 49⅝ × 48¼ inches

48 BART VAN DER LECK *Composition 1917 no. 4 (Leaving the Factory)* 1917, oil on canvas, 37½ × 40¼ inches

49 BART VAN DER LECK *Composition 1918 no. 4 (Design for Carpet)* 1918, oil on canvas, 22 × 18 inches

5 0   B<small>ART VAN DER</small> L<small>ECK</small>   *Still Life with a Wine Bottle*   1922, oil on canvas, 15¾ × 12¾ inches

## The Design of the Kröller-Müller Museum

COLLECTORS WHO HAVE ASSEMBLED a substantial group of paintings, prints, or other works of art often wish to open their collections to the public by building their own museums. Proud of the works they have managed to bring together, they wish to share their cultural capital with others. On the face of it, the idea seems straightforward and the task correspondingly simple: the works of art are already there; why not build a gallery and invite others to share in the enjoyment? Very soon, however, these would-be museum patrons discover the difficulties involved in opening a collection to the public: the expense of maintaining art in a secure, climate-controlled environment and the challenge of encouraging visitors to return. Ultimately, many collectors are compelled to accept the fact that they cannot afford their dreams of a permanent collection identified in perpetuity with their names.

Helene Kröller-Müller might very well have been a member of this disappointed group. Having amassed a huge collection in a relatively short time (the first two decades of the twentieth century), she wanted to create a gallery, initially as part of a house to be built outside The Hague, in which she could put her collection on display. Although she and her husband were among the wealthiest families in the Netherlands around the First World War, an economic downturn in the early 1920s made it impossible for them to realize her plans—which in the meantime had grown into a desire for a rather large museum. If the Dutch government had not stepped in during the 1930s to provide financial support, a Kröller-Müller museum would never have come into being. Ironically, the time it took to implement the by-then drastically reduced plans may from a museological point of view have been an advantage. Had the original designs for the museum (dating to the late 1910s and early 1920s) been realized, the result might have looked old-fashioned as soon as it was completed. The late-1930s plan that was eventually constructed resulted in a museum building with modest but elegant and light-saturated galleries that coincided perfectly with the then-current practice of displaying works of art in white-washed spaces. Although it was planned as a temporary structure, the Kröller-Müller Museum that opened to the public in 1938 became very popular and the building has been in continuous use for more than sixty years.

Much has been written about the collaboration between Mrs. Kröller-Müller and the architects with whom she worked over a period of more than twenty-five years.[1] The story is remarkable indeed. Peter Behrens, Ludwig Mies van der Rohe, H. P. Berlage, and Henry van de Velde—a veritable cross-section of early modernism—were all hired to supply Mrs. Kröller-Müller with a design for what initially was going to be a house-museum and later became a plan for a full-fledged museum. Behrens (hired in 1911) and

Mies (hired in 1912) were each asked to design a house-museum at Ellenwoude, an estate in the stylish town of Wassenaar, near The Hague. Neither of them was allowed to take the design much further than a preliminary stage—in the case of Behrens probably because Mrs. Kröller-Müller found the design too monumental.[2] As far as Mies was concerned, the problem was not that she disliked the design (cat. 51), but that her art consultant H. P. Bremmer voted against it. Nevertheless, the designs of these two architects may very well be among the best-known unrealized buildings in the history of modern architecture. While Mrs. Kröller-Müller was making up her mind about the designs, the architects were commissioned to build full-scale models in wood and cloth (fig. 1), a representational step that is otherwise unheard of in architectural practice and therefore mentioned in numerous books on architecture of the modern period.[3]

Berlage's and Van de Velde's association with Mrs. Kröller-Müller was equally unusual and in each case came about at a very propitious moment for the architects. Both men were hired principally to design Mrs. Kröller-Müller's house-museum, but they nevertheless entered into the service of the Building Department of Wm. H. Müller & Co. What is so unusual about this arrangement is that both architects already had well-established practices of their own, which they had to abandon so that they could devote all their attention to projects for their new boss. Moreover, both architects had socialist backgrounds but did not seem to mind working for this huge corporation. Berlage was hired in 1913 (after his design for Ellenwoude [fig. 2] was chosen over that of Mies, although it too remained unexecuted) and stayed on until 1919. Thus, during World War I, when many of his colleagues had no work—unless they accepted government-sponsored commissions, such as designs for public housing—Berlage could work on many significant projects, including the design of a museum

Fig. 1  Peter Behrens, Ellenwoude House, full-scale model, 1912, photograph, Kröller-Müller Museum.

Fig. 2  H. P. Berlage, Ellenwoude House, plaster model, 1912, photograph, Kröller-Müller Museum.

Fig. 3  H. P. Berlage, *Design for Museum on the Franse Berg*, east elevation, 1918, pencil and watercolor on paper, Kröller-Müller Museum.

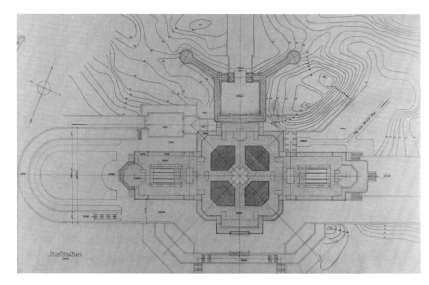

Fig. 4  H. P. Berlage, *Design for Museum on the Franse Berg* (not built), ca. 1917, pencil and watercolor on paper, Kröller-Müller Museum.

Fig. 5  Henry van de Velde, *Design for South Side of Museum on the Franse Berg* (not built), 1921, pencil on paper, Kröller-Müller Museum.

building on the family's huge estate in the east of the country, the Hoge Veluwe. Berlage's design for this building (1917–1918) did not advance much further than the sketch phase (figs. 3–4), and it is therefore difficult to say what the museum would have looked like had it been built. But the few drawings that are preserved (cats. 52, 56, 57) show that both inside and out the building would have been dressed in a monumental style to enhance its presence as a beacon of culture in the midst of the Hoge Veluwe's sand dunes. This effect is underlined by the minaret-like towers that, as in several other projects by Berlage of the period, would have been topped with lights and would have served to draw the passerby's attention to this temple for the arts.

When Berlage resigned in 1919, he was replaced by the Belgian architect Henry van de Velde, who during World War I had lost his job as director of an art school in Weimar, Germany. Van de Velde therefore gladly accepted the job offer and stayed on as the head of Wm. H. Müller & Co.'s Building Department until mid-1926, when he moved back to Belgium to lead a new school for decorative arts. While he too designed many different structures for the company and family (including a new house outside The Hague), his principal commission was to design a museum at the Hoge Veluwe (fig. 5, cats. 53–55). Unfortunately for Van de Velde and for the Kröller-Müllers, an economic depression in the early 1920s made it impossible to build this museum. However, Mrs. Kröller-Müller liked Van de Velde's design so much that she asked the architect and his staff to detail every aspect of the building completely so that it could be built as soon as financial circumstances improved. The drawings (all of which still exist in the Kröller-Müller Museum) show that the hallways, stair halls, and galleries would have been decorated

with colored stone, ornamental floor patterns, and ornate skylights (cats. 58, 59). While Van de Velde's architecture in general does not tend to overwhelm the observer, in this museum the viewer would certainly have had to visually isolate the works of art from the environment.

Van de Velde's emphasis on complex, decorative detail showed that he was not *au courant* with the latest developments in the thinking about how to display art to its best advantage in a museum setting. Beginning in the early 1910s, museum curators in Western Europe increasingly questioned the idea that the museum was simply a public storage space for art and instead promoted the concept of the museum as a place with a didactic purpose. They preferred flexible exhibition spaces in which the greatest variety of art objects could be shown. Light-colored, neutral walls became the norm and have since become so pervasive that it is hard to imagine that the development is actually less than a century old.[4]

Years after Van de Velde had to abandon his fully developed scheme for a Kröller-Müller museum, in 1936–1938 he finally had an opportunity to build a temporary structure (fig. 6). The gallery spaces he created (fig. 7) clearly corresponded to new museological trends. It is, however, hard to say if Van de Velde's plans changed because he and Mrs. Kröller-Müller had converted to a modernist museum design approach or if they had been forced by the Depression to drastically simplify the design of their museum building. Whatever the reason, Van de Velde abandoned the use of expensive

Fig. 6  Henry van de Velde, Temporary Kröller-Müller Museum, exterior view, photograph, late 1930s, Kröller-Müller Museum.

Fig. 7  Henry van de Velde, Temporary Kröller-Müller Museum, interior view, photograph, late 1930s, Kröller-Müller Museum.

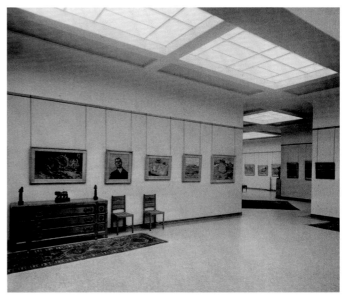

materials and created a simple one-story brick structure consisting of cabinet-like gallery spaces in which Old Master paintings could be accommodated as easily as nineteenth- and twentieth-century art. The best feature of the building, however, is that it has extremely pleasing proportions. At no point does the art look overpowered by the architecture, but neither does the architecture disappear into the background. Building details such as the rounded corners at the entrance to each room and the geometric arrangement of skylights and heating panels in the ceilings give each space a simple elegance; the presence of an architectural framework is certainly felt. It is no exaggeration to say that the Kröller-Müller is one of the few museums in which architecture and art coexist without tension. This is why the temporary museum building became so popular and remains today as a permanent building.

## Notes

1. The publication with the most detailed information in this regard is Johannes Van der Wolk, *De Kröllers en hun architecten* (Otterlo: Rijksmuseum Kröller-Müller, 1992).

2. Van der Wolk, *De Kröllers en hun architecten,* p. 17.

3. Henry Russell Hitchcock, *Architecture: Nineteenth and Twentieth Centuries* (Harmondsworth, Middlesex: Penguin Books, 1958), p. 365. See also Rem Koolhaas, "The House That Made Mies," *Any* 1 (March–April 1994), pp. 14–15; and Terence Riley and Barry Bergdoll, eds., *Mies in Berlin* (New York: Museum of Modern Art, 2001), pp. 166–169.

4. See Wim de Wit, "When the Museums Were White: A Study of the Museum as Building Type," in Selma Holo, Katrina Ampil Bagaybagayan, and Jennifer Jaskowiak, eds., *Open House West: Museum Architecture and Changing Civic Identity,* (Los Angeles: Fisher Gallery, University of Southern California, 1999), pp. 12–19.

51 LUDWIG MIES VAN DER ROHE *Ellenwoude House in Wassenaar* 1912, pastel and watercolor on print, 17⅞ × 55¾ inches

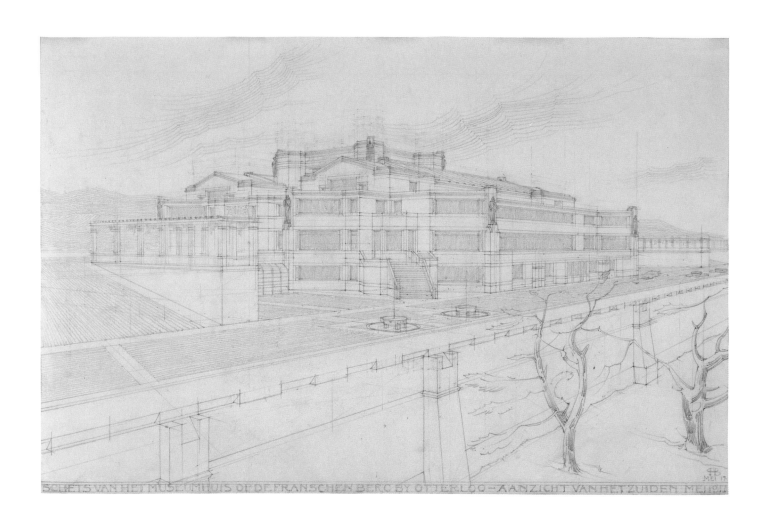

5 2  H. P. BERLAGE  *Sketch of Museum on the Franse Berg I, South Perspective*  1917, pencil on paper, 18¾ × 29⅜ inches

53　Henry van de Velde　*Museum on the Franse Berg II, Gallery*　ca. 1925, pencil on paper, 23 × 26⅜ inches

54   HENRY VAN DE VELDE   *Museum on the Franse Berg II, Perspective View*   ca. 1925, ink on paper, 21⅝ × 30½ inches

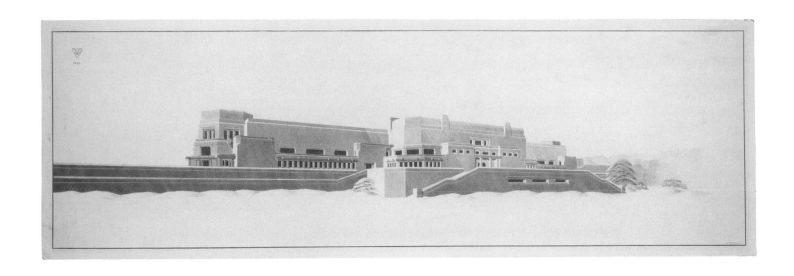

55  HENRY VAN DE VELDE  *Design for Museum on the Franse Berg II, Perspective View*  1923–1926, color pencil on paper, 24 × 76⅛ inches

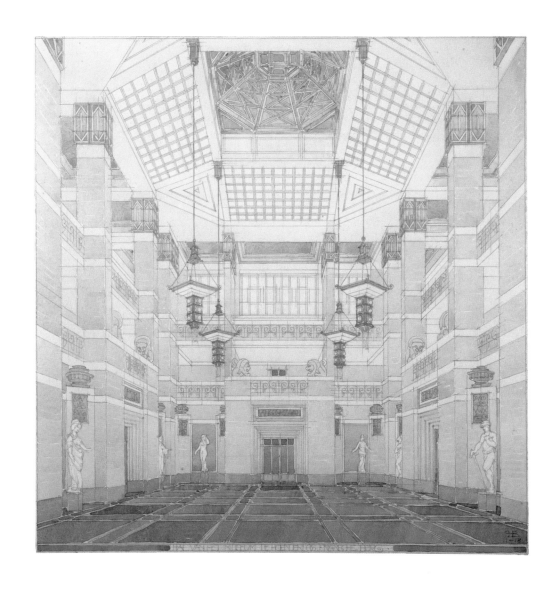

56 H. P. BERLAGE *Hall of Museum on the Franse Berg I* 1918, watercolor on paper, 19⅝ × 19⅝ inches

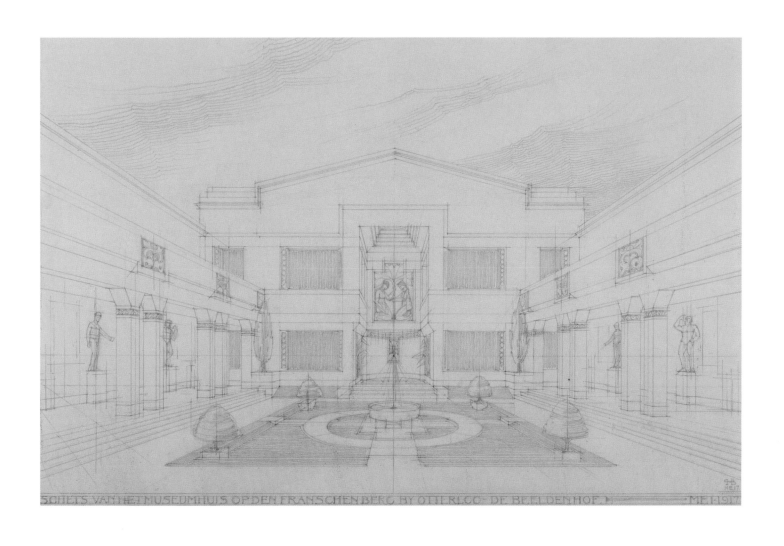

57　H. P. BERLAGE　*Sketch of the Museum on the Franse Berg I, Sculpture Court*　1917, pencil on paper on cardboard, 18¾ × 29⅛ inches

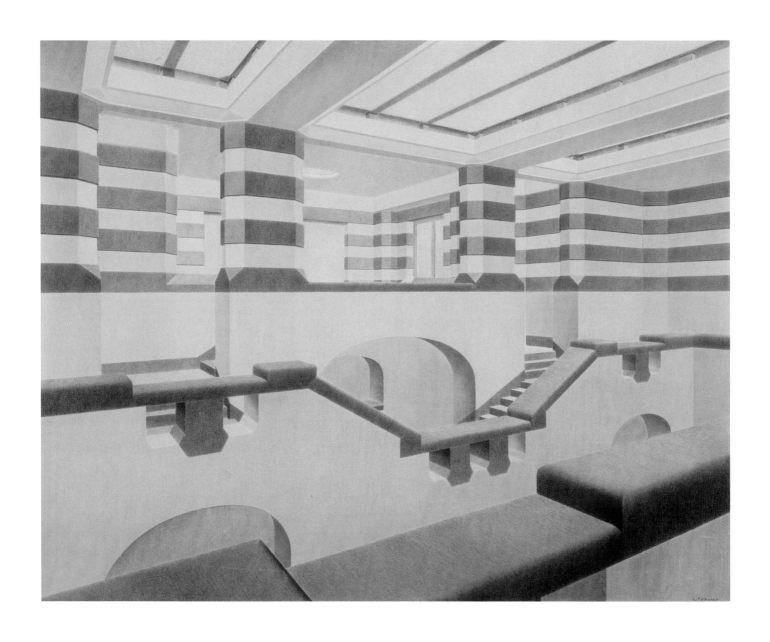

58 HENRY VAN DE VELDE *Color Study of Stairwell of Museum on the Franse Berg II* ca. 1925, color pencil on paper, 32⅞ × 41⅛ inches

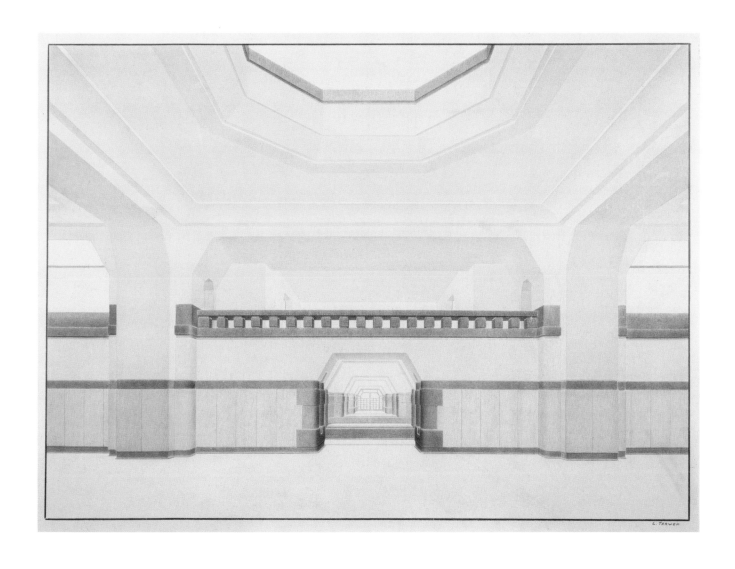

59　HENRY VAN DE VELDE　*Design for Museum on the Franse Berg II, Interior View*　ca. 1925, color pencil on paper, 26⅛ × 36⅜ inches

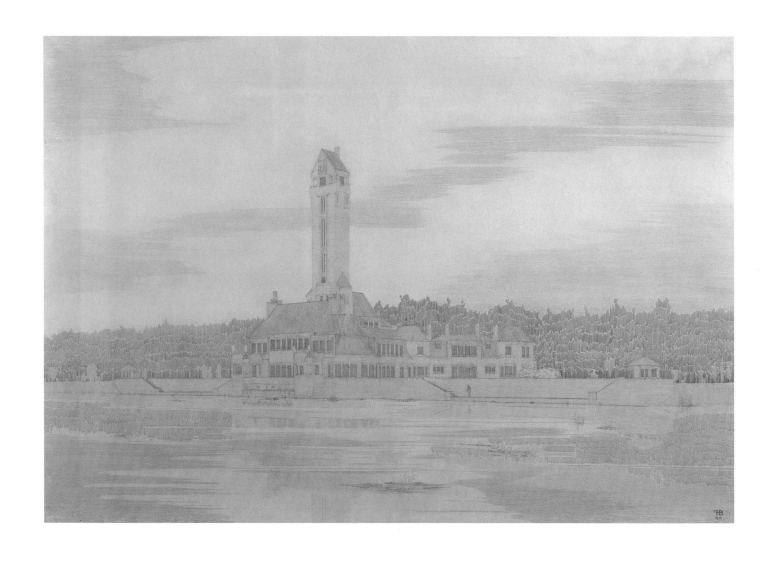

6 0   H. P. BERLAGE  *Design for St. Hubertus Hunting Lodge*  1916, color pencil on paper, 55½ × 80½ inches

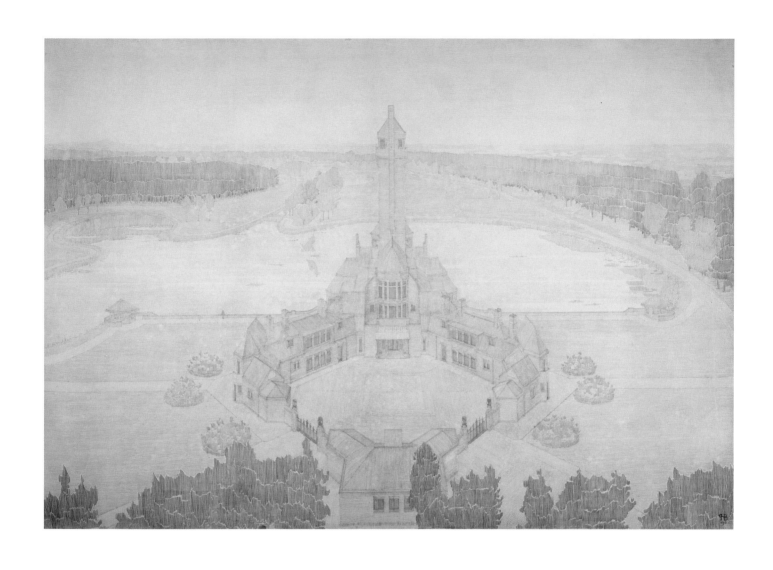

61 H. P. BERLAGE *Design for St. Hubertus Hunting Lodge* 1916, color pencil on paper, 56¼ × 81⅝ inches

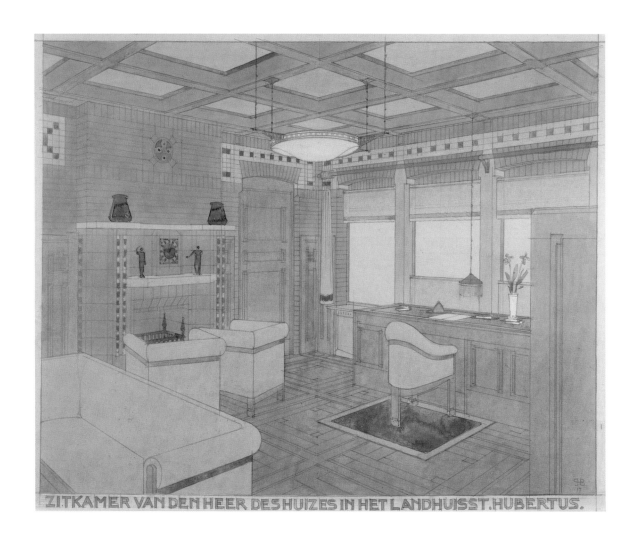

ZITKAMER VAN DEN HEER DES HUIZES IN HET LANDHUIS ST. HUBERTUS.

62 H. P. BERLAGE *Sitting Room of the Master of St. Hubertus Hunting Lodge* 1917, color pencil on paper, 15¾ × 19¼ inches

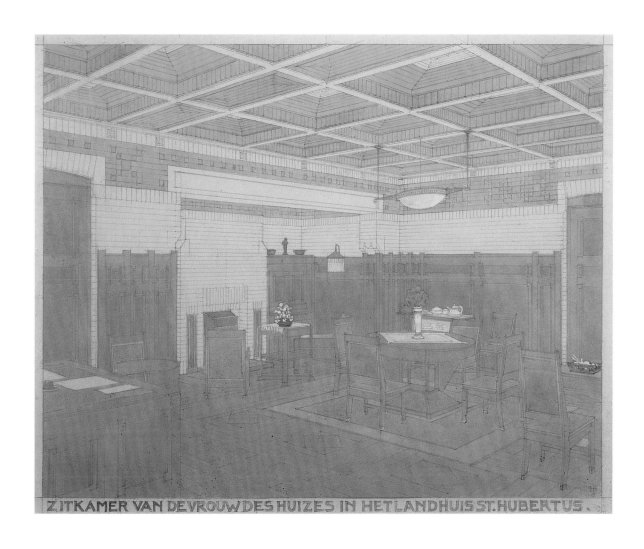

Sitting room of the Mistress of St. Hubertus Hunting Lodge

ZITKAMER VAN DE VROUW DES HUIZES IN HET LANDHUIS ST. HUBERTUS.

63 H. P. BERLAGE *Sitting Room of the Mistress of St. Hubertus Hunting Lodge* 1917, color pencil on paper, 15¾ × 19¼ inches

Helene Kröller-Müller
and the Furniture
of H. P. Berlage

Stephen Harrison

WHILE H. P. BERLAGE IS BEST KNOWN for his important contribution to Dutch architecture at the turn of the twentieth century, his designs for applied arts and furniture also provide a vital link to the theory and practice of emerging modernism.[1] His work profoundly influenced the course of design in Holland and led both directly and indirectly to the Amsterdam School and De Stijl movements.[2]

Berlage also played an important role in the development of the taste and focus of Holland's most avid early modern collector, Helene Kröller-Müller. She collected advisers, artists, and architects with the same passion as she did paintings and sculpture, and Berlage was one of the most prominent. Not only was the architect employed by her husband Anton Kröller to design buildings for the family and Wm. H. Müller & Co. at Helene's behest, but he was instrumental in creating the interior environments in which she lived and studied. Mrs. Kröller-Müller both collected and commissioned Berlage's furniture, and she remains one of the most significant patrons of his career. Berlage's work for the Müller firm and for the Kröller-Müller family was among his most influential for its innovative use of materials and ordering of spatial relationships. In particular, Holland House, his office building for the Müller Company in London, and the St. Hubertus Hunting Lodge for the family at Otterlo, are recognized as two of Berlage's most important works.

However, lesser known but perhaps more directly indicative of Berlage's role in Helene Kröller-Müller's visual milieu was his design and decoration of the Art Room to which she returned day after day to study with her mentor, H. P. Bremmer. The link between Bremmer and Berlage was strong. It was Bremmer who had favored Berlage's design over that of the young Mies van der Rohe in 1912 when Helene was considering a new house for the display of her collection—a crucial step in the development of her aesthetic taste in design. Berlage's strongly held convictions about the relationship of materials and color to form and decoration were perfectly in tune with Bremmer's method of studying art, which emphasized a similar focus on material, technique, and color to arrive at a better understanding of the overall emotive qualities of art.

The Art Room of 1916 (fig. 1) was conceived in accordance with Berlage's theory of *eenheid in veelheid* or unity in plurality,[3] producing a harmony of color and decoration that was conducive to the study of art and artifacts. It was filled with new furniture that Berlage designed specifically for the room as well as objects that Helene Kröller-Müller had collected. Some of the Chinese ceramics on display there had been acquired from a 1917 sale of the furnishings of another of Berlage's most devoted patrons, Carel Henny, an executive with his family's insurance firm, De Nederlanden van 1845.[4] Henny, like the Kröller-Müllers, had employed Berlage to design building works, resulting in several

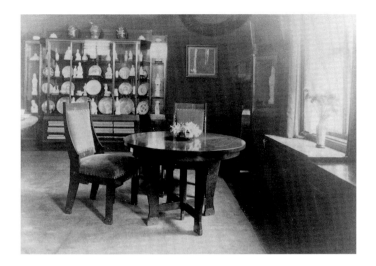

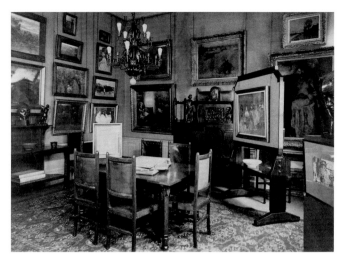

of Berlage's most important commissions. The house Berlage designed for Henny in The Hague in 1898, known as the Villa Henny but dubbed the "yellow peril" for its use of bright yellow roofing tiles, was not far from the Kröller-Müller house and would surely have been known to Mrs. Kröller-Müller since the design was vigorously discussed in the press.[5]

The Villa Henny is perhaps the most significant of Berlage's early residential designs, and he was given license to create along theoretical lines. Although noteworthy for its use of a grid system and strict proportional relationships, it was the overall unity of the Villa Henny design and the innovative use of color that would fully mature in Berlage's designs for the Art Room and the St. Hubertus Hunting Lodge for the Kröller-Müllers.

The parallels between Carel Henny and Helene Kröller-Müller are intriguing. Both were avid students of art, both collected Asian and ancient ceramics, both nourished a passion for the building arts and for the potential of art to inspire, and both found a conduit for this expression in the work of Berlage.[6] It seems likely that it was at the Villa Henny sale in 1917 that Helene acquired the sideboard cabinet (cat. 64) and other furniture designed by Berlage for the Villa.[7] The sideboard from the dining room (fig. 2) shares with other documented furniture from this house the principles espoused by Berlage—honesty in construction, minimal ornamentation, and functional styling. In this way, Berlage shared the sensibilities of English theorists Walter Crane and William Morris as well as American architects Henry Hobson Richardson and Frank Furness, all of whom advocated an originality in design that began with nature but did not imitate it.[8]

Berlage also drew inspiration, without resorting to slavish imitation, from the writings and drawings of the French architectural historian Eugène Emmanuel Viollet-le-Duc,

Fig. 1  H. P. Berlage, Art Room, Groot Haesebroek, Wassenaar, 1916, Kröller-Müller Museum.

Fig. 2  H. P. Berlage, Sideboard from the "Villa Henny Suite," installed in Helene Kröller-Müller's private museum, Wm. H. Müller & Co. headquarters, Lange Voorhout, ca. 1920.

particularly in the use of medieval iron strap hinges and architectonic form. It was in this use of architectural styling that Berlage most closely linked his designs for buildings and furniture. Berlage often wrote and lectured that a piece of furniture is a building and likewise a building is like furniture because to both can be applied the same principles of style.[9] This philosophy followed on from the writings of Viollet-le-Duc, German theorist Gottfried Semper, and the Dutch art critic P. J. H. Cuypers. Berlage's philosophy of unity in design resulted in buildings that were radical in their day for the systematic use of color and ornamentation on the interiors as well as the exteriors. Berlage created whole environments and was often commissioned to design interiors. Like his contemporaries in England and Germany who designed more than just architecture, Berlage also contributed designs for furniture, glass, and ceramics for sale in the artistic cooperative 't Binnenhuis, an interior design shop in Amsterdam.

It was this totality of design that Helene Kröller-Müller was no doubt drawn to in her quest for artistic immersion. The furniture that Berlage produced for the Art Room (cats. 66, 67) was luxurious in material and modern in form. In these designs Berlage reveals his affinity for Viennese design, most notably that of Josef Hoffman, Adolf Loos, and Joseph Olbrich.[10] There is a refined, rational elegance to the profiles of the chairs and tables that echoed work produced for the Wiener Werkstätte, the Austrian counterpart to 't Binnenhuis—a stripping away of ornament to let the materials prevail. Yet Berlage did not fully depart from historical reference, and the chairs clearly pay homage to the forms of ancient Egypt, which Berlage was known to have admired and even copied.[11] Berlage further developed his aesthetic relationship to Vienna in his designs for Holland House and St. Hubertus Hunting Lodge. However, it was left to the Belgian architect Henry van de Velde to complete both after Berlage left the Kröller-Müllers in 1920.

The references to both ancient and contemporary thought in the Art Room interior constituted the milieu in which Helene Kröller-Müller lived and studied. Berlage gave her an environment for the absorption of knowledge, which coincided with the direction she sought from Bremmer and the artists she collected. Indeed, this blend of art and design was a tangible component of her life as a scholar and collector. Although their professional relationship had ended, Helene Kröller-Müller continued to display Berlage's furniture among her paintings. One of them, a long, wide chest acquired from Berlage in 1915 (cat. 65) always sat below Van Gogh's *Four Sunflowers Gone to Seed* (1887), a unified combination made all the more poetic when she chose to be laid in repose in front of them both upon her death in 1939.[12] The significance of Helene Kröller-Müller's association with H. P. Berlage is still evident in the furniture and buildings that remain— a unique contribution to the progress of art collecting and life in the early modern age.

## Notes

1. See Pieter Singelenberg, *H. P. Berlage, Idea and Style: The Quest for Modern Architecture* (Utrecht: Haentjens Dekker & Gumbert, 1972); Sergio Polano, *Hendrik Petrus Berlage: Complete Works* (New York: Rizzoli, 1983); and Titus M. Eliëns, *H. P. Berlage (1856–1934) ontwerpen voor het interieur* (The Hague: Gemeentemuseum, 1998).

2. For more on the Amsterdam School, see Maristella Casciato, *The Amsterdam School* (Rotterdam: 010 Publishers, 1996) and Wim de Wit, ed., *The Amsterdam School: Dutch Expressionist Architecture 1915–1930* (New York and London: Cooper-Hewitt Museum, 1983). See also Reyner Banham, *Theory and Design in the First Machine Age* (London: The Architectural Press, 1960). Banham's seminal discussion of Dutch architecture and design in this period elucidates the debt owed to Berlage by De Stijl followers.

3. Marjan Boot, "Carel Henny en zijn huis: Een demonstratie van 'good wonen' rond de eeuwwisseling," *Nederlandsch Kunsthistorisch Jaarboek* 25 (1974), p. 92. I am grateful to Bram Majtlis for his assistance with translation of this and all other references in Dutch.

4. Boot, "Carel Henny en zijn huis," p. 97.

5. Polano, *Hendrik Petrus Berlage*, p. 154.

6. Boot, "Carel Henny en zijn huis," pp. 97–98.

7. In addition to the sideboard from the dining room of the Villa Henny, the Kröller-Müller Museum collection also includes a standing chest, a table, and six chairs of teakwood that were likely to have been purchased at the sale, which occurred on 20 September 1917.

8. Singelenberg, *H. P. Berlage, Idea and Style*, p. 150. Singelenberg cites Henry Russell Hitchcock's landmark study *Modern Architecture* (1929) as the most salient study of these relationships.

9. Boot, "Carel Henny en zijn huis," p. 92.

10. Singelenberg, *H. P. Berlage, Idea and Style*, pp. 162–163.

11. Eliëns, *H. P. Berlage (1856–1934)*, pp. 14–19. Berlage copied an Egyptian chair in the collection of the Rijksmuseum, Leiden, for a commission in Rotterdam ca. 1895, which now resides in the Museum Het Princesshof, Leeuwarden.

12. Conversation with Piet de Jonge, Kröller-Müller Museum, Otterlo, February 2003. I am indebted to Mr. de Jonge for his assistance with this essay.

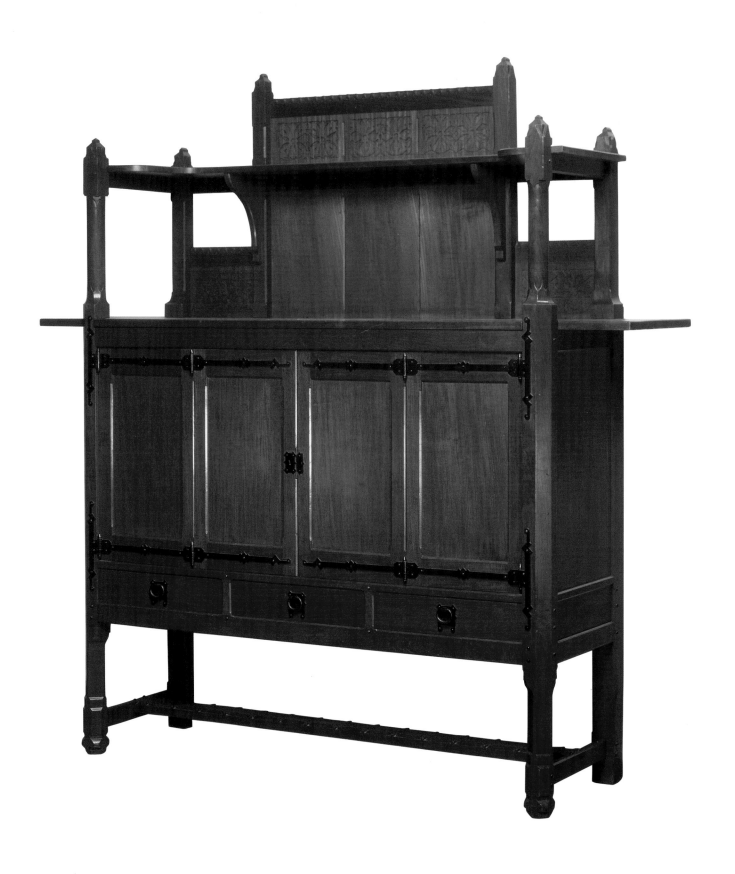

64 H. P. BERLAGE *Sideboard from "Villa Henny Suite"* ca. 1898, teak with carving, 80½ × 79½ × 33½ inches

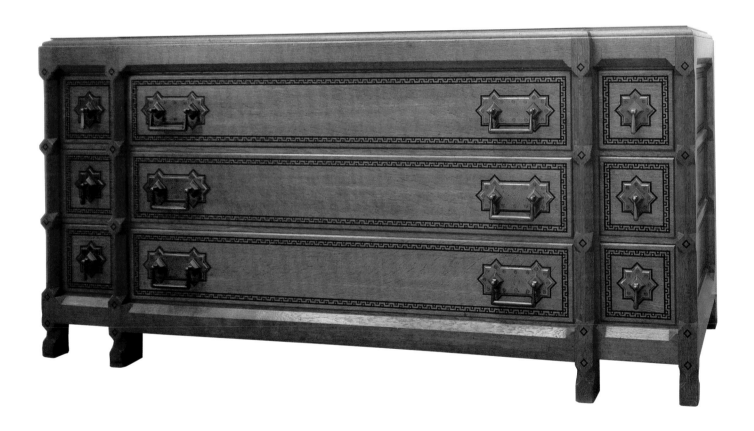

6 5  H. P. Berlage  *Chest*  1915, oak with inlaid ebony, 34¼ × 73 × 23⅝ inches

66 H. P. BERLAGE *Chair from "Art Room Suite"* 1915, coromandel wood with original upholstery, 35⅝ × 19⅞ × 24½ inches

67 H. P. BERLAGE  *Round Table from "Art Room Suite"*  1917, teak, 29⅛ × 49¼ × 49¼ inches

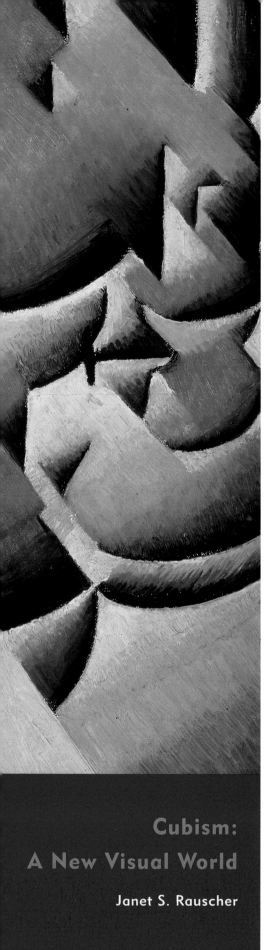

I N  T H E  E A R L Y  Y E A R S  O F  T H E  T W E N T I E T H  C E N T U R Y ,  avant-garde Parisian artists sought artistic styles as significant to modern audiences as the technical and social innovations blossoming in Europe and North America. Steeped in the progressive atmosphere that nurtured the women's and labor movements and protested the impending war, the artists who promoted Cubism were among those who wanted to adapt painting to address these changes.

Paris was ripe not only for social change; the visual world had changed significantly within the previous half-century. X-rays were discovered in the late nineteenth century, and in 1906 electric street lamps replaced gas lamps in Paris.[1] Printed public advertising was becoming more prolific. The railway system had expanded significantly and the automobile made seeing new places easier. Cubist painter Fernand Léger described his generation's understanding of their visual world: "The view through the door of the railroad car or the automobile windshield, in combination with the speed, has altered the habitual look of things. A modern man registers a hundred times more sensory impressions than an eighteenth-century artist."[2]

Many Cubists began their careers studying and working in the style of Impressionism. They regarded the Impressionists' rejection of conventional Salon subjects as the first leap in modernizing painting. Léger gave the Impressionists credit for having "liberated painting,"[3] and many of the Cubists appreciated Impressionist contributions to modern painting but felt that the era called for an artistic style that addressed the concerns of modern life.

In this search for a new artistic style, Pablo Picasso and Georges Braque developed Cubism. The structural quality of paintings by Paul Cézanne (fig. 1)—whose work was shown in several large exhibitions around his death in 1906—was their main source of inspiration, and they seem to have been looking at African art as well. Both influences can be seen in the differences between Picasso's *Portrait of a Woman* (cat. 68), painted around 1901, and his *Standing Nude* of 1907–1908 (cat. 69). The nude in the later work is as anonymous to us as the African masks Picasso saw exhibited in Paris around 1907. Because we view the figure from slightly below, she exudes a kind of power over the viewer that is not seen in the earlier portrait. Picasso's palette has changed, too; the earth tones and the composition of the nude figure as the sum of her geometric shapes reveal Cézanne's influence.

As they developed the first stages of Cubism, Picasso and Braque abandoned the traditional artistic aim of depicting objects as they appear at particular moments and in particular places. Instead, they sought to reveal what we know, tacitly, about objects by depicting them from different views and in different states in the same two-dimensional

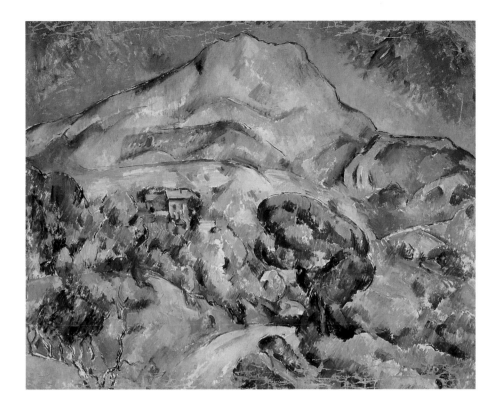

Fig. 1 Paul Cézanne, *Mont Sainte-Victoire, above the Tholonet Road*, 1900, oil on canvas, Hermitage, St. Petersburg, Russia.

picture plane. The effect of multiple perspectives was achieved by breaking objects into their elements and scattering these pieces throughout the work. Later, the Cubists would introduce collaged elements into their paintings. Because it demanded that viewers use their memories to aid their visual understanding, Cubist painting was the first manifestation of visual art that was conceptual as well as perceptual. Gone was the attempt to render objects three-dimensionally, a goal of Western painting since the Renaissance. The resulting paintings range from recognizable, if abstract, to utterly disorienting. Despite the geometricity of Cubist paintings, Cubism was not the art of painting in a series of cubes. Like Impressionism, Cubism gained its name through a less-than-positive review.

Thanks in large part to the efforts of painter Jean Metzinger, Cubist paintings were hung together in the 1911 Salon des Indépendants (the exhibition was usually hung alphabetically by artist). Generally, the popular and critical reactions to Cubist painting were not positive, but the movement did have its defenders, particularly the poets André Salmon and Guillaume Apollinaire. Many critics understood the Cubists' desire to make art relevant to their era and called for popular support of Cubism despite ambiguous, or even disdainful, responses to its aesthetics. Arthur Jerome Eddy, one such critic, published

an elegant text in defense of modern art. He argued: "It is the man who challenges and denies who stirs other men to *think for themselves.* That is the chief value of the cubist paintings—they compel us to *think for ourselves,* to take a careful inventory of our stock of stereotyped notions . . ." and "Personally I have no more interest in Cubism than in any other 'ism,' but failure to react to new impressions is a sure sign of age. I would hate to be so old that a new picture or a new idea would frighten me."[4]

Because Helene Kröller-Müller was interested in work that expressed the individual genius of each artist and captured the spirit of her era, she began collecting Cubist art in 1913 with a painting by Juan Gris (cat. 72).[5] In her collecting of Cubist painting, Mrs. Kröller-Müller's support of Fernand Léger was particularly noteworthy. In 1922 she visited his Paris studio with her adviser H. P. Bremmer. She later recalled the visit in a letter: "Nothing in Paris has made such an impression on me as his work, although I must honestly admit that in the first five minutes I stood looking at it in dismay. . . . I again have the pleasant feeling that I had to and did persuade the Prof. [Bremmer] to like it. Together with me he is now convinced; Léger is the 'coming man.' "[6]

Indeed, Léger's oeuvre was well developed by the time of Mrs. Kröller-Müller's visit. In his early work, Léger had mimicked Impressionist painting, but his belief that each artist should work "in accord with his epoch" soon drove him to abandon imitating work from an age he considered "melodious"[7] in favor of a style more reflective of the ways in which he experienced his own time, especially the years leading to and encompassing World War I. Unlike most of his Cubist colleagues—who frequently portrayed guitars

Fig. 2 Fernand Léger, *Nude Figures in a Wood,* 1909–1911, oil on canvas, Kröller-Müller Museum.

and mandolins, brandy and wine glasses, pipes, and reading glasses as their subjects—
Léger had little interest in the trappings of artistic culture and was proud to represent
the technical innovations of his modern age, subjects of interest, he felt, to society at
large. He did so using mechanical forms—often pipelike tubes—that recall the very
innovations his paintings celebrate.

Despite her initial aesthetic misgivings about Cubism, Mrs. Kröller-Müller must
have believed that Léger's stated goal of creating "an objective and unsentimental art
designed to satisfy an anonymous, collective society" was well aligned with her own
understanding of modern painting.[8] Between 1925 and 1926 she purchased several of
Léger's paintings, including one of his largest and most famous works, *Soldiers Playing
at Cards* (cat. 75) which was joined in her collection by another of his seminal works,
*Nude Figures in a Wood* (fig. 2). These canvases, which straddle World War I, demon-
strate a shift in the subject matter that Léger pursued following his time in the military.
Having witnessed the atrocities of the war alongside men from outside of his artistic
circle, Léger abandoned the relative tranquility of his pastoral woodcutters in favor of
soldiers whose limbs resemble glinting gun barrels. In its social relevance and unusual
rendering, this work achieves the early goals of Cubism.

## Notes

1. Mark Antliff and Patricia Leighten, *Cubism and
Culture* (London: Thames and Hudson, 2001),
explores Cubism as a response to social and
technological changes.

2. Fernand Léger, "Contemporary Achievements
in Painting," trans. Alexander Anderson, in
Charles Harrison and Paul Wood, eds., *Art in
Theory 1900–1990: An Anthology of Changing
Ideas* (Oxford: Blackwell, 1999), p. 157. Léger's
essay was first published in the journal *Soirées
de Paris* in 1914. Harrison and Wood excerpt
Anderson's translation from Fernand Léger, *The
Functions of Painting* (New York: Viking, 1973).

3. Léger, "Contemporary Achievements in
Painting," p. 158.

4. Arthur Jerome Eddy, *Cubists and Post-
Impressionism* (Chicago: A. C. McClurg & Co.,
1914), pp. 65, 5.

5. Johannes van der Wolk, "Kröller-Müller: One
Hundred Years," in R. W. D. Oxenaar, *Kröller-
Müller: The First Hundred Years,* trans. J. W. Watson
and L. J. M. Coleman-Schaafsma (Otterlo: Kröller-
Müller Foundation, 1988), p. 24.

6. Quoted in Van der Wolk, "Kröller-Müller:
One Hundred Years," p. 61.

7. Quoted in Werner Schmalenbach, *Fernand
Léger,* trans. Robert Allen with James Emmons
(New York: Harry N. Abrams, 1976), pp. 25, 10.

8. Quoted in Schmalenbach, *Fernand Léger,* p. 45.

6 8  PABLO PICASSO  *Portrait of a Woman* (*The Madrillenian*)  ca. 1901, oil on panel, 20½ × 13 inches

69 PABLO PICASSO *Standing Nude* 1907–1908, watercolor on paper, 24½ × 18 inches

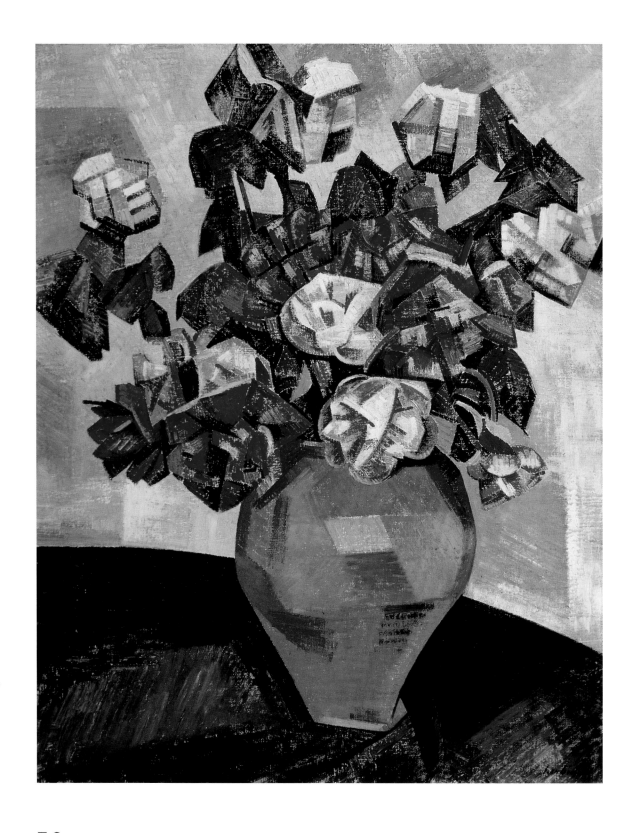

**70** Auguste Herbin *Roses* 1911, oil on canvas, 31½ × 25¼ inches

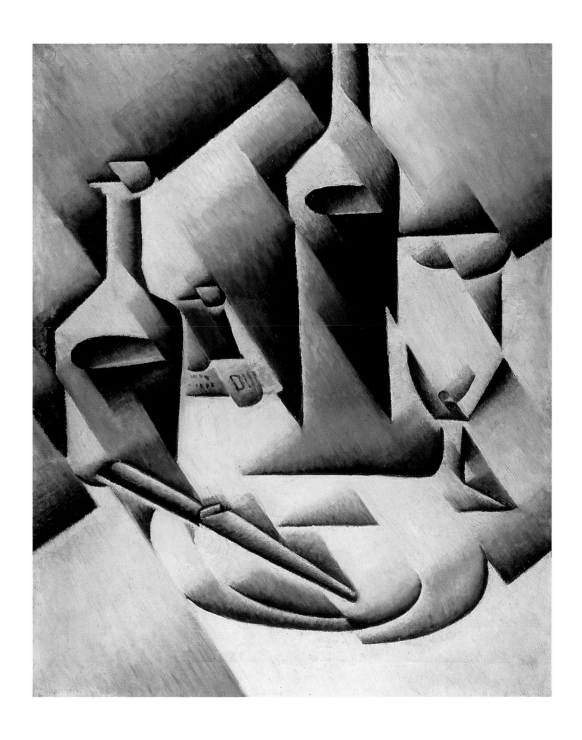

**71** JUAN GRIS *Bottles and Knife* 1912, oil on canvas, 21⅜ × 18 inches

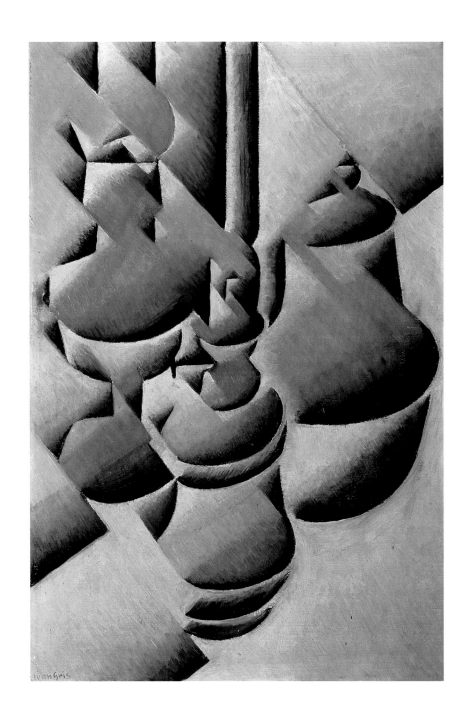

72  JUAN GRIS  *Still Life with Oil Lamp*  1912, oil on canvas, 19½ × 13⅜ inches

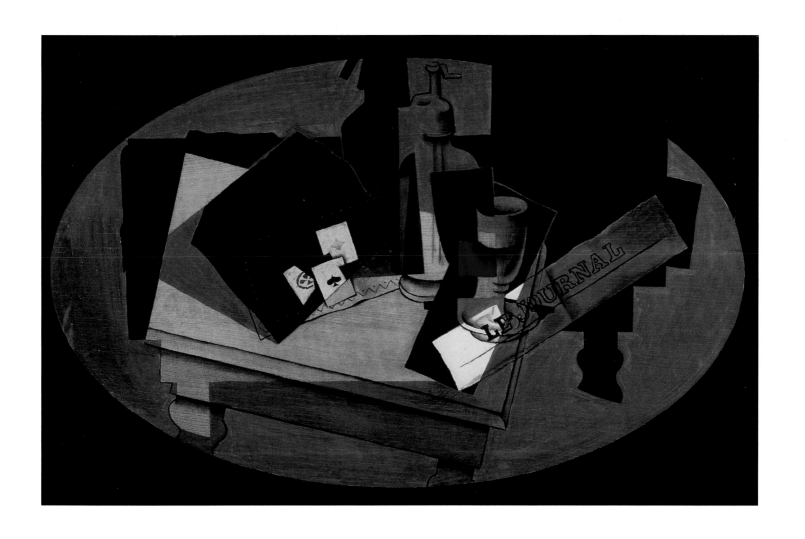

**73** JUAN GRIS *Playing Cards and Siphon* 1916, oil on panel, 28¾ × 46 inches

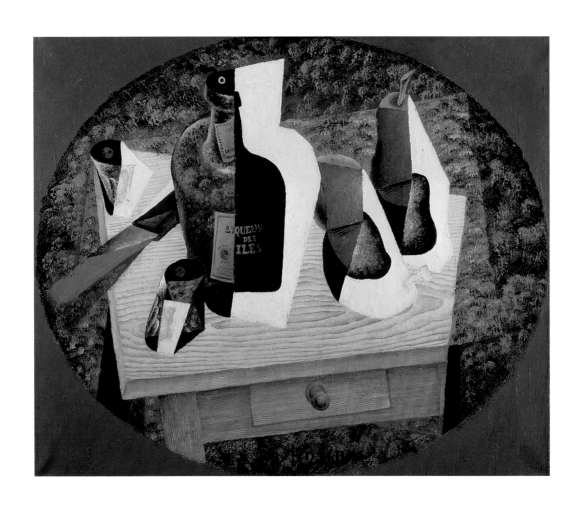

74　DIEGO RIVERA　*Still Life with a Liqueur Bottle*　1915, oil on canvas, 20 × 24 inches

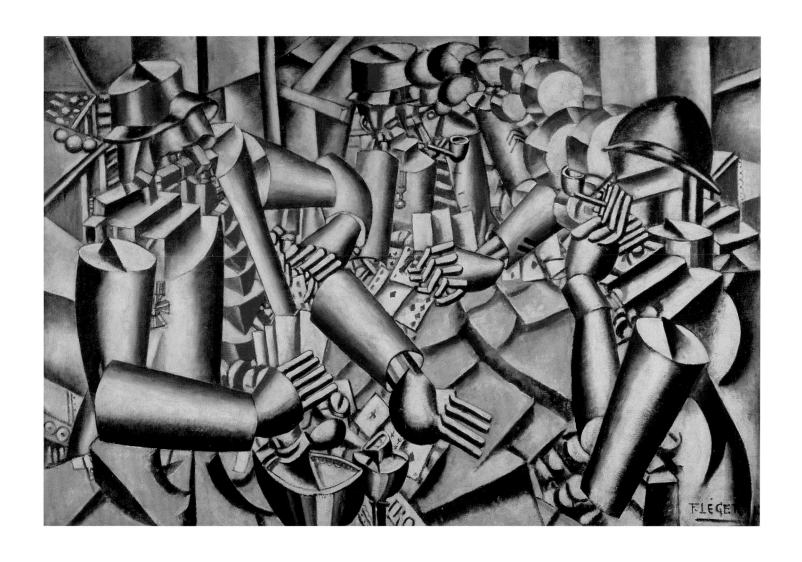

**75** FERNAND LÉGER *Soldiers Playing at Cards* 1917, oil on canvas, 50⅞ × 76½ inches

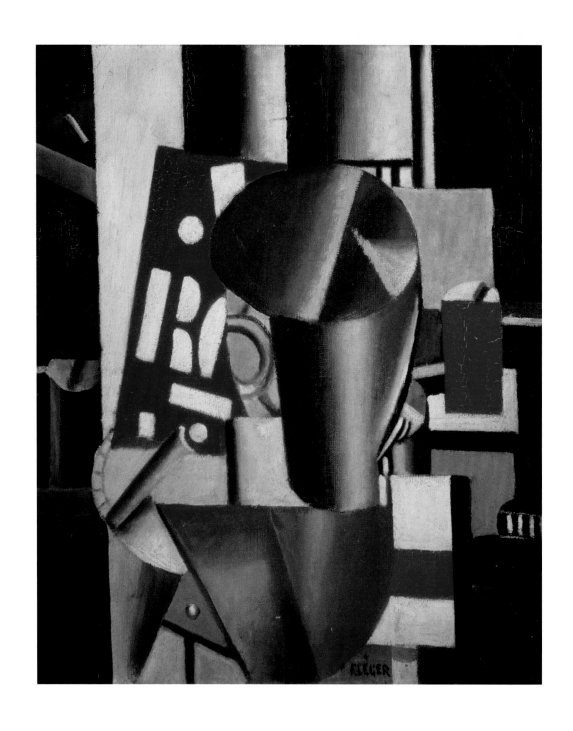

76 FERNAND LÉGER *The Typographer* 1919, oil on canvas, 21⅝ × 18 inches

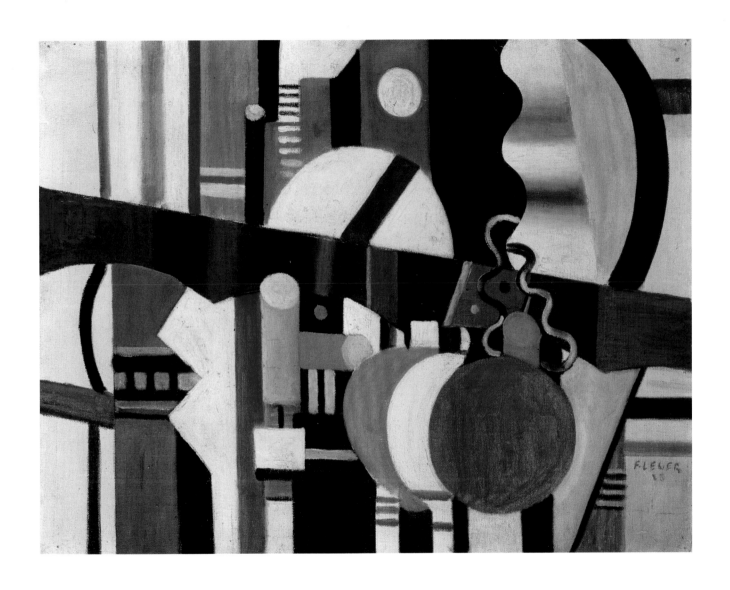

**77** FERNAND LÉGER *Mechanical Element* 1920, oil on canvas, 19¾ × 25½ inches

Piet Mondrian's
Turn from Cubism
to Neoplasticism

Marek Wieczorek

HELENE KRÖLLER-MÜLLER'S PATRONAGE helped to make possible one of the great episodes in the history of twentieth-century art: Piet Mondrian's pioneering turn to abstraction between 1915 and 1917. During this period, Mondrian was in dire financial straits, stranded for five years in his native Holland during World War I and scrambling to pay the rent for his apartment and studio in Paris by copying Old Masters at the Rijksmuseum. Through the mediation of the critic H. P. Bremmer, Mrs. Kröller-Müller acquired Mondrian's first abstract paintings and thus encouraged the artist to forge ahead with his pictorial innovations, despite increasing public disparagement. Mondrian would eventually become one of the giants of modernism.

The seven paintings on view in the exhibition span a period from 1913 to 1919 and reflect key moments in Mondrian's development toward the new pictorial style he would call "Neoplasticism" in 1917. The iconoclastic Dutchman rejected the "plasticity" or illusionistic spatial modeling of traditional painting and created a "new plasticity" or new kind of space. Neoplasticism came out of Mondrian's structural approach to Cubism, which he adapted to a more radically planar form, conceived as a step toward a future merger of painting with a utopian, "Neoplastic" environment—inspired in part by the writings of the esoteric nature philosopher Mathieu Schoenmaekers.[1] The paintings in this exhibition will be examined for their logical connections and innovative space, manifesting Mondrian's sense of discovery as he explored new territory. These works provide an exemplary introduction to Mondrian's abstraction, since they are visibly connected to their original motifs, including one subject here newly identified. Mrs. Kröller-Müller herself learned to appreciate such connections with the help of Bremmer, who introduced her to Mondrian's art and who was his main supporter during this important period.

## Beyond Passage

While working in Paris in 1912–1914, Mondrian transformed the Cubist idiom into a geometric plasticity and style uniquely his own. *Composition No. XI* (cat. 78) certainly owes much to Pablo Picasso and to the Post-Impressionist painter Paul Cézanne, an important precursor to Cubism. Cézanne had defined pictorial space through subtle color modulations and basic geometric shapes, achieving "passage" or the merging of slanted planes into pictorial structure (fig. 1). Picasso exaggerated this structure into a faceted form of plasticity, as in his early Cubist *Standing Nude* (cat. 69), but at the sacrifice of color. These artists taught Mondrian to organize space not through an imaginary, distant vanishing point, but through the point of an object that is closest to the viewer's eyes. Objects no longer lie in a concave expanse behind the picture plane, but on the surface, sometimes coming at us like a convex protrusion, as with most of Mondrian's works

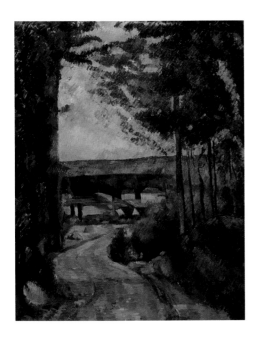

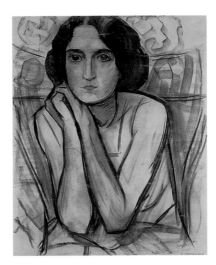

from 1912 through early 1917. *Composition No. XI* is based on a drawing of a seated woman (fig. 2), whose outlines are still recognizable in the painting. The figure protrudes, but to different effects. Mondrian adapted Picasso's and Cézanne's striated "constructive brush strokes," but his striations are mostly horizontal or slightly curved, and they are not attached to the outlines of the figure and thus no longer read as shadows or the illusion of shadowed edges that define the slanted and merging planes in Picasso's analytic Cubism.[2]

Mondrian's outlines are not only detached from the planes but also longer and more pronounced, suggesting space as a transparent, skeletal structure. In Holland, Cubism had been received as an extension of Symbolism, whereby lines and colors were seen as endowed with an expressive power of their own, and for Mondrian this meant the dissociation of line and color.[3] As poet-critic Guillaume Apollinaire recognized, Mondrian's Cubism is more abstract than Picasso's, who at that time was exploring matter.[4] We know from his sketchbook notes of 1912–1914 that Mondrian viewed matter through an esoteric lens, that he sought to look beyond, or rather, "through" surface appearances, at the forces underlying matter, forces that he thought should be expressed in painting through emphatic lines placed in various directions.[5] Because the planes between the lines are level and not shadowed, the lines in *Composition No. XI* form a kind of armature, making the figure protrude in a ghostly manner. The outlines of the figure are echoed in parallel lines or curves—notably the arms, shoulder, and elbow—which may explain Mondrian's

declared affinity with the idiosyncratic, curvilinear Cubism of Fernand Léger (see cat. 75).[6] In his sketchbooks, Mondrian noted that the individuality of portraiture "can never lead to universal beauty."[7] Henceforth, he began to de-individualize his motifs, which would become a hallmark of his mature work and writings in *De Stijl*, the journal of the eponymous group he co-founded in 1917.

## Figure/Ground Equivalence

With *Composition in Line and Color* (cat. 79), Mondrian took an important new step in his evolution toward Neoplasticism. Although the motif is no longer directly recognizable, it was important for structural reasons, for its predominance of verticals and horizontals. The outline of a group of trees reflected along a waterline (fig. 3) is still vaguely traceable, as is the light shining through the trees in a windowlike section of the painting just above the center.[8] In his sketchbooks, Mondrian associated the vertical lines of trees with the "male principle," and their counterpoint, the recumbent horizon, with the "female principle."[9] By de-individualizing the motif, he also followed Symbolism's dream of communicating directly through intuition, without resorting to particular symbols.[10] Symbolism came out of a strand of Post-Impressionism that attempted to cause the viewer to experience direct, involuntary sensations through the orientation of lines, as in Seurat's magnificent *Sunday at Port-en-Bessin* (cat. 24), in which the gentle mood

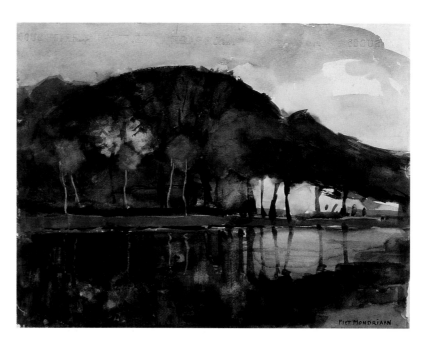

Fig. 3  Piet Mondrian, *Geinrust Farm with Saplings,*
1905–1906, watercolor on paper, Gemeentemuseum,
The Hague, S. B. Slijper Bequest.

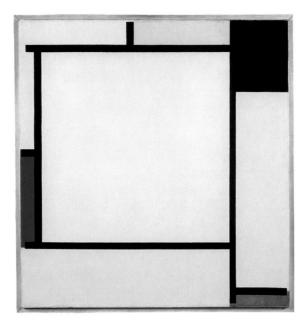

Fig. 4 Piet Mondrian, *Tableau 2*, 1922, oil on canvas, Solomon R. Guggenheim Museum, New York.

of a harbor scene on Sunday is supported by a delicate balance of upward and downward slanted lines and a subtle play of visually rhyming elements.[11] By transcending arcane symbolism, Mondrian's Cubist reworking of the motif results in a beautifully balanced asymmetry that breaks up the shoreline and staggers the orthogonals, portending the later Neoplastic paintings (fig. 4). There, the opposition between figure and background that normally causes us to see illusionistic space is abolished, both being "equivalent," in Mondrian's words. But in the 1913 *Composition in Line and Color,* this equivalence, despite Cubist convexity, is already partially achieved because the subtle interplay of colors triggers a dynamic spatial "pulsing," whereby color planes protrude or recede without sliding back in space diagonally.

## Movement in Repose

The optical dynamism of Mondrian's breakthrough paintings of 1915, 1916, and early 1917 (cat. 80, fig. 5, cat. 81) stems from his attempt to paint life itself, not in its outward appearance, but from the inside, as a creative force and expansive movement that acts from the inside outward. Following Schoenmaekers, Mondrian equated life with movement, but "the plastic expression of life, of movement" required ridding painting of individual or "particular movement."[12] "Neoplasticism requires a reality that expresses both the totality and the unity of things," Mondrian wrote, which meant seeing (and rendering) balance and repose in the totality of all movement, or its dialectical opposite,

movement in repose.[13] Herein lies the strength of the breakthrough paintings, in which Mondrian appealed to "the profound repose to which we inwardly aspire."[14]

While on a two-week trip to Holland in the summer of 1914, Mondrian was caught by surprise by the outbreak of the Great War, which prevented him from returning to his home in Paris until the summer of 1919. Thrown back upon his roots, he worked slowly, at first only producing about one abstract painting per year. But he initially found inspiration in the vastness and repose of the sea at Scheveningen and Domburg. One of the great masterpieces of early abstraction is his *Composition No. 10 (Pier and Ocean)* of 1915 (cat. 80). The composition is assumed to be based on a jetty or breakwater of wooden poles, visible in the longer verticals in the bottom center of the painting, which stretches into the sea at Domburg, here shown with a high horizon, indicated by a greater density of horizontal marks. However, as Carel Blotkamp convincingly argues, an early sketch that may be related to the series of studies for *Composition No. 10* shows similarities with the pier of Scheveningen—not a breakwater, but an amusement pier with a long promenade and large pavilion. Blotkamp thus suggests that the initial basis for these works could be an architectural motif, as was the case with earlier paintings of Paris façades and the next composition.[15] I will discuss below how architecture continued to play a crucial conceptual role in Mondrian's invention of Neoplasticism.

It is well known that Mondrian's next painting, *Composition 1916* (fig. 5), is based on the church of Domburg, as can be seen from its final extant charcoal study (fig. 6). Here, the church façade, recognizable by its Gothic windows and cross, is completely dissolved into a dynamic, transparent skeleton of vertical and horizontal forces. Both works show cubist convexity, but now vertically oriented, as opposed to the horizontal *Composition No. 10.* "In architecture the outward is an expression of the internal structure," Mondrian wrote, and the verticals and horizontals correspond to the forces to which all life on earth is subject.[16] But where architecture encloses and limits space, abstract painting is able to open space from the inside outward, thus expressing the "life force" of expansion through line, as Mondrian claimed.[17] Painting thus began to provide the necessary counterbalance, from the inside of the building outward. From 1917 onward, Mondrian's abstraction would shift from a linear to a planar model of expansion. In Neoplastic painting, "expansion is expressed by a (new) spatial expression," he wrote, "repose, by equilibrated movement."[18]

## From Line to Plane

*Composition in Black and White* of 1917 (cat. 81) is generally considered Mondrian's first truly abstract painting, but I propose that this work, as well as the abstract *Composition in Color A* and *Composition in Color B* (cat. 82), with which it was first shown as a triptych (fig. 7), are all based on a church motif.[19] I believe the façade of Notre Dame des Champs in Paris (fig. 8) provided the model for all three compositions. The format of this motif, with its lower elevation and its expansive rose window, allowed Mondrian to combine and cancel out the horizontal and vertical orientations of the two previous paintings into a

Fig. 7  Frits Hengebar, installation photograph of the exhibition *Hollandsche Kunstenaarskring*, Amsterdam, 1917, Theo van Doesburg Archive, Rijksbureau voor Kunsthistorische Documentatie, The Hague.

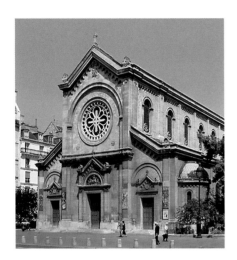

Fig. 8 Façade of Notre Dame des Champs on the Boulevard Montparnasse, Paris.

balanced, expansive, and spherical arrangement. In this case, there are fewer studies than in the other two series: one vague sketchbook sketch, an oil sketch based on it, another small loose sketch, and two beautiful larger abstract drawings (figs. 9, 10).[20] These two must have served as final studies or cartoons for the paintings, since, like the final drawing for *Composition No. 10,* they are exactly the same size as the canvases.[21] As in the other series, they demonstrate the beginnings of asymmetry, as can be seen from figure 9, which still shows the cross of the rose window and a section of its circular outline, but which breaks up the symmetry toward the periphery. As he did with *Composition No. 10,* Mondrian moved further toward asymmetry while working on the canvas, as can be seen from the first state of *Composition in Black and White,* which he had photographed in 1916, presumably because he thought it finished (fig. 11).[22] The final study for the painting (fig. 9) can therefore also be dated to 1916.

If these new identifications are correct, *Composition in Color A* and *Composition in Color B* are colored abstractions of a church motif, just like *Composition 1916,* but they are more pronounced in their separation of color and line.[23] This separation allowed Mondrian to accomplish an important shift in his abstract career: the shift from line to rectangular plane, which affected the transformation of the lines while he simultaneously worked on *Composition in Black and White* (from fig. 11 to cat. 81). Hence, what were rectangular relations that existed only *between* the lines (in cat. 80, figs. 5, 11), now have become rectangular relations between and *within* the lines themselves, which thus have become planes (more "interiorized" or "determined," in Mondrian's words—i.e., conceptually motivated). These planes have shed their rounded, "painterly" tips and engage in a more conceptual play of rectangular relations, not only "inwardly," amongst themselves, but also outwardly and expansively, in relation to the edge of the canvas. The shift from line (with rounded ends) to rectangular plane is best characterized as the shift from a painterly to a conceptual approach. The planes meet the edge unapologetically, without cubist blurring, and thus acknowledge their status as part of the canvas plane. This crucial moment in Mondrian's development signals that his works are ready to encounter, and ultimately merge with, the planes of architecture. "The function of architecture . . . is to enclose and limit," the artist wrote, "plastically, however, the rectangular plane is expansive in character," which is where painting (and color) can provide a counterpoint to the limiting wall planes of the interior.[24] Indeed, even the colors establish this outward connection. When the triptych was first exhibited (fig. 7), Mondrian was unhappy with the way the lighting affected the colors, as Van Doesburg also noted in a letter addressed to the artist. "I believe that my work should be made in the place where it is to hang," Mondrian remarkably wrote in reply, "and in direct relation to that environment."[25]

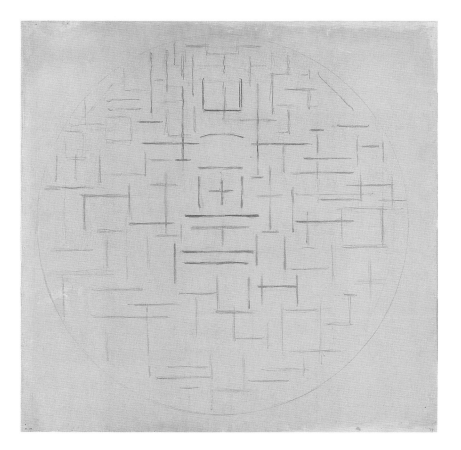

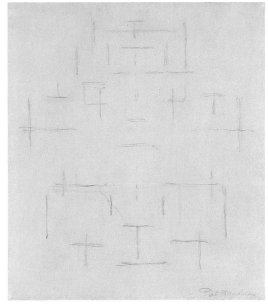

## Spiritual Edifice

The question of the role that Mondrian's motifs played has provoked a long and still on-going debate in art history. Commentators generally agree that once Mondrian started naming his works "Composition" in 1912, he was less concerned with the motif than with the general impression the work evoked in the viewer. The most famous example is a lecture by Bremmer, who said *Composition No. 10* evoked in him a "Christmas mood," which Mondrian approved of: "If one expresses the idea of Christmas in a really abstract way," he wrote to his patron, "one expresses peace, balance, predominance of the spiritual, etc."[26] Similarly, in a letter to Van Doesburg, he explained that the final study for *Composition 1916* (similar to fig. 6, but no longer extant) was "meant to express (abstractly) the idea of ascent, of greatness. The same idea which prevailed with the building of cathedrals, for instance. Because *only plasticity* must express this general idea, *not the representation,* I refrained from giving it a title. An *abstract* human mind will receive the intended impression as a matter of course. I always aim to express the universal—i.e., the interior (being closest to spirit)."[27]

Fig. 9   Piet Mondrian, *Composition in Circle (Church Façade?),* 1916(?), charcoal on paper, Private collection.

Fig. 10   Piet Mondrian, *Study for a Composition in Color,* 1916–1917, charcoal on paper, Sidney Janis Gallery, New York.

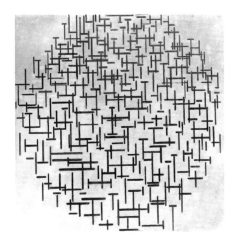

Fig. 11 Piet Mondrian, first state of *Composition in Black and White*, 1916.

These and similar letter fragments emphasize the by now familiar notion of the "interior," and establish a connection with "spirit" and "mind," which directly bear on the role architecture played in Mondrian's paintings from the summer of 1913 onward. When in Mondrian's view architecture responds to nature's forces, it is, as a man-made edifice, essentially an expression of *geest*, which means both "mind" and "spirit." Only the human mind sees "through" the inner workings of nature, or the structure of a building, and it is in this sense that we can understand Mondrian's comment that the "conscious recognition of relationships is connected with the spiritual."[28] In other words, Mondrian understood the old architecture as having intuitively been closest to the interior forces of nature, as having expressed these universal forces through upward-striving and vertical-horizontal relations.[29] In *Composition in Color B* (cat. 82), we experience this subtle upward dynamic, which, on closer inspection, was also already present in *Composition in Black and White* (cat. 81), also without a *particular* direction. The latter composition gives this uplifting sensation through the distribution of the black planes (with a lower density at the top), the two thin vertical strips of wood placed on either side of the frame, and even its original, elevated position as the central part of a triptych (fig. 7).

By 1917, once Mondrian introduced his "planar plasticity" in direct relation to the building in which the abstract painting was to be hung, he no longer was in need of motifs and often began to work "without a given in nature."[30] "Grandeur, gravity, and repose are fundamental and are not essentially tied to any particular appearance," he wrote.[31] In the phenomenal series of diamond paintings, of which Mrs. Kröller-Müller collected some of the earliest examples (cats. 83, 84), the artist introduced increasingly abstract ideas, such as the question of repetition and symmetry, which are aspects of nature that were to be avoided in Neoplasticism because they lead to stasis.[32] The diamond was a format that Mondrian pioneered for modern art in 1918. Despite this format, however, he would always hold onto the balance between verticals and horizontals, which aligns with architecture yet resists its static appearance. The diamond compositions also convey expansion, precisely because of their format. When the two forces—Neoplasticism's expansion and the limitation imposed by architecture's enclosure—finally balanced each other out, as Mondrian believed they would, a complete, utopian environment, the spiritual edifice of which he dreamed, would have come closer to realization.

## Notes

I would like to thank Carel Blotkamp for his valuable comments and extend thanks to Benjamin Binstock for his editorial help and guidance.

1. For a discussion of the complex etymology of the Dutch neologism *Nieuwe Beelding* (Neoplasticism), which was coined by Schoenmaekers, see Marek Wieczorek, *The Universe in the Living Room: Georges Vantongerloo in the Space of De Stijl—Het heelal in de huiskamer: Georges Vantongerloo en de Nieuwe Beelding van De Stijl* (Utrecht: Centraal Museum, 2002), pp. 82–86.

2. Picasso's most abstract "analytic" Cubism between 1910 and 1912 also employs small, isolated elements that function as signs, an element entirely lacking from Mondrian's approach. For the sign-function and excellent semiotic readings of Picasso's Cubist pictures, see Yve-Alain Bois, "The Semiology of Cubism," and Rosalind Krauss, "The Motivation of the Sign," in Lynn Zelevansky, ed., *Picasso and Braque: A Symposium* (New York: Museum of Modern Art, 1992), pp. 169–208 and 261–286.

3. For the reception of Cubism in Holland, see Jan van Adrichem, "The Introduction of Modern Art in Holland, Picasso as *Pars Pro Toto*, 1910–1930," *Simiolus* 21 (1992), pp. 162–211.

4. In his review of the 1912 Salon des Indépendants, Apollinaire described Mondrian's *Composition No. XI*: "His female portrait displays a sensitive cerebral quality. This kind of Cubism clearly follows a different path from that of Braque and Picasso, artists whose *'recherche de matière'* is presently arousing such interest." Guillaume Apollinaire, *Chroniques d'art 1902–1918*, ed. LeRoy C. Breunig (Paris: Gallimard, 1960), p. 378.

5. See Robert P. Welsh and Joop M. Joosten, *Two Mondrian Sketchbooks 1912–1914* (Amsterdam: Meulenhoff International, 1969), pp. 23, 39–40, 67–68.

6. In a letter from 1917 to Van Doesburg, Mondrian recalled his time in Paris from 1912 to 1914 and called Léger of all the Cubists "the most abstract, but in the curved line: actually quite strong." He made a little sketch of curved lines (more like brackets) that resemble the rhythm of curved lines in the Léger painting cited here. Theo van Doesburg Archives, Rijksbureau voor Kunsthistorische Documentatie, The Hague, letter 23, undated (datable late December 1917). Carel Blotkamp linked the curved lines of Mondrian's painting to his drawing by suggesting a relationship with the agitated, upward fanning charcoal lines and flowerlike forms surrounding the woman, which are reminiscent of the artist's earlier, esoteric preoccupations. Carel Blotkamp, *Mondrian: The Art of Destruction* (New York: Harry N. Abrams, 1994), pp. 64–66.

7. Welsh and Joosten, eds., *Two Mondrian Sketchbooks*, p. 28.

8. Joop Joosten first suggested the connection between the painting and a series of works on paper—*Geinrust Farm with High Horizon* (the farm is invisible behind the growth in the current example). He also believes *Composition in Line and Color* was reworked in the second quarter of 1914. Joop M. Joosten, *Piet Mondrian: Catalogue Raisonné of the Work of 1911–1944*, vol. 2 of Joop M. Joosten and Robert P. Welsh, *Piet Mondrian: Catalogue Raisonné* (New York: Harry N. Abrams, 1994), p. 227. Previously, this painting had been interpreted as based on a windmill, and various commentators saw the arms of the mill in what they perceived as a cruciform composition. Joosten mentioned in a personal communication with the author that the stretcher is marked with the word "mill" in Dutch, but that this stretcher originally belonged to the 1908 *Mill in Sunlight* (Gemeentemuseum, The Hague), which is the same size.

9. See Welsh and Joosten, eds., *Two Mondrian Sketchbooks*, pp. 16, 19–26. Mondrian takes the opposition from Schoenmaekers's writings, as noted by Yve-Alain Bois, "The Iconoclast," in *Piet Mondrian, 1872–1944*, eds. Yve-Alain Bois et al. (Milan: Leonardo Arte in association with the Gemeentemuseum, the National Gallery of Art, and the Museum of Modern Art, 1994), p. 333.

10. Mondrian's notion of "intuition" is derived from the concept of *Anschauung* in German idealism, which also retains the sense of visual contemplation. For an approach to Symbolism that looks at "the substance of words and of colours itself" as "the starting point for constructing new imaginary spaces," see Dee Reynolds, "Between the Lines: Form and Transformation in Mondrian," in *Symbolist Aesthetics and Early Abstract Art: Sites of Imaginary Space* (Cambridge: Cambridge University Press, 1995), pp. 153–194.

11. Seurat was influenced by the Dutch polymath D. P. G. Humbert de Superville, whose new formal language or "grammar" of signs for the modern world was based on "unconditional" lines, which in art express everything from uplifting feelings (e.g., upward-slanting lines in physiognomy) to larger cosmological forces. See Barbara Maria Stafford, *Symbol and Myth: Humbert de Superville's Essay on Absolute Signs in Art* (Cranbury, N.J.: Associated University Press, 1979). Mondrian likely encountered Humbert's ideas at the academy, or via his interpreter Charles Blanc's *Grammaire des Arts du dessin* (1867), which was widely used in art academies by the late nineteenth century. See Herbert Henkels, "Mondrian in His Studio," in *Mondrian: From Figuration to Abstraction* (Tokyo: The Tokyo Shimbun, 1987), p. 173. See also Carel Blotkamp, *Mondriaan in detail* (Utrecht: Veen-Reflex, 1987).

12. Piet Mondrian, "Dialogue on the New Plastic" (1919), in Piet Mondrian, *The New Art—The New Life: The Collected Writings of Piet Mondrian*, ed. and trans. Harry Holtzman and Martin S. James (New York: Da Capo Press, 1993), p. 79. Holtzman and James mostly use the idiosyncratic translation "New Plastic" for *Nieuwe Beelding*.

13. Mondrian, "The Manifestation of Neo-Plasticism in Music and the Italian Futurists' *Bruiteurs*" (1921), in *The New Art*, p. 150. About repose Mondrian wrote: "It is movement in pure equilibrated relationship that expresses repose." See his "Natural Reality and Abstract Reality: A Trialogue (While Strolling from the Country to the City)" (1919–1920), in *The New Art*, p. 117. See also, "The New Plastic in Painting" (1917), in *The New Art*, p. 46, note b.

14. Mondrian, "Natural Reality and Abstract Reality," p. 88.

15. Apparently, Mondrian told both Alfred Barr and László Moholy-Nagy that the final study for the painting was based on the Scheveningen pier. Blotkamp, *Mondrian*, pp. 85–87. I have elaborated on this connection and shown in detail how all six abstract drawings relate to the Scheveningen pier and the final painting in Marek Wieczorek, *Space and Evolution in Piet Mondrian's Early Abstract Paintings* (Ann Arbor: UMI Press, 1997), pp. 83–94.

16. Mondrian, "Natural Reality and Abstract Reality," p. 101.

17. The term "life force," which Mondrian borrowed from Schoenmaekers, appears in direct relation to "plastic" expression in line: "Line must be open and straight in order to express expansion determinately....When it is, then it radiates the life force." Mondrian, "Natural Reality and Abstract Reality," pp. 118–119.

18. Mondrian, "The New Plastic in Painting," p. 47.

19. Joop Joosten identified *Composition in Black and White* as the first "non-objective" painting. See Joop Joosten, "Piet Mondrian: Abstraction and Compositional Innovation," *Artforum* 11 (April 1973), p. 56. See also Bois, "The Iconoclast," p. 340. Some commentators have associated the painting with *Composition No. 10* from 1915 on formal grounds, but to my knowledge Els Hoek is the only scholar who made the connection explicit: "Mondrian left the pier outside

the picture and depicted only the water's surface (which blends into the sky at the horizon)." Els Hoek, "Piet Mondrian," in *De Stijl: The Formative Years, 1917–1922*, ed. C. Blotkamp, trans. Charlotte I. Loeb and Arthur L. Loeb (Cambridge: MIT Press, 1986), p. 50.

20. The earliest sketch has almost disappeared underneath Mondrian's handwriting in his sketchbook. See Welsh and Joosten, eds., *Two Mondrian Sketchbooks*, p. 67. The oil sketch on cardboard and the loose sketch, torn off at the spine, are documented in Joosten, *Piet Mondrian: Catalogue Raisonné*, pp. 239–240, 448–449. There are also two sketchbook sketches of the side portal. See Welsh and Joosten, eds., *Two Mondrian Sketchbooks*, p. 83.

21. Joosten, *Piet Mondrian: Catalogue Raisonné*, p. 260, mentions the fact that the drawing is the same size as these paintings, but assumes it was a study for other works that are no longer extant, and he does not draw the connection between Notre Dame des Champs and the drawing or the paintings. That connection was drawn, albeit tentatively and in passing, by Robert Welsh in 1973, but he made no attempt at specific identifications. Robert Welsh, "The Birth of De Stijl, Part I: Piet Mondrian, The Subject Matter of Abstraction," *Artforum* 11 (April 1973), p. 53.

22. All four large studies for *Composition No. 10* (cat. 80) were almost strictly symmetrical; the composition became asymmetrical only once Mondrian began working on canvas. It is known that Mondrian reworked *Composition in Black and White* for a long time, as can be seen from its cracked surface, about which the artist complained.

23. This observation is corroborated by the fact that Mondrian initially had wanted to add color to *Composition No. 10*. The identification of the motif of Notre Dame also means that Mondrian found a solution for his desire to privilege the vertical over the horizontal while still maintaining an overall balance between the two. He thereby

eliminated what he now considered "too much of a particular direction, a particular 'elevation'" for the Domburg studies (fig. 7). Letter to Bremmer, 15 July 1916, cited in Joosten, *Piet Mondrian: Catalogue Raisonné*, p. 255.

24. Mondrian, "Natural Reality and Abstract Reality," p. 110.

25. Letter to Van Doesburg, 16 May 1917, Theo van Doesburg Archive. The comment explains partly why Mondrian used muted colors—i.e., no full-fledged primaries yet—until 1920, even though he had written about them since 1917.

26. Joosten, *Piet Mondrian: Catalogue Raisonné*, p. 251.

27. Van Doesburg Archives, letter 1, undated (datable before 26 October 1915).

28. Mondrian, "The New Plastic in Painting," p. 37. This view, which sees the mind and understanding as part of a larger "world-spirit," derives from the German Idealist philosopher G. W. F. Hegel. Mondrian cites the Dutch popularizer of Hegel, Gerard Bolland, to whom Schoenmaekers is also indebted.

29. See Mondrian, "The New Plastic in Painting," p. 72.

30. Mondrian, "The New Plastic in Painting," p. 72, note u; and letter to Van Doesburg (74), April 18, 1919, Theo van Doesburg Archives.

31. Mondrian, "Natural Reality and Abstract Reality," p. 103.

32. As Bois demonstrated, Mondrian confronted and temporarily embraced repetition in these works by introducing modularity, which ultimately allowed him to move away from repetition. Bois, "The Iconoclast," pp. 320–324. As Mondrian would write in 1930, "equilibrium through equivalence excludes similarity and symmetry, just as it excludes repose in the sense of immobility." Mondrian, "Realist and Superrealist Art (Morphoplastic and Neo-Plastic)" (1930), in *The New Art*, p. 229.

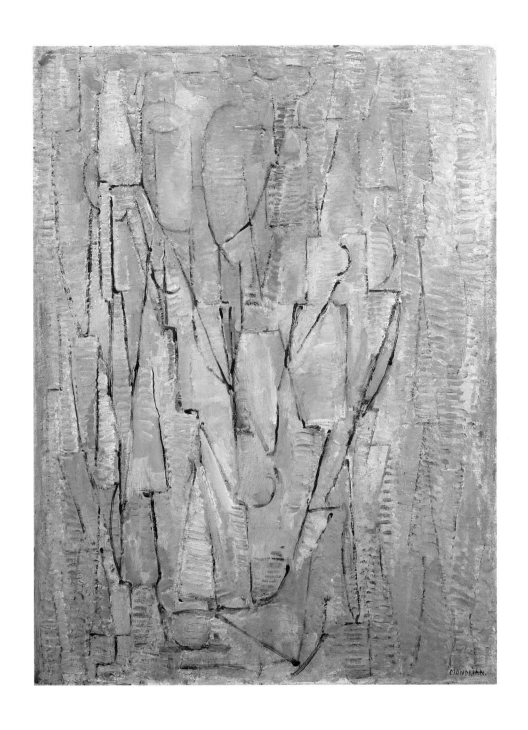

78  PIET MONDRIAN  *Composition No. XI*  1913, oil on canvas, 29¾ × 22½ inches

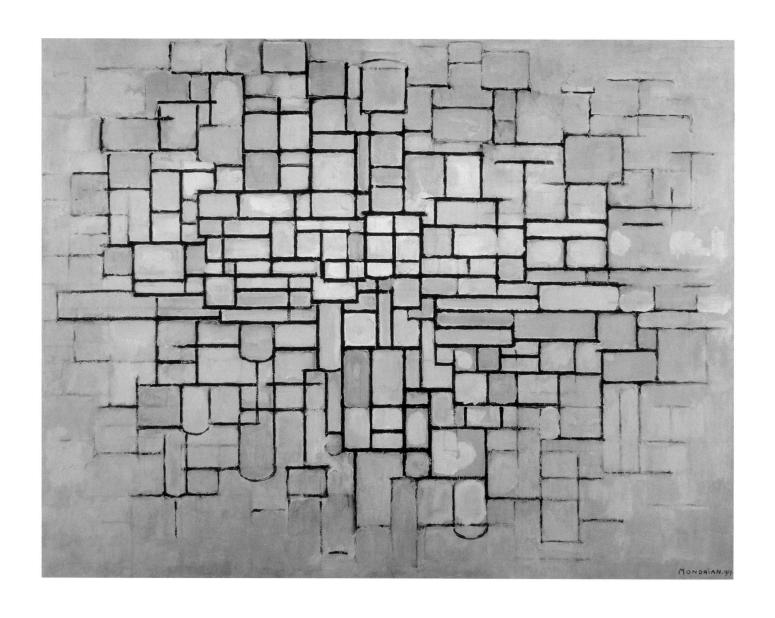

79 PIET MONDRIAN  *Composition in Line and Color*  1913, oil on canvas, 34¾ × 45¼ inches

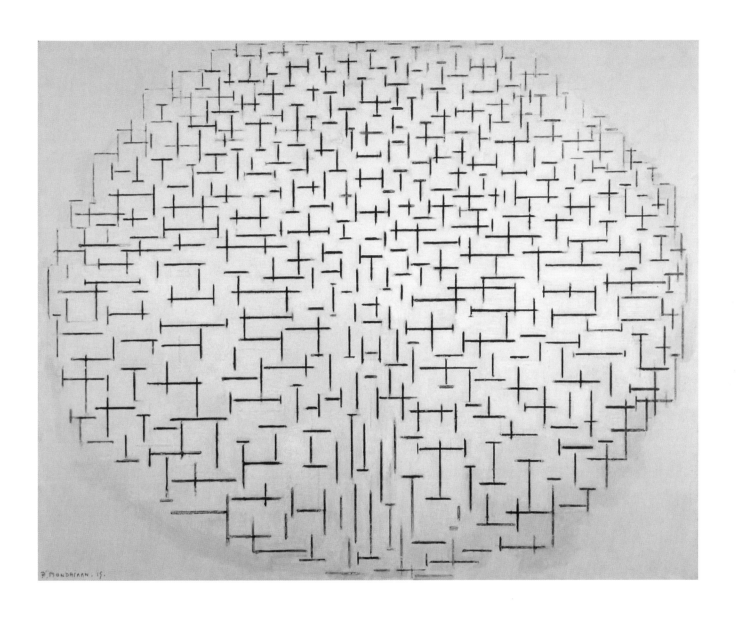

80 PIET MONDRIAN  *Composition No. 10 (Pier and Ocean)* 1915, oil on canvas, 33¾ × 42½ inches

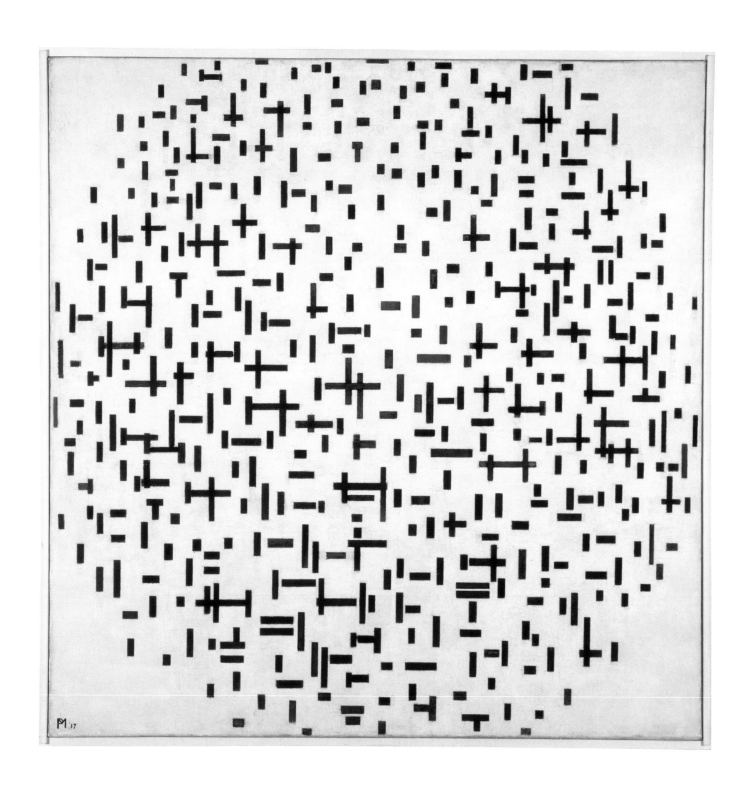

81  PIET MONDRIAN  *Composition in Black and White*  1917, oil on canvas, 42½ × 42½ inches

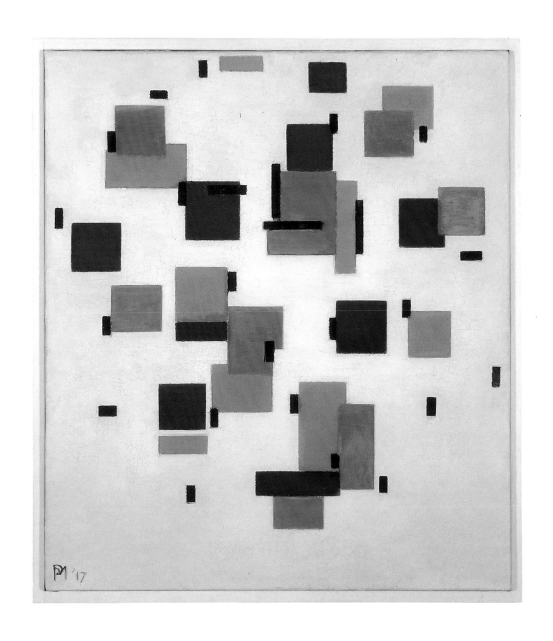

82 PIET MONDRIAN *Composition in Color B* 1917, oil on canvas, 19⅞ × 17¾ inches

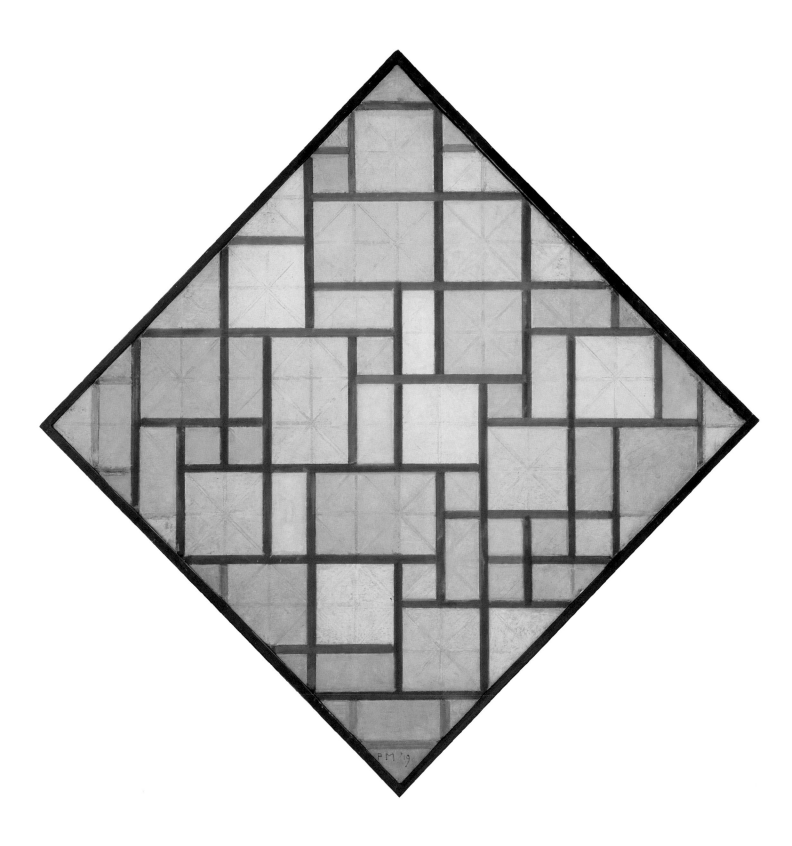

83 PIET MONDRIAN *Composition in Diamond Shape* 1919, oil on canvas, 24¾ × 24¾ inches

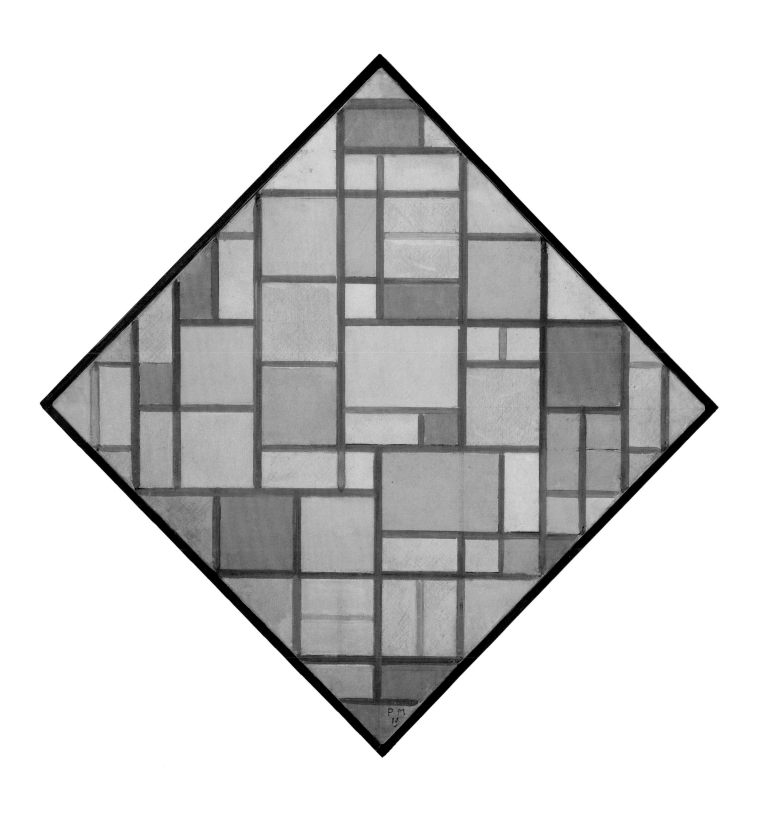

84 PIET MONDRIAN *Composition in Diamond Shape* 1919, oil on canvas, 19¼ × 19¼ inches

# Checklist of the Exhibition

H. P. BERLAGE (1856–1934)
*Sketch of Museum on the Franse Berg I,*
*South Perspective,* 1917
Pencil on paper
18¾ × 29⅜ inches
KM 109.650
CAT. 52

H. P. BERLAGE
*Hall of Museum on the Franse Berg I,* 1918
Watercolor on paper
19⅝ × 19⅝ inches
KM 107.252
CAT. 56

H. P. BERLAGE
*Sketch of Museum on the Franse Berg I,*
*Sculpture Court,* 1917
Pencil on paper on cardboard
18¾ × 29⅛ inches
KM 114.388
CAT. 57

H. P. BERLAGE
*Design for St. Hubertus Hunting Lodge,* 1916
Color pencil on paper
55½ × 80½ inches
KM 108.325
CAT. 60

H. P. BERLAGE
*Design for St. Hubertus Hunting Lodge,* 1916
Color pencil on paper
56¼ × 81⅝ inches
KM 100.071
CAT. 61

H. P. BERLAGE
*Sitting Room of the Master of St. Hubertus*
*Hunting Lodge,* 1917
Color pencil on paper
15¾ × 19¼ inches
KM 101.009
CAT. 62

H. P. BERLAGE
*Sitting Room of the Mistress of St. Hubertus*
*Hunting Lodge,* 1917
Color pencil on paper
15¾ × 19¼ inches
KM 110.098
CAT. 63

H. P. BERLAGE
*Sideboard from "Villa Henny Suite,"* ca. 1898
Teak with carving
80½ × 79½ × 33½ inches
KM 123.707
CAT. 64

H. P. BERLAGE
*Chest,* 1915
Oak with inlaid ebony
34¼ × 73 × 23⅝ inches
KM 125.408
CAT. 65

H. P. BERLAGE
*Chair from "Art Room Suite,"* 1915
Coromandel wood with original upholstery
35⅝ × 19⅞ × 24½ inches
KM 122.526
CAT. 66

H. P. BERLAGE
*Round Table from "Art Room Suite,"* 1917
Teak
29⅛ × 49¼ × 49¼ inches
KM 119.093
CAT. 67

H. P. BREMMER (1871–1956)
*Fir Trees (Harskamp),* 1912
Oil on canvas
9½ × 19 inches
KM 106.468
CAT. 32

MAURICE DENIS (1870–1943)
*April,* 1892
Oil on canvas
14¾ × 24 inches
KM 100.972
CAT. 38

MAURICE DENIS
*Harvest,* 1898
Oil on cardboard
39⅜ × 29½ inches
KM 107.485
CAT. 39

THEO VAN DOESBURG (1883–1931)

*Composition I (Still Life),* 1916
Oil on canvas
26⅜ × 25 inches
KM 106.123
CAT. 42

HENRI FANTIN-LATOUR (1836–1904)

*Portrait of Mlle Eva Callimaki Cartagi,* 1881
Oil on canvas
51½ × 38½ inches
KM 111.231
CAT. 33

HENRI FANTIN-LATOUR

*Still Life with Pot of Primroses,* 1866
Oil on canvas
28¾ × 22¾ inches
KM 100.774
CAT. 34

HENRI FANTIN-LATOUR

*Still Life with Peaches,* 1904
Oil on canvas
7¾ × 11¾ inches
KM 107.338
CAT. 35

VINCENT VAN GOGH (1853–1890)

*Loom with Weaver,* 1884
Oil on canvas
26⅞ × 33⅛ inches
KM 107.755
CAT. 1

VINCENT VAN GOGH

*Self-Portrait,* 1887
Oil on cardboard
12⅞ × 9½ inches
KM 105.833
CAT. 2

VINCENT VAN GOGH

*Café Terrace at Night (Place du Forum),* 1888
Oil on canvas
31¾ × 25⅝ inches
KM 108.565
CAT. 3 AND COVER

VINCENT VAN GOGH

*Olive Grove,* 1889
Oil on canvas
28½ × 36⅛ inches
KM 104.278
CAT. 4

VINCENT VAN GOGH

*La Berceuse (Portrait of Madame Roulin),* 1889
Oil on canvas
35¾ × 28⅜ inches
KM 109.725
CAT. 5

VINCENT VAN GOGH

*Portrait of Joseph Roulin,* 1889
Oil on canvas
25½ × 21¼ inches
KM 103.101
CAT. 6

VINCENT VAN GOGH

*The Garden of the Asylum at Saint-Rémy,* 1889
Oil on canvas
36 × 28¼ inches
KM 101.508
CAT. 7

VINCENT VAN GOGH

*Pine Trees at Sunset,* 1889
Oil on canvas
36 × 28¼ inches
KM 102.808
CAT. 8

VINCENT VAN GOGH

*Still Life with a Plate of Onions,* 1889
Oil on canvas
19½ × 25¼ inches
KM 111.075
CAT. 9

VINCENT VAN GOGH

*Sorrowing Old Man ("At Eternity's Gate"),* 1890
Oil on canvas
32⅛ × 25¾ inches
KM 111.041
CAT. 10

VINCENT VAN GOGH

*Tree Trunks in the Grass,* 1890
Oil on canvas
28½ × 36 inches
KM 100.189
CAT. 11

VINCENT VAN GOGH

*The Good Samaritan (after Delacroix),* 1890
Oil on canvas
28¾ × 23½ inches
KM 104.010
CAT. 12

VINCENT VAN GOGH

*Corner of a Garden,* 1881
Ink, chalk, and pencil on paper
17½ × 22¼ inches
KM 115.487
CAT. 13

VINCENT VAN GOGH

*Windmills at Dordrecht,* 1881
Chalk, pencil, and watercolor on paper
10¼ × 23⅝ inches
KM 126.249
CAT. 14

VINCENT VAN GOGH

*Young Man with Sickle,* 1881
Chalk and watercolor on paper
18½ × 24 inches
KM 111.847
CAT. 15

VINCENT VAN GOGH

*Behind the Schenkweg,* 1881–1883
Ink, pencil, and paint on paper
7½ × 13⅛ inches
KM 113.904
CAT. 16

VINCENT VAN GOGH

*Woman Praying,* 1881–1883
Ink, chalk, and watercolor on paper
17 × 11¼ inches
KM 125.556
CAT. 17

VINCENT VAN GOGH

*Carpenter's Yard and Laundry,* 1882
Chalk and watercolor on paper
11¼ × 18½ inches
KM 116.039
CAT. 18

VINCENT VAN GOGH

*In the Old Town (The Paddemoes),* 1882
Ink and pencil on paper
9⅞ × 12⅛ inches
KM 118.997
CAT. 19

VINCENT VAN GOGH

*Cemetery in the Rain,* 1886
Ink and paint on paper
14⅜ × 18⅞ inches
KM 123.588
CAT. 20

VINCENT VAN GOGH

*Cypresses,* 1889
Ink and chalk on paper
12⅛ × 9 inches
KM 115.638
CAT. 21

VINCENT VAN GOGH

*Wheat Field with Sun and Clouds,* 1889
Ink, charcoal, and chalk on paper
18¾ × 22¼ inches
KM 125.482
CAT. 22

JUAN GRIS (1887–1927)

*Bottles and Knife,* 1912
Oil on canvas
21⅜ × 18 inches
KM 105.470
CAT. 71

JUAN GRIS

*Still Life with Oil Lamp,* 1912
Oil on canvas
19½ × 13⅜ inches
KM 106.242
CAT. 72

JUAN GRIS

*Playing Cards and Siphon*, 1916
Oil on panel
28¾ × 46 inches
KM 102.219
CAT. 73

AUGUSTE HERBIN (1882–1960)

*Roses*, 1911
Oil on canvas
31½ × 25¼ inches
KM 108.656
CAT. 70

BART VAN DER LECK (1876–1958)

*Mining Industry*, 1916
Leaded glass
145½ × 82½ inches
KM 126.621
CAT. 43

BART VAN DER LECK

*Batavier Line*, 1916
Lithograph
30½ × 45 inches
KM 121.068
CAT. 44

BART VAN DER LECK

*Color Study for Mrs. Kröller-Müller's Art Room,*
1916–1917
Gouache on paper
27½ × 30¼ inches
KM 111.320
CAT. 45

BART VAN DER LECK

*Composition 1916 no. 4 (study)*, 1916
Gouache on paper
47½ × 49 inches
KM 111.346
CAT. 46

BART VAN DER LECK

*Composition 1916 no. 4 (study)*, 1916
Gouache on paper
49⅝ × 48¼ inches
KM 113.271
CAT. 47

BART VAN DER LECK

*Composition 1917 no. 4 (Leaving the Factory)*, 1917
Oil on canvas
37½ × 40¼ inches
KM 100.312
CAT. 48

BART VAN DER LECK

*Composition 1918 no. 4 (Design for Carpet)*, 1918
Oil on canvas
22 × 18 inches
KM 102.341
CAT. 49

BART VAN DER LECK

*Still Life with a Wine Bottle*, 1922
Oil on canvas
15¾ × 12¾ inches
KM 111.211
CAT. 50

FERNAND LÉGER (1881–1955)

*Soldiers Playing at Cards*, 1917
Oil on canvas
50⅞ × 76½ inches
KM 101.351
CAT. 75

FERNAND LÉGER

*The Typographer*, 1919
Oil on canvas
21⅝ × 18 inches
KM 110.217
CAT. 76

FERNAND LÉGER

*Mechanical Element*, 1920
Oil on canvas
19¾ × 25½ inches
KM 105.418
CAT. 77

LUDWIG MIES VAN DER ROHE (1886–1969)

*Ellenwoude House in Wassenaar*, 1912
Pastel and watercolor on print
17⅞ × 55¾ inches
KM 104.706
CAT. 51

PIET MONDRIAN (1872–1944)

*Composition No. XI,* 1913
Oil on canvas
29¾ × 22½ inches
KM 103.263
CAT. 78

PIET MONDRIAN

*Composition in Line and Color,* 1913
Oil on canvas
34¾ × 45¼ inches
KM 108.406
CAT. 79

PIET MONDRIAN

*Composition No. 10 (Pier and Ocean),* 1915
Oil on canvas
33¾ × 42½ inches
KM 104.241
CAT. 80 AND BACK COVER

PIET MONDRIAN

*Composition in Black and White,* 1917
Oil on canvas
42½ × 42½ inches
KM 106.482
CAT. 81

PIET MONDRIAN

*Composition in Color B,* 1917
Oil on canvas
19⅞ × 17¾ inches
KM 101.144
CAT. 82

PIET MONDRIAN

*Composition in Diamond Shape,* 1919
Oil on canvas
24¾ × 24¾ inches
KM 103.029
CAT. 83

PIET MONDRIAN

*Composition in Diamond Shape,* 1919
Oil on canvas
19¼ × 19¼ inches
KM 101.062
CAT. 84

PABLO PICASSO (1881–1973)

*Portrait of a Woman (The Madrillenian),* ca. 1901
Oil on panel
20½ × 13 inches
KM 108.153
CAT. 68

PABLO PICASSO

*Standing Nude,* 1907–1908
Watercolor on paper
24½ × 18 inches
KM 104.812
CAT. 69

JOHAN THORN PRIKKER (1868–1932)

*The Bride,* 1892–1893
Oil on canvas
58 × 34⅝ inches
KM 100.945
CAT. 37

ODILON REDON (1840–1916)

*Oannès,* ca. 1900–1910
Oil on canvas
25 × 20 inches
KM 109.934
CAT. 40

ODILON REDON

*The Cyclops,* ca. 1914
Oil on cardboard mounted on panel
26 × 20¾ inches
KM 103.098
CAT. 41

DIEGO RIVERA (1886–1957)

*Still Life with a Liqueur Bottle,* 1915
Oil on canvas
20 × 24 inches
KM 100.848
CAT. 74

THÉO VAN RYSSELBERGHE (1862–1926)

*A Family Gathering in an Orchard,* 1890
Oil on canvas
45½ × 64¼ inches
KM 108.370
CAT. 28

THÉO VAN RYSSELBERGHE

*Fir Trees near St. Clair,* 1917
Oil on canvas
28¾ × 45¾ inches
KM 100.878
CAT. 31

GEORGES SEURAT (1859–1891)

*Sunday at Port-en-Bessin,* 1888
Oil on canvas
26 × 32¼ inches
KM 106.269
CAT. 24

PAUL SIGNAC (1863–1935)

*Breakfast,* 1886–1887
Oil on canvas
35¼ × 45⅞ inches
KM 106.849
CAT. 23

PAUL SIGNAC

*View of Collioure,* 1887
Oil on canvas
13 × 18 inches
KM 109.889
CAT. 25

PAUL SIGNAC

*The Jetty of Portrieux,* 1888
Oil on canvas
18 × 25½ inches
KM 108.323
CAT. 26

JAN TOOROP (1858–1928)

*The Connoisseur of Prints (Portrait of Dr. Aegidius
Timmerman),* 1900
Oil on canvas
26⅛ × 29⅞ inches
KM 105.338
CAT. 27

JAN TOOROP

*In the Dunes,* 1903
Oil on canvas
21⅞ × 24 inches
KM 100.931
CAT. 29

JAN TOOROP

*The Three Brides,* 1892–1893
Pencil and black and colored chalk on paper
30¾ × 38½ inches
KM 104.449
CAT. 36

HENRY VAN DE VELDE (1863–1957)

*Twilight,* ca. 1889
Oil on canvas
17¾ × 23⅝ inches
KM 106.502
CAT. 30

HENRY VAN DE VELDE

*Museum on the Franse Berg II, Gallery,* ca. 1925
Pencil on paper
23 × 26⅜ inches
KM 110.459
CAT. 53

HENRY VAN DE VELDE

*Museum on the Franse Berg II, Perspective View,*
ca. 1925
Ink on paper
21⅝ × 30½ inches
KM 102.046
CAT. 54

HENRY VAN DE VELDE

*Design for Museum on the Franse Berg II,
Perspective View,* 1923–1926
Color pencil on paper
24 × 76⅛ inches
KM 101.561
CAT. 55

HENRY VAN DE VELDE

*Color Study of Stairwell of Museum on the
Franse Berg II,* ca. 1925
Color pencil on paper
32⅞ × 41⅛ inches
KM 110.110
CAT. 58

HENRY VAN DE VELDE

*Design for Museum on the Franse Berg II,
Interior View,* ca. 1925
Color pencil on paper
26⅛ × 36⅜ inches
KM 103.700
CAT. 59

# Notes on Contributors

DAVID A. BRENNEMAN has been the Frances B. Bunzl Family Curator of European Art at the High Museum of Art since 1995 and Chief Curator since 2001. He has organized numerous exhibitions, including *Toulouse-Lautrec: Posters and Prints, Monet & Bazille, Degas & America, Monet: A View from the River,* and *Paris in the Age of Impressionism.* Before coming to the High, he was Assistant Curator of Paintings at the Yale Center for British Art in New Haven, Connecticut, where he specialized in eighteenth- and early nineteenth-century paintings.

STEPHEN HARRISON is the Curator of Decorative Arts at the High Museum of Art, where he has recently completed a reinstallation of the renowned Crawford Collection of American Decorative Arts. Harrison was the co-curator and author with Charles Venable of the *China and Glass in America, 1880–1980* exhibition that chronicled dining in the twentieth century, organized by the Dallas Museum of Art. Harrison has held academic appointments at Southern Methodist University and the University of North Texas and lectures often on the history of design and interior decoration. He is also a regular contributor to *Better Homes and Gardens.*

PIET DE JONGE is the Head of Collection and Presentation at the Kröller-Müller Museum. He has organized several exhibitions at the Museum, including *Helene and Vincent,* which focussed upon Helene Kröller-Müller's extensive Vincent van Gogh collection. He has been the curator for numerous exhibitions of modern and contemporary artists such as Hermann Nitsch, Arnulf Rainer, Günther Brus, Nicola de Maria, Imi Knoebel, and Per Kirkeby. De Jonge has also organized several large group exhibitions, the most recent of which was *In the Rough* for the Museu Serralves in Porto. He is currently conducting research for a biography of Helene Kröller-Müller.

JANET S. RAUSCHER is an M.A. student in the history of art at the Henry Radford Hope School of Fine Arts at Indiana University; her research centers on nineteenth- and twentieth-century Scandinavian art. She is a former Associate Editor at the High Museum of Art.

NANCY J. TROY is Professor and Chair of the Department of Art History at the University of Southern California. The recipient of numerous awards, including fellowships from the Guggenheim Foundation, National Endowment for the Humanities, and Getty Research Institute, she has been editor-in-chief of *The Art Bulletin* and has participated in the organization of several museum exhibitions. She has also published widely on modern art, architecture, and design in Europe and America, beginning with *The De Stijl Environment* (1983) and culminating with *Couture Culture: A Study in Modern Art and Fashion* (2003).

MAREK WIECZOREK is Assistant Professor of modern art history at the University of Washington in Seattle. He is an alumnus of the Whitney Independent Study Program and the Amsterdam School for Cultural Analysis and has curated museum exhibitions in the Netherlands and United States. His publications on modern and contemporary art include *The Touch of Light: Laser Paintings by Carel Balth* (1993) and *The Universe in the Living Room: Georges Vantongerloo in the Space of De Stijl—Het heelal in de huiskamer: Georges Vantongerloo en de Nieuwe Beelding van De Stijl* (2002).

WIM DE WIT is the Head of Special Collections and Visual Resources and Curator of Architectural Drawings at the Getty Research Institute in Los Angeles. He was the curator for architecture at the Chicago Historical Society, where he organized such exhibitions as *Louis Sullivan, the Function of Ornament* and *Grand Illusions: Chicago's World's Fair of 1893.* He was a curator responsible for the collections at the Netherlands Documentation Center for Architecture in Amsterdam and was the guest curator for *The Amsterdam School: Dutch Expressionist Architecture, 1915–1930* at the Cooper-Hewitt Museum in New York.

# Index

COLOPHON

This book is printed in English in clothbound and paperbound editions totalling 12,000 books. The text is set in Vendetta and Geometric. The paper stock is 150 gsm Ikonosilk.

Kelly Morris, Manager of Publications
Lori Cavagnaro, Assistant Editor
Christin Gray, Publications Coordinator

Designed by Jeff Wincapaw
Proofread by Laura Iwasaki and Carrie Wicks
Typeset by Jennifer Sugden
Indexed by Norma Roberts
Color separations by iocolor, Seattle
Produced by Marquand Books, Inc., Seattle
   www.marquand.com
Printed and bound by Snoeck-Ducaju & Zoon, Ghent, Belgium